THE LENS BOOK

CHOOSING AND USING LENSES FOR YOUR SLR

ROGER HICKS AND FRANCES SCHULTZ

David & Charles

For Oleg Svyatoslavsky

A DAVID & CHARLES BOOK

Copyright © Roger Hicks and Frances Schultz 1994

First published 1994

A catalogue record for this book is available from the British Library.

ISBN 0 7153 0149 7

Designed and typeset by Les Dominey Design Company
on an Apple Macintosh
and printed in Singapore
by C. S. Graphics Pte Ltd
for David & Charles
Brunel House Newton Abbot Devon

(Previous page) **Cornfield, Châlons-sur-Marne**
This detail from a cornfield near Châlons-sur-Marne is one of our favourite pictures, and it could have been shot with almost any lens that focused reasonably close. We used an old 90mm f/2.5 Vivitar Series One macro lens and ISO 50 Fuji transparency film for warm, saturated colours. The slow film meant that we could not stop down quite as far as we would have liked, because we needed a reasonably brief exposure – there was a slight breeze, and the leaves might have moved. As it was, the exposure was something like 1/15 at f/11. The camera was, of course, on a tripod. (RWH/FES)

CONTENTS

INTRODUCTION

One of the most fascinating things about photography is that you never stop learning. Just as you master one technique, you realise that it has opened the door to three or four new challenges, new ideas, new ways of seeing. Like a philosopher, you never actually get right to the heart of anything; you just become ignorant on a higher level.

Choosing and using lenses is a good illustration of this. There are plenty of people who will tell you exactly what you need – based on *their* experience. Well, that's fine if you take the same sort of pictures they do; but the chances are that you don't. There is a strong likelihood that they have an axe to grind, and that their perspective is in any case limited by the lenses they have used. A dealer or a manufacturer is trying to sell you lenses; the camera-club 'expert' is trying to bolster his authority; the photo-magazine journalist is trying to do both, while disguising the fact that he couldn't actually earn a living as a photographer.

Our credentials are simple. We are freelances, and we earn our living by selling words and pictures. We don't deny that we would earn a lot less if we sold only pictures, but we do know that without the pictures there would be many occasions when we couldn't sell the words. We have sold words and pictures together; words on their own, in non-illustrated books; and pictures alone, to illustrate other people's words (and record covers, and advertisements). We are not the greatest photographers in the world, but we are good enough to earn a living at it. And while we can't disguise our

prejudices, at least we admit that they exist.

We don't have a big-company budget behind us, so everything we buy has to earn its way – and the money we pay for it has to come out of our pockets. Oh, yes; and we love photography, which makes us 'amateurs' in the strictest sense. As well as the pictures we are paid to take, we also take pictures just for the fun of it. We do, however, enjoy certain advantages over most amateurs, and over many professional photographers too for that matter. First, we can devote a lot more time to photography; and if practice doesn't make perfect, it certainly makes for improvement. Second, because we originate a lot of our projects, we can afford a degree of experimentation – even playfulness – which is not open to many. Third, because of our track record, we can often borrow equipment from manufacturers and their agents: we can try before we buy, which can make an enormous difference when you are looking at a single lens which might cost as much as many photographers' whole outfits.

This is the point where it is traditional to say, 'If you enjoy the book as much as we enjoyed writing it ...' etc. With any luck, you have the enjoyable part without the effort of rewrites, picture-sorting, racing against deadlines, dealing with recalcitrant so-called public relations officers, and the sheer grind which goes into any book. Take that out, though, and we really did have fun with it. We hope you will too.

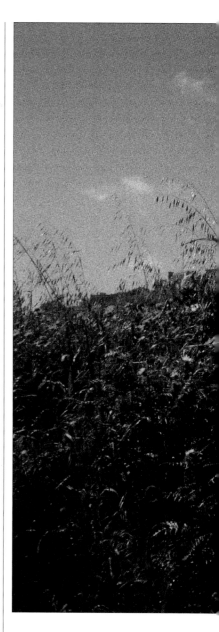

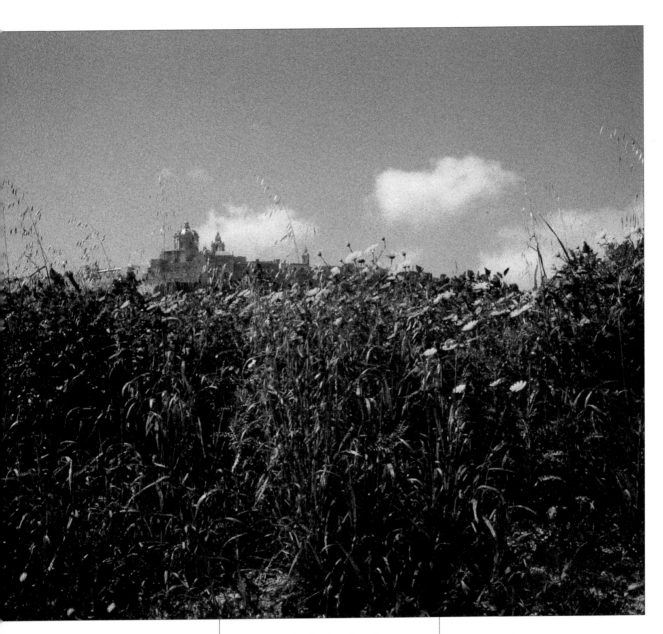

Mdina

Before you spend large sums of money on a new lens, try spending smaller sums of money on a different film. This picture of the old capital of Malta was shot on ISO 1000 Scotch film, which is extremely grainy and gives a 'painterly' quality to images shot with it. The very high speed of the film allowed a small aperture for front-to-back sharpness, while still retaining a high enough shutter speed to freeze any movement of the long grass. The actual exposure was probably 1/500 at f/16; the lens, as far as we can recall, was the 28mm f/1.9 mounted on a Nikon F. (RWH)

ACKNOWLEDGEMENTS

In the course of writing this book, we were lent equipment by both Pentax and CZ Scientific Instruments Ltd, who import Sigma lenses into the UK. Despite the fact that we use mostly Nikon SLRs, the Pentax Z-1 has entered the ranks of the cameras we use regularly, and several of the Sigma lenses have gone on the 'to buy' list. The very first Sigma lens that we ever tested, the 14mm f/3.5, we subsequently bought from Sigma; and it looks as if the 15mm f/2.8 fish-eye and the 300mm f/2.8 will go the same way. The only reason we do not plan to buy any more lenses is that we cannot afford them.

As well as Mr Yamaki of Sigma and Mr Purkis of CZ Scientific Instruments, we would also like to thank Colin Glanfield for endless help and advice; Henry's Camera in Margate and Brian Cowley Photographic in Canterbury, our local camera stores in England; Del's Camera in Santa Barbara, our local camera store in California; Bob Shell and Bonnie Paulk at *Shutterbug* magazine, for support and help above and beyond the call of editorship; and Alison Elks at David and Charles for the same.

Unless otherwise noted, all pictures were taken with Nikon or Leica cameras, generally carried on Kik-90 straps. Tripods were Benbo, Gibran, Linhof and Manfrotto, normally used with either Kennett Engineering ball-and-socket heads or the superb NPC ProBall. Cameras were carried in Sundog and Billingham bags; we also wear Billingham photographers' jackets. Unless otherwise noted, all black and white pictures were shot on Ilford XP-2. All but one or two of the black and whites were printed by Frances using Ilford materials, Paterson darkroom equipment, and a Meopta Magnifax with Meograde variable-contrast head, supplied by Paterson Photax.

To save space in the captions, Frances is FES and Roger is RWH; where the picture is a collaboration we give both names. All exposure data (where given) is from memory, and may not be dead accurate. In fact, lens information is from memory too, so there may be the occasional shot which we say was taken with a 200mm, when in fact it was a 135mm. We are not deliberately trying to mislead you but we don't take notes, and we don't know anyone else who does either.

Staircase, Alabama State Capitol

For the price of her 35mm f/2.8 PC-Nikkor shift lens, Frances could probably have bought two other lenses; but she reckons that there are no two other lenses which would be as useful to her. Most photographers will tell the same story: they have one lens which accounts for at least half of their pictures. This picture of the interior of the State Capitol at Montgomery, Alabama would be all but impossible to take with any other lens. You could approximate it by using an extreme wide-angle and cropping the foreground, but quality would suffer, or you could build a scaffolding and use a conventional (non-shift) 35mm lens, but the viewpoint would not be the same. Film was Ilford XP-2. (FES)

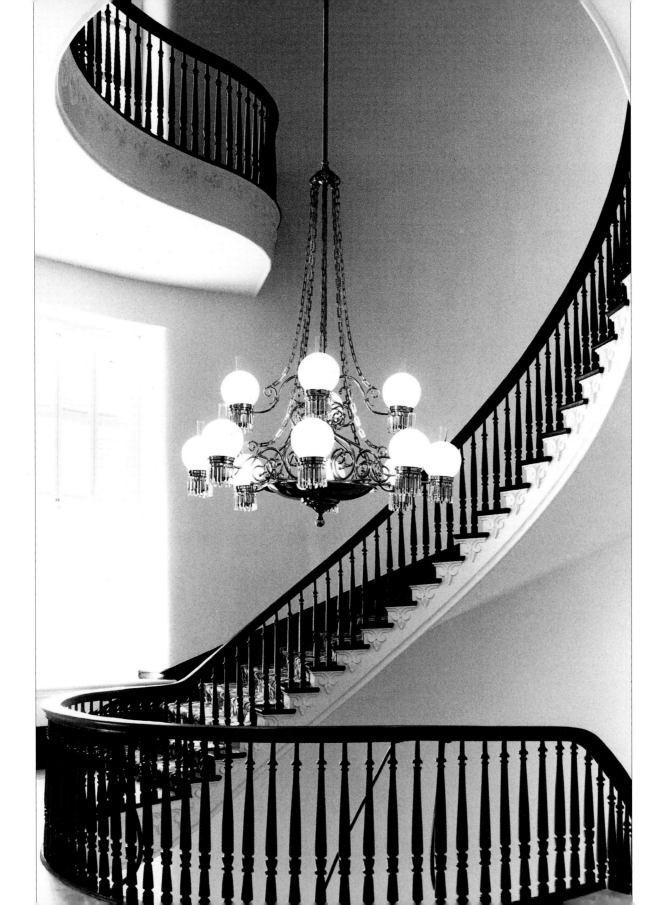

1 WHAT SORT OF PHOTOGRAPHER ARE YOU?

One of the great attractions of the 35mm SLR is the tremendous range of lenses it takes. You can get super-telephotos that can pick out a dozing tiger (or an indiscreet politician) from half a mile away, and you can get ultra-wide lenses which allow you to create dramatic photographs of cramped interiors. Macro lenses let you photograph the tiniest details at life size or larger on the film, and super-fast lenses allow you to take available-light pictures when there is hardly any light available. The cheapest lenses you can buy will cost you less than half a dozen rolls of film; the most expensive can cost more than a new car. In this bewildering variety, what do you need? Well, this will depend on what sort of photographer you are. So, what sort of photographer are you?

The easiest way to answer this question is to break it down into five separate questions, and then answer each of those in turn. The questions are these:

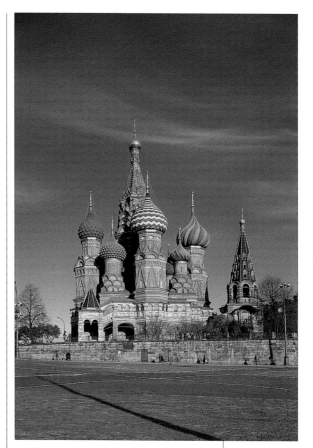

1 First, what sort of pictures do you really, really want to take, but find difficult because of equipment limitations?

2 Second, how important is photography to you?

3 Third, what do you want to do with your pictures once you have taken them?

4 Fourth, what is available for your camera?

5 Finally, what can you afford?

We have already stated our position in the introduction, so let's go on to look at how all this applies to you.

WHAT DO YOU WANT TO SHOOT?

We all have our fantasies about what we would really like to photograph – the Himalayas, beautiful models on tropical beaches, big game in Africa, and so forth – but for most of us, most of the time, these are not the kind of

St Basilius, Moscow

In so far as we specialise in anything, we specialise in travel pictures; and all our equipment is chosen with travel in mind. This means light weight (especially important when flying); compact size, robustness and simplicity (simple equipment is easier to repair if anything goes wrong); and as little battery dependence as possible. This was shot fairly early in the morning, using the 35mm f/2.8 PC-Nikkor and a Gibran tripod with an NPC head. We were extremely lucky that there were no vehicles parked in front of the church. A public works truck did draw up, but pulled away again when they saw that it would spoil the picture. Muscovites are justly proud of their monuments!. (RWH/FES)

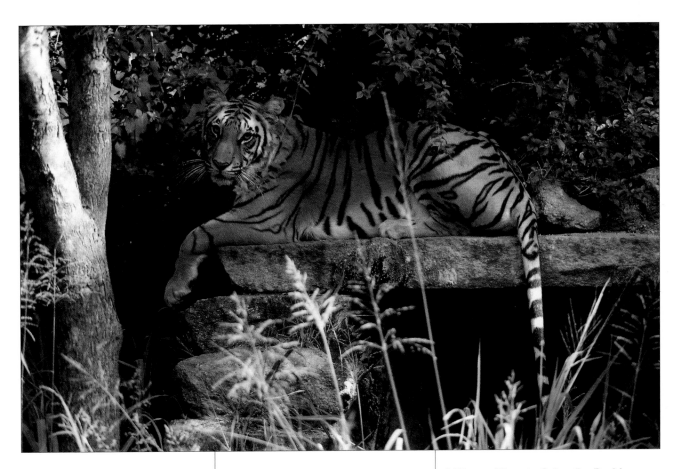

Tiger, Mysore Zoo

Tigers are the text-book example of subjects where the photographer does not normally want to get too close. You need a long lens, in order to be able to keep your distance, and a fast lens in order to allow easy focusing and (if necessary) hand holding. This was taken hand held with a 200mm f/3 Vivitar Series One, which is about the shortest lens you would want to use. A 300mm f/2.8 would often be more useful, but at Mysore Zoo you can get somewhat closer to uncaged tigers than is entirely comfortable. Exposure was probably 1/1000 at f/2.8 to f/4 on Kodachrome 64. (FES)

pictures we take; we shoot nearer home, or at less exotic holiday destinations. This is the kind of thing we are talking about here.

Sticking with reality, then, when was the last time you found that your photography was limited by your equipment? And what, precisely, was the limitation? Was there not enough light and your lens wasn't fast enough? Did you want to get closer, but your lens wouldn't let you? Did you want to pick out a small part of the scene, but you were too far away? Or did you want to get more in, but you couldn't get back far enough?

Different Ways to Solve the Problem

The easiest way to solve problems like these is with new lenses: a faster lens for poor light; a macro lens to get closer; a telephoto lens to bring distant subjects closer; a wide-angle to get more in. In this book you will find information about all of these lenses (and more), and about how to use them.

Admittedly, you could use faster film instead of buying a faster lens; or you could put the camera on a tripod and use a longer exposure. You could buy close-up lenses or extension tubes instead of a macro lens. You could enlarge just a section of the image instead of using a telephoto. About the

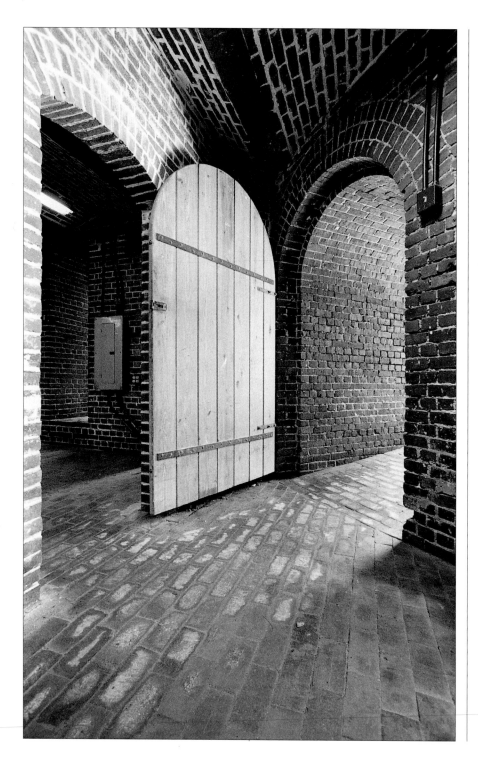

Doorway, Fort at Key West, Florida

Roger is a complete sucker for old doorways. There may be some deep Freudian significance to this, but a simpler explanation is that they provide wonderful studies in texture and light and shade. The modern electrics spoil the picture slightly, and we disagree on how it should be cropped. It was shot with the 17mm f/3.5 Tamron, probably one second at f/16, and Frances likes it 'all in' because she reckons that the foreground welcomes you into the picture. Roger would prefer it cropped, as he believes it takes up too much of the picture. Try cropping it with a piece of paper. Which view to you support? (RWH)

Blakely's State Battlefield Park, Alabama
This is the sort of picture our ancestors would have called 'pictorial' – to distinguish it, presumably, from a mere record shot, or even a portrait 'likeness'. There is a slight overall loss of sharpness due to camera shake, caused by not using a tripod: we had only one tripod with us, and Roger was using it when Frances took this picture. On the other hand, this loss of sharpness actually adds to the pictorial quality of the photograph, which really does look very nice when enlarged to 11x14in (or 30x40cm) and hung on the wall. The lens was probably the 90mm f/2.5 Vivitar Series One; exposure was probably 1/125 at f/8. (FES)

only problem you couldn't solve without buying another lens is getting more in, which is why so many compacts have 35mm and 38mm lenses instead of the old 50mm 'standard' lens. The trouble with all these cheaper alternatives is that they are less convenient than having the right lens, or they deliver poorer quality, or sometimes both. By all means try them, and if you are happy with them, fine; but if you find that you are using (say) fast film or close-up lenses on a regular basis, you might well be better advised to buy the equipment you really need.

Also, there are some subjects where

the *only* way to get consistently first-class results is to use specialist lenses. Sports and similar kinds of action photography, for example, require long, fast lenses. It is true that these are horribly expensive, and it is true that you can take some excellent pictures without them; but it is also true that unless you have them, you will be at an enormous disadvantage compared with anyone who does own one. There are other examples: macro, shift lenses, and so forth. Where alternatives exist to buying specialist lenses, we will tell you about them – but buying the right lens for the job will almost always be preferable, if you can afford it, or are willing to give up other things in order to pay for it.

HOW IMPORTANT IS PHOTOGRAPHY TO YOU?

This is not a trick question. Some people are absolutely obsessive about photography. The photography addict devotes every available minute to reading books and magazines about photography, to going to exhibitions and camera stores, and even in some cases to taking pictures. We know one very good photographer who says in all seriousness that if he could not take his camera with him he would not bother to go on holiday. We also know equipment nuts who never take a single picture, but that is another matter.

Then there are the more relaxed photographers. They want a good picture, sure; but they also want a good time. Photography isn't a matter of life and death, after all. Where the obsessive photographer might get up at dawn, the relaxed photographer will get a bit more sleep. Where the obsessive

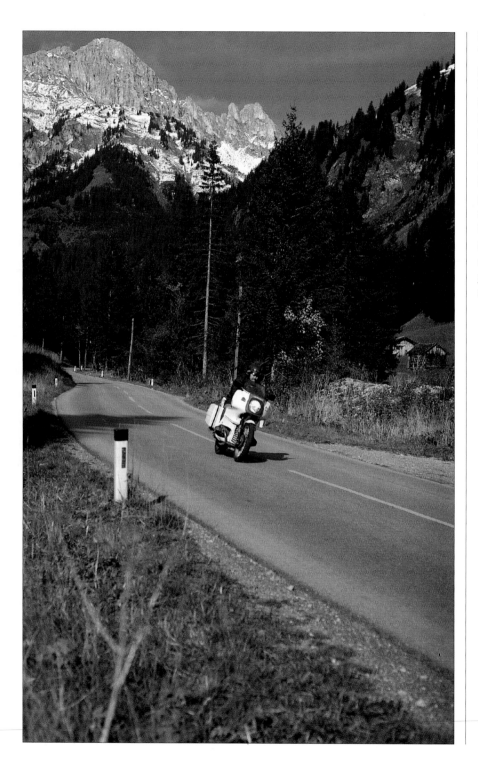

Motorcycling, Swiss Alps
This was Frances's first ever published picture, the cover of Roger's 1985 book Motorcycle Touring in Europe – that's Roger on the motorcycle. What is particularly interesting is that it was shot with a standard 50mm lens on a fully auto camera, a 50mm f/1.8 Series E Nikon lens on a Nikon EM. The only real defect is the out-of-focus dead plant in the foreground, which Frances would probably 'garden' out of the way today. Roger made about half a dozen passes. Once you have gone to the expense of getting to the Swiss Alps, the additional cost of a few extra exposures is negligible, and it is better to give yourself all the chances you can of making sure that the shot is 'in the can'. (FES)

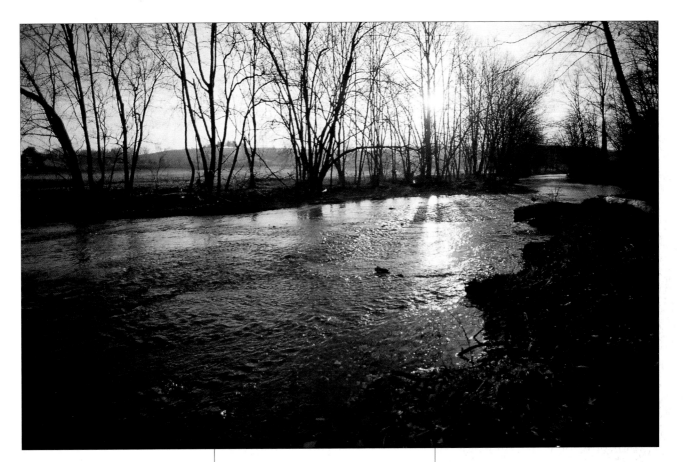

Cedar Creek, Virginia

A perennial problem with illustrative shots is trying to make a dull subject interesting. This is Cedar Creek in the Shenandoah Valley, scene of an important battle in the War Between the States, but it is (after all) just a river. By shooting very early in the morning, shortly after sunrise, we managed to capture something of what it must have been like a century and a quarter earlier as the troops splashed across the ford. The lens was a 35mm Summilux, and the film was Konica 100 slide film. (RWH)

photographer would walk five miles in order to get one shot, the relaxed photographer might just shoot from the car park at a scenic overview.

Perhaps by using the word 'obsessive' we have created the wrong impression – and anyway, one man's obsession is another man's modest effort. For example, we do get up at dawn to take pictures, and we don't mind walking a few miles; but we don't spend the night in the back of a pick-up truck at 10,000 feet in below-zero temperatures in order to be able to capture a mountain sunrise. We know a photographer who does! The same photographer once lived in a cave on a

remote Hawaiian beach for a week so that he could get the very best wave pictures.

Only you can say how much effort you put into your photography, and there is absolutely nothing wrong with being either relaxed or obsessive, so long as you get the sort of pictures that satisfy you. Professionals have to be at least a bit obsessive, of course, but amateurs do not. You have to realise, though, that an 'obsessive' photographer is likely, in the long run, to get better pictures than the casual or relaxed photographer. This is not unreasonable: the harder you work at something, the better you are likely to

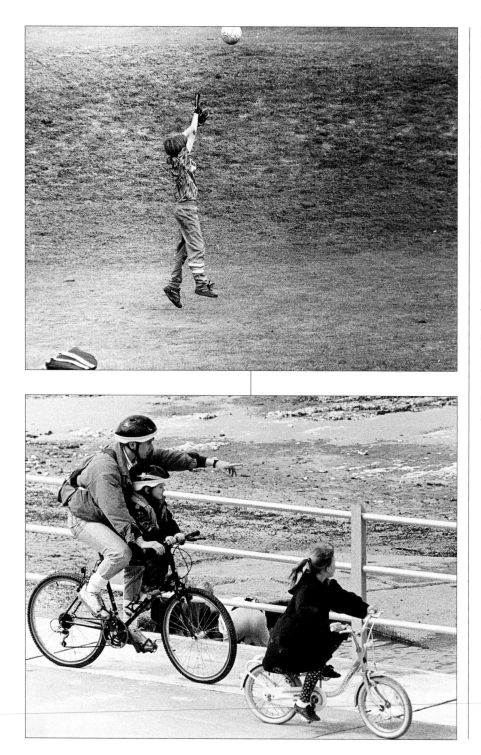

Footballer, bicyclist

What you might call 'traditional' action photography is not a field in which either of us has been very interested – until we got the 300mm f/2.8 Sigma. If you are interested in this sort of photography, there is simply nothing like a fast 300 lens. The price is alarming, it is true, but being able to hand hold shots at maybe 1/1000 second without any great fear of camera shake is an enormously liberating experience. These were literally just test pictures, taken within half a mile of where we live; but they were inspiration enough to make us want to try some 'serious' photography with this lens, which we acquired less than a week before sending the manuscript to the publishers. The shot of the young footballer would have been improved by using either a red filter to darken the grass, or a green filter to lighten it, but the effect is still impressive. The cyclist is on Ilford HP5 Plus, while the footballer is on Ilford Delta 400: both were rated at EI 800. In the original prints, the finer grain (but lower contrast) of the Delta is readily detectable. (Both RWH)

Ford's Theatre, Washington DC
The Presidential Box where Lincoln was shot is just to the right of the centre of the picture. In order to show it in the context of the sweep of the balconies, we had to use the very widest lens we possess: the 14mm f/3.5 Sigma. Only one commercially available lens in the world covers a wider angle of view, the 13mm Nikkor, and it would have been a boon here: as you can see, even the 14mm was not quite wide enough. Even the users of medium-format and large-format cameras cannot buy lenses with wider coverage than the Sigma 14mm or Nikkor 13mm. (RWH/FES)

become at doing it. As long as you realise this, you can do what you like.

WHAT LENSES ARE AVAILABLE FOR YOUR CAMERA?

The reason so many of our examples in this book are taken from the Nikon system is because Nikons are what we and most other professionals use. This is not necessarily because Nikons are the very best made cameras in the world, or because every single lens in the Nikon line-up is the best available: there are other systems which are just as well made, and whose lenses are just as good, or arguably even better. The great advantage of the Nikon is, however, that it is extraordinarily versatile, and accepts probably a greater range of lenses and accessories than any other system.

If you have one of the less comprehensive systems, you may find that you have to go to outside suppliers – independents – for some lenses, and you may even find that some lenses are simply not available for the system you want, either from the 'independents' or from the 'marque' manufacturers. For obvious reasons, we cannot list the availability of every lens for every camera, so the only way to find out if a particular type of lens is available for your camera is to check the manufacturer's catalogue for marque lenses, and then take a look at the independent offerings from firms like Sigma.

Should You Change Your System?
Most professionals change their equipment very rarely, and they almost never change it all at once.

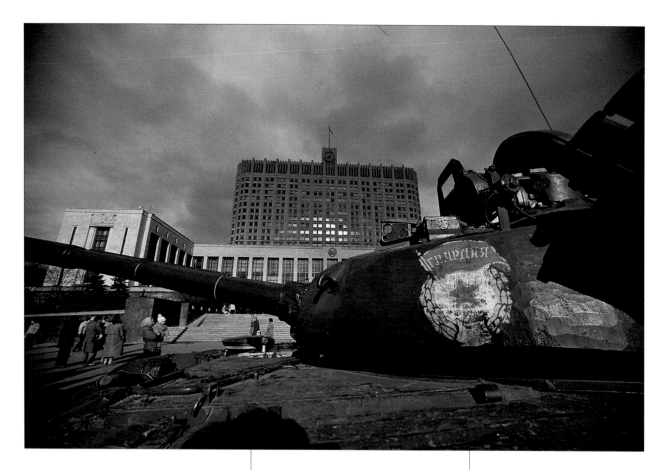

Instead, they continue to build their system, buying a compatible body here, a compatible lens there. When a body wears out or is plainly superseded, or when a very much improved lens comes out, they may replace old equipment; but, in general, the way that they build a system is step by step. This is the way to get the equipment you want.

As we have already mentioned, we use Nikon. Sometimes we wish we had another system and, if we did, we are sure that we would be just as happy with that system; but, there again, we are also sure that there would be times when we wished we had Nikons again. The point is that the benefits of changing are smaller than the benefits of sticking with the system we have. Don't change your system unless you find that it is really limiting what you can do – or, of course, if you really

don't like it. Regardless of what some camera-magazine pundits say, some cameras *are* better than others, and some people find some systems more *simpatico* than others. If you own and like Pentax, stick with Pentax. If you own and like Olympus, stick with Olympus. Changing camera systems costs money, and you could better spend that money on lenses and film.

It is worth adding that the Nikons we use are mostly Nikon F cameras, last made in 1973. They are stone-age by modern standards, with no automation of any kind; the ones we use don't even have built-in meters. This is, however, totally irrelevant to lens quality. As long as your camera is a well-made light-tight box, which holds the film at the correct distance from the lens, and as long as it has an accurate shutter, you have all you need. Our old Nikons are

Russian parliament building, Moscow

The Red Army tank was in front of the Russian parliament building – the 'White House' – as part of a re-enactment of the Muscovites' stand against the August 1990 coup. The picture is somewhat spoiled by the people in the background, who are obviously neither demonstrators nor particularly frightened, but it still has a good deal of impact. It was shot with an ultra-wide lens – the 14mm f/3.5 Sigma – to emphasise the tank and its insignia, but the ray of sun through a break in the clouds is responsible in large part for whatever drama the picture has. This is an example of a picture where the choice of lens was less important than being in the right place at the right time, and waiting for the sun to strike the tank. (RWH)

Sturdivant House, Selma, Alabama

The Sturdivant House is a beautiful ante-bellum building which has been superbly restored. The only convenient way to show the interiors, though, is with an ultra-wide lens – the widest you can muster. In our case, this is the 14mm f/3.5 Sigma. There is some wide-angle distortion – the door is 'stretched' to a considerably greater width than in real life – but careful levelling of the tripod-mounted camera means that verticals remain vertical and the picture is surprisingly natural looking. Exposure determination was difficult: we took incident-light readings in several places, then bracketed one stop either way. Exposure was about 1/8 at f/11 on Fuji 100. (RWH/FES)

wonderfully reliable, and we are used to them, so we stick with them. Modern cameras are very good; but they will not necessarily give you any better results than older cameras, because it is the lens that determines image quality. How much image quality you need will depend on what you want to do with the pictures.

WHAT DO YOU WANT TO DO WITH THE PICTURES?

Some people take pictures for the family album, or for souvenirs to show to their friends. Some take them for camera-club competitions. Some take them to hang on the wall. We take them to sell, and sometimes for exhibitions. These different applications make very different demands on the camera, the film and the lens.

Happy Snaps

Taking pictures just for the fun of it, to remind you of happy times and beautiful places, is arguably the finest application of photography. We do it. Any photographer who doesn't do it is likely to be a very dull person.

The great thing about happy snaps is that they do not have to meet very high technical standards. Most of the pictures are small, maybe 5x7in (13x18cm) at most, and you are more likely just to have them enlarged to postcard or even wallet size. You may blow the occasional picture up to 5x7in or 13x18cm at most, or even to poster size, but that isn't what you are shooting for: you are shooting mainly for the memories.

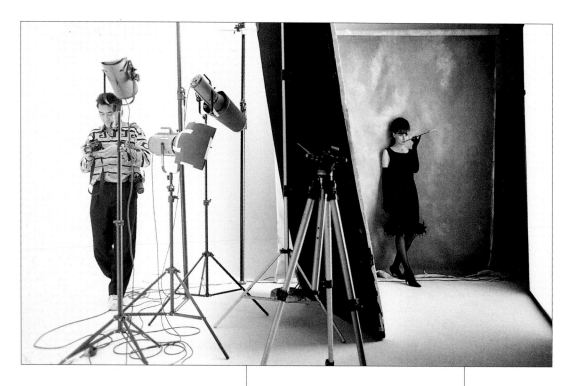

Also, if you are interested mainly in happy snaps, the chances are that you do not get through a lot of film: ten or twenty films a year, or maybe even less. When you consider that a professional might get through ten or twenty films a *day*, you can see the difference! What you are paying for when you buy an expensive camera is (in large part) durability, and if you don't put scores of films a year through your camera, you don't need professional ruggedness. With lenses, it is true, extra money normally buys extra sharpness as well as extra durability; but if you only ever shoot colour prints, even the cheapest zooms should be adequate, and mid-priced zooms will be more than you need. If you are shooting wallet-sized pictures, the difference between top-of-the-line lenses and modestly priced ones is not going to be worth bothering

with. Do not let anyone sell you a more expensive lens than you need.

Camera Club and Exhibition Pictures

A lot depends here on whether you shoot colour or black and white. With colour, you are limited more by the film than by the sharpness of the lenses. With the possible exception of super-slow films like Ektar 25, no colour film can deliver the sharpness of which the best lenses are capable. Even at that, you will need to use a first-class lab, or process and print the film yourself. Good zooms should be adequate, and good prime lenses will be more than adequate.

In black and white, on the other hand, the resolution of the lens is likely to run out before the resolution of the film becomes a problem. This is

On the right is Audrey Hepburn look-alike Annalisa Orsi from the Lookalikes model agency in Clapham. On the left is William Cheung, editor of Practical Photography. The occasion was a seminar which Roger gave to the winners of a Pentax competition, but the main reason for including it here is because it was shot with a Pentax LX, which Frances used for the first time that day – and fell in love with. Although we are committed to Nikon, and could hardly extricate ourselves from the system, the LX is one of the cameras which we would seriously consider if we were starting from scratch: a superb traditional SLR with an excellent range of lenses. It is more important to choose a camera you like than to have the very latest model. (FES)

Jeff Davis's boyhood home

Much of the interest of this picture lies in the rich, dark vegetation in the foreground, which means that it will not look as good in reproduction as in the original; but it is a good example of the kind of picture which you might want to exhibit in the camera club. Arguably, the sky should be 'burned in' or darkened a little during printing, because it is somewhat featureless. Even so, the picture still has considerable impact. It is a hand-held shot taken with a 35mm f/2.8 PC-Nikkor, but the PC facility was not used and it could as well have been taken with a conventional 35mm f/2.8 or with a 35–85mm (or 28–105mm, or similar) zoom. (RWH)

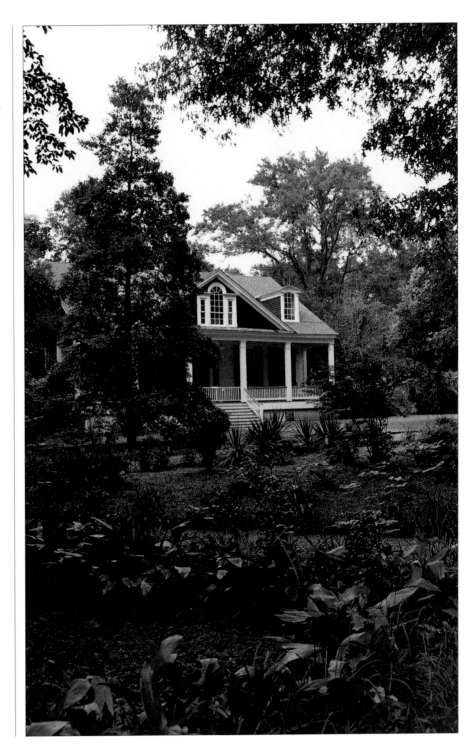

especially true if you shoot on super-sharp films like Ilford's Delta 100. If you like big prints, (anything much over 8x10in or 18x24cm), the differences in quality between different lenses will become increasingly obvious. This is why some people switch to larger formats (rollfilm and even 4x5in) if they want to make big black and white prints.

Our view is that 35mm is fine, even for big prints, as long as you accept that it is 35mm and do not expect large-format quality. Even so, and even with the finest available lenses, we really prefer not to go larger than about 11x14in or 12x16in at the biggest; 30x40cm, say. For this sort of quality there have only ever been a handful of zooms that are good enough, and good prime lenses will be considerably sharper in most cases.

Shooting for Sale

Most pictures for publication are shot on either black and white or on colour slide film. Paradoxically, the quality requirements for black and white for publication are often lower than they are for exhibition. Only very rarely is a monochrome picture run much larger than A4 (210x297mm, about 8^{1}/$_{4}$x11^{3}/$_{4}$in) in a book or magazine, while exhibition prints are often much larger.

The quality requirements for colour slide are extremely demanding, however. Maximum sharpness is essential, and the only way to get it is to use the best possible prime lenses, to shoot on slow, sharp film, and to work as carefully as you know how. We come back to this in the next chapter, in particular when we talk about tripods.

Having said this, there is one

Beach, Gran Canaria

The 'tanning yards' on the island of Gran Canaria are crowded even in December, when this picture was taken. This is the sort of shot where a zoom is ideal, as the image can be precisely framed from a camera position which often allows little or no change of viewpoint. This was shot with a 35–85mm standard zoom, probably the most useful single lens you can buy if you do not need the extra speed of a prime lens. Even a slow zoom would have been adequate – the exposure was about 1/250 at f/5.6 on Fuji 50 film – but an f/2.8 lens is easier to focus and provides that extra reserve of speed when you need it. The focal length selected was probably 40–45mm, and the camera was a Nikkormat FTn, hand held. (FES)

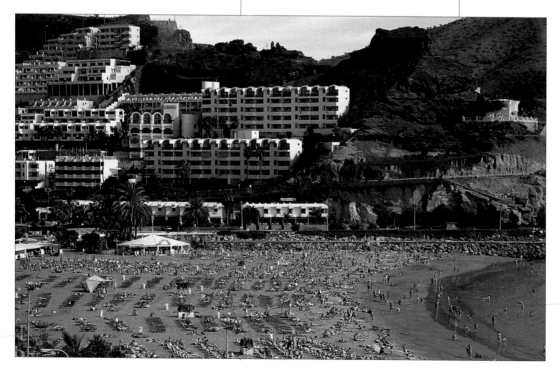

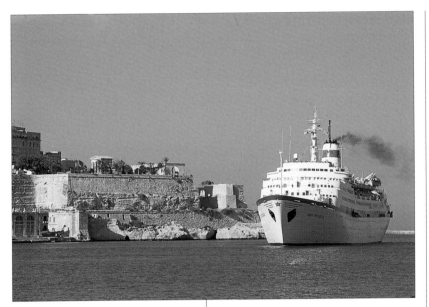

Liner entering Grand Harbour, Malta

A cruise to the historic ports of the Mediterranean is not the time to experiment with a new camera outfit. The same is true of all the other 'vacations of a lifetime' such as African safaris, tours of China or Russia, or visits to American Civil War battle sites. Either buy new cameras well in advance, so that you are totally familiar with them, or stick with your old cameras and lenses. This was actually shot with a 135mm f/2.3 Vivitar Series One and a 2x teleconverter, because our 200mm lens had succumbed to vibration on a 4000km motorcycle tour of southern India, and anyway there was no room to pack anything longer. (RWH)

overriding consideration in any professional photography. It is this: *any* picture is better than *no* picture. If you see a flying saucer, and you have only got an old Instamatic with an outdated film in it, do you seriously think that lack of technical quality is going to stop an editor from publishing it? And if you can get a really dramatic picture of a motor race, or an exceptionally beautiful picture of, say, an old house, shoot it anyway, even if you don't have the best equipment in the world. If you don't play, you can't win.

WHAT CAN YOU AFFORD?

It may seem strange to leave this until last, but, in a sense, it has to be the last question you ask yourself. Think of it this way: it makes more sense to say, 'I want this lens, but can I afford it?' rather than to say, 'I can afford this lens, but I don't know if I want it'.

Once you decide that you really do need a particular lens, we strongly

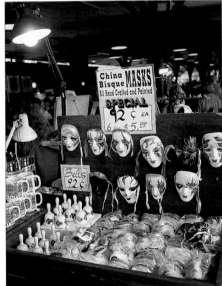

Mardi Gras masks

For grab shots like these masks in the Old Market in New Orleans you need to use a lens (and a camera) that you are totally familiar with. This was actually shot with a non-reflex, an M-series Leica, fitted with a 35mm f/1.4 lens; exposure was about 1/125 at f/4. The 35mm f/1.4 is Roger's standard lens, just as the 35/2.8 is Frances's standard; but in poor light like this she uses the 28mm f/1.9. We are constantly tempted to buy another 35/1.4, for the Nikons, but two 35mm f/1.4 lenses do seem a trifle excessive! Either way, fast wide-angles are among the most useful lenses for reportage. (RWH)

advise you to go for it. This advice holds good even if it costs more than you expected. If you genuinely can't afford it, wait. *Don't* buy some other lens just because it is cheap, or because someone else tells you that it is what you want. At the end you won't have the lens you wanted, and you won't even have the money to put towards it. Also, ask yourself whether you really can't afford it, or whether you just think you shouldn't buy it. More than once, we have agonised about whether to buy a lens that we really wanted, then gone ahead and bought it even though there might have been other things we should have bought instead. After a few months, though, the minor financial crisis passes, and you still have the lens that you wanted!

This first piece of advice may sound a bit nannyish – 'Be a good boy and save your pennies' – and the second piece of advice may seem a bit reckless – 'Buy it first, and count the cost later' – but this is the approach that works for us. Besides, when you get the lens you really want, you may be amazed at the rush of creativity that it unleashes.

Dream Outfits and the Trip of a Lifetime

Even if you could afford it, you might not be well advised to buy everything you want. Dealers know that a surprisingly common phenomenon is the photographer who buys a 'dream outfit' and then doesn't use it. It may be bought with a windfall – a small inheritance, a lottery or Premium Bond win. It may be a retirement present to himself. It may be that the photographer is simply a rich man, and buys what he thinks he needs. Whatever the reason, these 'dream outfits' are regularly bought back by camera stores, often at a fraction of their value, and then sold on again at a handsome profit.

Another sad sight, often seen on safaris, is photographers struggling with new equipment that they clearly don't

Abstract

There is no substitute for personal vision, and the lens you find most useful will depend on that vision. This is the drain hole of an old cast-iron pump, which Frances saw as a picture – Roger would never have noticed it! To shoot it, she used her 90mm f/2.5 Vivitar Series One macro lens: close focusing is essential to her way of 'seeing', though on this occasion she was probably shooting from a couple of feet (60cm) away. It is hard to say whether the picture would have been improved or not by using a tripod and stopping down for greater depth of field: this was hand held, probably 1/500 at f/8. (FES)

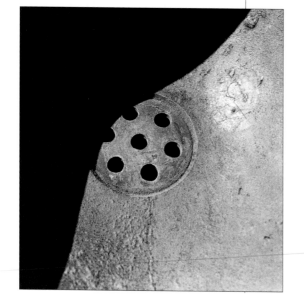

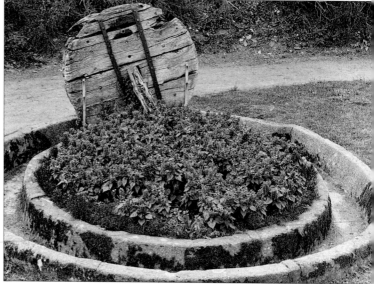

Driftwood and rose

Still lifes are a rewarding but surprisingly difficult branch of photography. The attraction of the idea lies in the contrast in textures of this burnt, weathered driftwood and the rose; but, unfortunately, the whole picture is a little flat and dull. It would probably work better with dappled light and with extra light 'kicked' onto the rose, and it might be better with greater depth of field, though equally well it might not. If you want to practise still lifes, you need a lens which will focus reasonably close. This was shot with the 90–180mm f/4.5 Vivitar Series One zoom, on a plain white paper background. (FES)

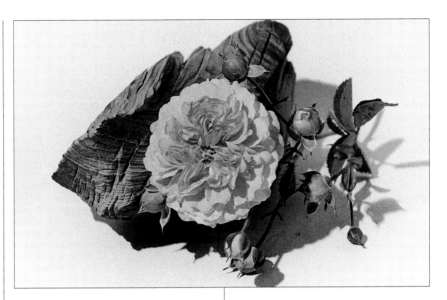

Old cider press used as planter, Brittany

Frances spotted this old cider press in Dol de Bretagne, and photographed it on Ilford XP-2 using her 90mm f/2.5 Vivitar Series One. She remembers it was the 90mm because she had to jockey around to get the best viewpoint: if she had had our old 35–85mm f/2.8 Vivitar Series One standard zoom, or our new 28–70mm f/2.8 Sigma, it would have been rather easier. We were, however, travelling by motorcycle, which concentrates the outfit wonderfully: you just cannot carry every lens you need, so you need to strip your equipment to the bare essentials. Given that she will not travel without her 35mm f/2.8 PC-Nikkor, the 90mm macro lens won out over the bulkier zoom. (FES)

know how to use, but which they bought because they knew they were going on the picture-taking opportunity of a lifetime. What happens, of course, is that they get either no pictures at all, or pictures which are grossly inferior to what they would have got if they had stuck with the cameras they knew. A twenty-year-old Nikkormat and a 200mm f/4 lens may not be 'state of the art', but, unless you are totally familiar with the new equipment before you leave, the camera you know is a better, safer bet than the latest all-singing, all-dancing fully auto SLR, complete with brand-new 70 – 210mm f/2.8 zoom and 300mm f/2.8 telephoto.

You might think, 'Chance would be a fine thing'. But you never know your luck. All we are warning you about is buying more than you need. Do it our way, one lens at a time, and at worst you will have wasted the price of that lens. Do it the other way, and it can cost you both a fortune and the pictures that you miss.

The Small Outfit – by Choice

Many photographers, even when they have a lot of expensive and exotic lenses to choose from, will admit that nine-tenths or more of their pictures are taken with two or maybe three of them. Some may be quite ordinary, like a 35–85mm or 28–80mm 'standard zoom'. Others may be relatively exotic, like Frances's 35mm PC-Nikkor. The trick lies in finding the right lenses for *you*.

If you cannot afford exactly the lens you want, get the closest to it that you can afford. Ultimately, it's your eye that matters. Yes, better lenses will give you better pictures, but a good photographer with a bad lens will produce better pictures than a bad photographer with a good lens. Ideally, you want to match the lenses you use to the way that you 'see' – you want, in fact, to be a good photographer with a good lens. The next thing to consider, therefore, is what constitutes a 'good' lens.

2 SOME OPTICAL FACTS OF LIFE

It is sad but true that in optics, as in life, it is very difficult to get 'something for nothing'. Other things being equal, the more you want, the more it will cost you. Of course, all things are not always equal, and part of the purpose of this book is to help you tip the inequalities in your favour. Even so, 'you get what you pay for ' is a good starting point.

At the most basic, you don't need a lens at all: you can use a pinhole. There is a pinhole picture on page 134. It is very soft, though, and it requires a very long exposure: several seconds, because a pinhole typically works at f/128 or less.

A single piece of glass – even a magnifying glass – will also give you an image. It will not be very sharp, but it will still be sharper than a pinhole image, and it will be a lot faster: enough to allow a hand-held exposure in good light. Some old box cameras used single-glass lenses, working at maybe f/12. Quality was just about acceptable, because of the combination of a small working aperture, big negatives, and very small degrees of enlargement.

Using two pieces of glass, and putting them together in the right way, allows a little more speed as well as a rather sharper image. With three pieces of glass, you can make quite a satisfactory lens – the Cooke Triplet is the best-known design – and with four, you can get a lens that is very good indeed: the Zeiss Tessar is a four-glass (or 'four-element') lens. It is known as a four-element, three-group lens, because two of the glasses are cemented together to make a single group: a 'cemented doublet'. Three glasses cemented together are known, predictably enough, as a 'cemented triplet'. The only trouble with the four-glass Tessar is that you can't make it very fast, or the image quality suffers. For 35mm cameras, the four-glass Tessar-type design is stretched to the limit at f/2.8, even with the best of modern optical glasses. For more

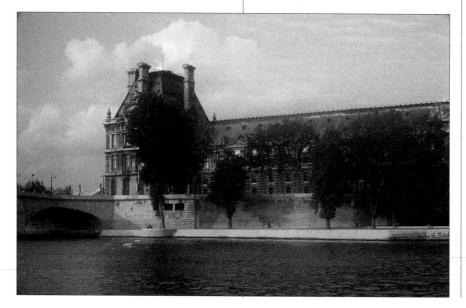

Banks of the Seine, Paris
This was shot with the same Canon f/1.2 as the picture of the water jug opposite. This time, it was stopped all the way down to f/22 and the film was Scotch ISO 1000. Many old, fast lenses deteriorate badly if they are stopped down too far – some pre-war Leica lenses were designed to stop down only to f/12.5 – and so do some cheap zooms. Most good, modern lenses are, however, pretty good even at their minimum aperture, so if you really want to create effects like this, you will have to hunt carefully for a 'good, bad lens' (RWH)

Filling a water-bottle, Mexico

A subject with a great deal of detail and texture will often appear sharper than it is, because the brain supplies detail which is not actually present in the picture. You should not however neglect more conventional ways of assuring sharpness, such as using slow film, stopping down to the optimum aperture, and using a tripod. This was shot with our old 50mm f/1.2 Canon rangefinder lens from the late 1950s or early 1960s, which is truly appalling wide open or at f/22, but which is very sharp at f/5.6 or f/11 – the normal apertures for photography in good light. We were filling the water jug to replenish the radiator of our old diesel Peugeot, which was boiling as we climbed from sea level to the high plateau near the Tropic of Cancer. (RWH)

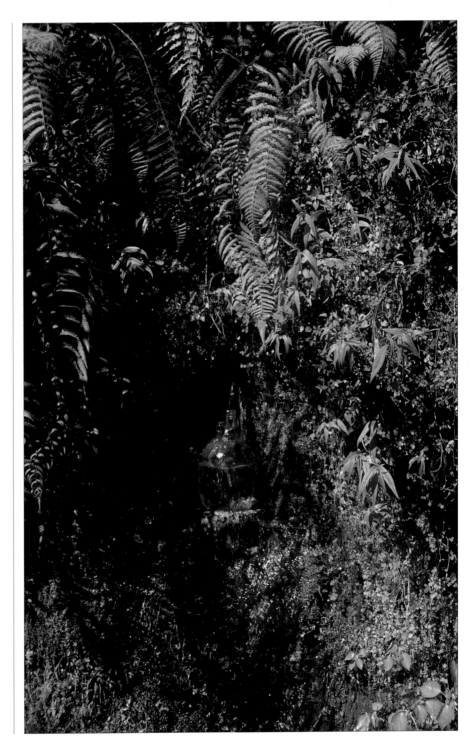

speed, you need more glass.

Nor is speed your only problem. The wider the angle of coverage you want, the more glasses you need. For a slow lens covering a very narrow angle of view, such as the Leitz 560mm f/6.8 Telyt, you can get away with just two glasses, and we have already seen that a four-glass Tessar design is all right for a 50mm f/2.8. For a 50mm f/1.4, though, six or seven glasses are commonplace; and the 21mm f/4.5 Zeiss Biogon uses eight glasses in five groups (singlet, singlet, doublet, triplet, singlet). More glass makes the lens bigger and heavier and more expensive.

So far, we have only considered the number of lens glasses that you need in order to make a sharp, fast or wide lens – which, you might think, was all you needed to worry about. But there is yet another problem: the actual physical dimensions of the lens.

The two glasses in the 560mm Telyt must be 560mm (22in) from the film when focused on infinity: the lens is an unwieldy 2ft (60cm) long. The 21mm Biogon, by contrast, is 45mm (1³/4in) from front to back, and the 'nodal point' of the lens (the point from which focus is measured) must be 21mm (⁷/8in) from the film, at infinity. A lot of this 21mm (⁷/8in) is taken up with glass, so the rear element of the lens is only about 5mm (1/4in) from the film. This is why a Biogon cannot be used in a single-lens reflex camera: there is no room for what the Japanese used to call the 'flipping mirror'.

TELEPHOTO AND REVERSE-TELEPHOTO DESIGNS

The solutions to these two problems – lenses that are inconveniently long, and

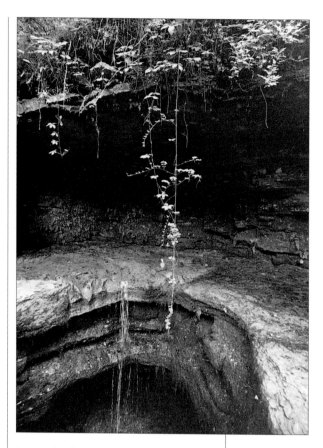

lenses that have no room behind them for the 'flipping mirror' – are remarkably similar. In order to shorten the physical length of a long-focus lens, another group of glasses – the 'telephoto group' – is put behind the main group. This is how a telephoto lens differs from a long-focus lens. In order to create more space behind an ultra-wide, on the other hand, another group of glasses is placed in front of the main image-forming group. This is known as the 'retrofocus group' (after the Angénieux Retrofocus lens, on which it was introduced) or the 'reverse-telephoto' or 'inverse-telephoto' group, because its effect is the reverse of the effect of a telephoto.

Falling spring

Just near Abraham Lincoln's birthplace is the water supply which prompted his father to build a log cabin there: a 'falling spring' in its own little cave. A picture like this could be shot with almost any lens, because much more depends on the composition than on anything else. Quite honestly, we have forgotten which lens we used, but it was probably the 35–85mm f/2.8 Vivitar Series One. This is a very sharp lens, but this picture was hand held. Limited depth of field, and probably a small degree of camera shake at something like 1/60 wide open, conspire to take the edge off sharpness. (RWH)

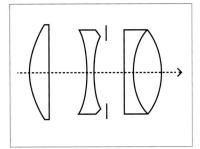

Tessar design

The Tessar is one of the all-time great lens designs, a development of the Cooke Triplet with the rear glass a cemented doublet. This simple four-glass design is all you need for a first-class and very compact f/2.8 lens, but it cannot be made much faster. The 45mm GN-Nikkor is a Tessar derivative.

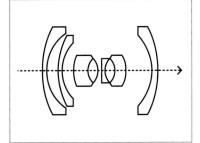

Non-retrofocus wide-angle

The Zeiss Biogon is one of the finest wide-angles ever made, covering approximately 90° and acceptable at its maximum aperture of f/4.5. In return for this coverage, sharpness and (relative) speed, it is however, an eight-glass lens consisting of a singlet, singlet, doublet, triplet, singlet. Most old 'mirror-up' lenses are symmetrical derivatives very similar to the Biogon. The rear glass is, however, very close to the film plane: the diaphragm is approximately 21mm from the film in the 21mm Biogon, and the rear glass is less than 10mm from the film. The 'flipping mirror' typically requires up to 40mm of clear space behind the lens.

The telephoto shortens the back focus (the distance from the rear nodal point to the film), while the reverse-telephoto lengthens it.

These extra groups of glasses do not make the lens any sharper. In fact, they do the opposite: a plain long-focus can be made sharper than a telephoto, and a plain wide-angle can be made sharper than a retrofocus lens. This is why some manufacturers still offer unwieldy long-focus lenses, and it is why Hasselblad continue to offer the 38mm Biogon on the non-reflex SWC/M as well as a range of retrofocus lenses which can be used with the reflex models. It is also why some manufacturers of 35mm SLRs used to sell 'mirror-up' lenses, where the mirror had to be locked up and a separate viewfinder was used: focusing was by scale, just like a snapshot camera. Some of these lenses delivered stunning quality: the Zeiss and Nikon

Non-retrofocus lens

This is an old 21mm f/4.5 Biogon from a 1950s Contax rangefinder camera, specially adapted for an M-series Leica. As you can see, the rearmost glass is very close indeed to the film plane. In the days before modern CAD, and before modern LD glasses, several SLR manufacturers offered similar lenses – including, in fact, the very same Biogon for the Contarex. These old 'mirror-up' lenses are mostly astonishingly sharp and contrasty. Our 21mm f/4 for the Nikons was stolen years ago, and it was at least as good as the Biogon. If you can find one, you may be astonished at how good it is, but make sure you get the finder with it. The price of a 21mm finder defies belief!

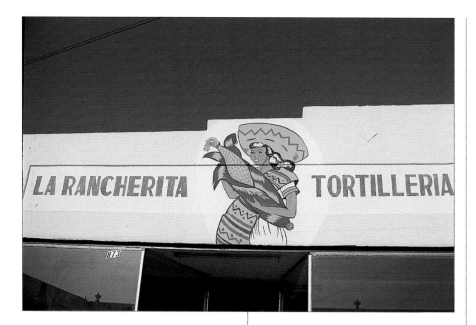

Sigma 70–210mm f/2.8

Most (though not all) high-quality, long-focus lenses are supplied with their own tripod mount. This allows better balance, makes for less strain on the camera body, and allows the camera to be turned 'portrait' or 'landscape' without using up any of the movement on the tripod head (this is the wonderfully versatile NPC ProBall). Better still, as seen here, the collar for the mount can be quickly and simply removed, thereby making it easy to hand hold the lens, and to pack it.

21mm lenses, and the Canon 19mm, for example. But telephoto and retrofocus lenses are unquestionably more convenient.

ZOOMS

All of the lenses described so far have been of fixed focal length – so-called 'prime' lenses. If you use enough glasses, though, and build the lens so that the photographer can vary the separation between them, you can create a lens which can be set to a variety of focal lengths: a zoom, in fact. By now, you are typically into at least a dozen lens elements, and (as before) not all of these pieces of glass are doing anything for sharpness. By careful design, and with modern optical glasses, zooms can be made astonishingly good – but they still cannot be made as good as the best prime lenses.

The longer the zoom range, the more glass you need if you want to keep reasonable sharpness. The easiest way to measure zoom range is in terms of zoom ratio, the ratio of the longest focal length to the shortest. Thus, a typical 70–210mm zoom has a zoom ratio of 3:1; a 35–85mm zoom has a ratio of about 2.4:1; and an 18–28mm zoom is just over 1.5:1. This decrease in zoom ratios is by no means unusual. In general, the shorter the minimum focal length, the harder it is to provide a wide zoom ratio.

Given that you need more glass for speed, more glass for wide-angles, and more glass for zooms, it is not surprising that zooms are not very fast. Most zooms are around f/4, maybe as fast as f/3.5 and maybe as slow as f/4.5, but f/4 is a good average. Faster zooms tend to be

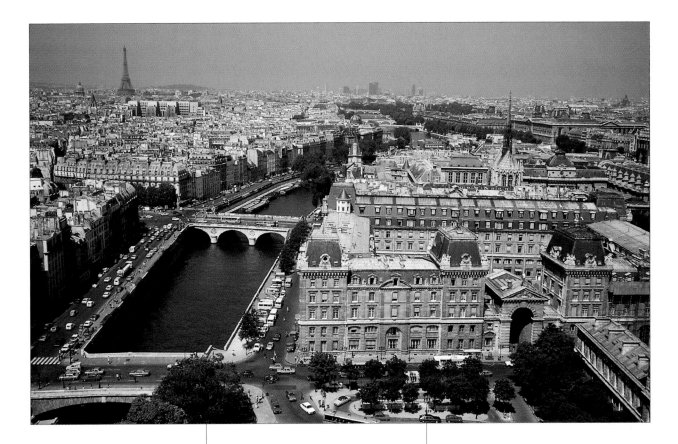

**View from the Bell Tower,
Notre Dame de Paris**

Contrast is one of the things you pay for in a good lens, and this was shot with a seriously expensive lens: a 90mm f/2 Summicron on a Leica. When you are shooting into the distance like this – we were on one of the bell towers of Notre Dame – you always have haze to contend with, and any lack of contrast in the lens will only make things worse. Even the very best zooms would probably be pushed beyond their limits by this sort of picture. Exposure on ISO 64 film was probably 1/250 at f/4, hand held. (RWH)

disproportionately bigger, heavier and more expensive: if you want an extra stop, from f/4 to f/2.8, you might have to pay three times as much as you would for the slower lens. The difficulty is not at the shorter end of the range of focal lengths, it is at the longer end. After all, *any* 200mm f/2.8 is a pretty big, expensive lens, so a 70–210mm f/2.8 zoom, for example, is even bigger and more expensive.

One way around this is to make variable-aperture zooms, where the effective aperture decreases as the focal length increases. For example, a lens which is f/3.5 at 28mm might drop to f/4.5 or less at 80mm. This is discussed in more detail on page 68.

COMPUTER-AIDED DESIGN AND EXPENSIVE EXPEDIENTS

One of the reasons why modern lenses are so good, and why even cheap zooms are acceptable, is computer-aided design (CAD). With current lens-design programs, designs can be tested, modified, and retested in hours or days. Formerly, when calculations and ray-traces were done manually, this could take weeks or months.

CAD programs are not always set up to produce the sharpest possible lenses, however. For cheaper lenses, they are typically set up to trade off sharpness against cost. Because the programs are so clever, astonishingly good lenses can

be designed using only the cheaper optical glasses, relatively shallow curves, and spherical ('common') curves for the surfaces of the elements. This keeps the cost down, but for the ultimate in performance, the designers will have to resort to more and more expensive exigencies such as special glasses, deep curves and aspheric surfaces.

Special Glasses

Finished elements made from some of the most expensive optical glasses are apparently as expensive, weight for weight, as pure gold. What the designer is normally looking for is a high refractive index – the ability to bend light sharply – together with low dispersion. 'Dispersion' refers to the way in which glass refracts light of different colours to different degrees: this is what makes a prism give a rainbow.

When you make a photographic lens, though, dispersion creates the unfortunate effect of red rays coming to a different focus from blue rays, with green rays somewhere in between. The potential for unsharpness is obvious. In the days when photographic plates were only blue-sensitive, this did not matter very much: only the blue light, after all, was image-forming. Then, when 'orthochromatic' ('right-coloured') and 'panchromatic' ('all-coloured') plates came in, lenses had to be redesigned to focus all colours in the same plane. The lenses which did this were called 'achromats' or 'achromatics' ('non-coloured'). This is what 'colour correction' means in lens design.

In fact, an 'achromat' only brings red and blue light to the same focus, and a higher degree of colour

correction is possible. An 'apochromat' ('away from colour') brings red, green and blue to a common focus, with a resultant increase in sharpness – which is why so many lenses are advertised nowadays as 'Apo'. There are, however, no rigorous definitions of apochromatic as applied to photographic lenses, so it is hard not to suspect that some lenses are more apochromatic than others – just as some are more achromatic than others. Likewise, Nikon's 'ED' (for 'Extra-low Dispersion') obviously refers to the special glasses used in ED lenses; but at what point does a glass become 'special'?

Very few lenses have been made using materials other than glass. In particular, calcium fluorite has been used for its special optical qualities. Fluorite elements are, however, very expensive, very fragile – a sharp knock is said to be enough to cause one to break – and unless they are sealed away from the atmosphere they deteriorate with time. Today, fluorites have mostly been replaced (except perhaps in a few specialist, cost-no-object military lenses) by special glasses.

Transparent plastics are rarely suitable for making high-grade lenses: they are too soft, lack dimensional stability, and have too restricted a range of optical properties. Usually, plastic elements are used only in the cheapest lenses, but Tamron has introduced a remarkable family of 'compound aspherics' of plastic moulded on to glass; we shall come back to these.

Deep Curves

The deeper the curve of a lens, the more it generally costs to make. The advantage of deep curves, particularly when combined with glasses of high

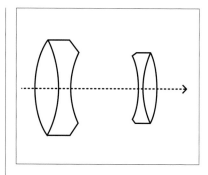

Telephoto design
A simple long-focus lens can be made perfectly satisfactorily with a cemented doublet – the first half of this lens section. Then, a second converging group (also a cemented doublet in this design) is added to shorten the back focus, and thereby shorten the whole lens.

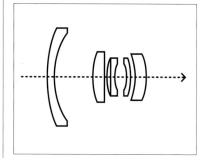

'Reverse-telephoto' design
The 'reverse-telephoto' design typically uses a symmetrical derivative as the main image-forming group (the five-glass part at the back of this lens section), together with a negative front group which may consist of as little as a single negative element. Faster or wider-coverage lenses than this 35mm f/2.8 Flektogon would have correspondingly more complex negative front groups.

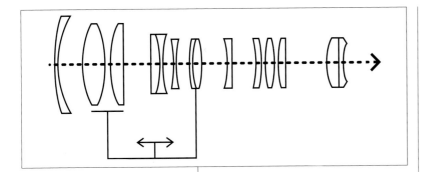

Zoom Lens
This is the lens that started it all, at least for the 35mm SLR: the original Voigtländer 'standard zoom' of 1958/59. The speed is the same as the Tessar – the extra nine glasses are required to give the 36–82mm zoom range. By modern standards, this is not a particularly complicated zoom (some current lenses have as many as twenty glasses). The elements which move to give the zoom action are marked in the drawing.

refractive index and low dispersion, is that you can do some very clever tricks with just one element instead of two or three. Also, for some extreme wide-angles and zooms, *very* deep curves are the best way to go.

Aspherics

The vast majority of lenses employ only 'common' curves, which are part of a sphere. It is possible, though expensive, to grind aspheric curves – that is, curves which are part of a parabola or hyperbola. Like expensive glasses and deep curves, aspheric surfaces permit very high degrees of correction without using extra elements: one aspheric glass can do the work of two spherical-curve glasses, or may permit degrees of correction which would simply be impossible with common curves.

At any one time, there is only a handful of aspheric lenses in production, and they are typically two or three times as expensive as their brethren which use common curves. Normally, only the very fastest lenses use aspheric surfaces, and not all surfaces are aspheric then: typically, only one element will feature aspheric curves.

With progress in lens design and glass manufacture, aspherics are becoming less and less necessary; some

lenses have even been redesigned, away from aspherics, to use only common curves. As mentioned above, though, Tamron has perfected a method of moulding plastic aspheric elements on to glass, thereby overcoming the problems of dimensional stability inherent in plastics and allowing some aspheric elements to be used for even better correction. This may in a few years be the only way in which aspheric surfaces survive.

CONTRAST AND NUMBER OF GLASSES

It might seem that by using enough glasses, of the right type and the right shape, you can accomplish almost anything. To a large extent, this is true. One inescapable fact, though, is that more glasses mean less contrast. Although multi-coating has enormously reduced the amount of light reflected at each glass/air interface, it has not eliminated it altogether, and the light which bounces around as a result of these reflections always reduces contrast.

In the bad old days, an uncoated lens used to suffer reflections of five to ten per cent at each glass/air surface, which is why it used to be a good idea to keep glass-air surfaces to a minimum. For example, the Zeiss 50mm f/1.5 Sonnar had only six glass-air surfaces, while the Leitz 50mm f/1.5 Summarit had ten. The Summarit was sharper; but the Sonnar was so much contrastier that it *looked* sharper.

Today, reflectivity at each glass/air surface ranges from about 1.5 per cent to about 0.01 per cent. The cheaper the lens, the less effective the coating is likely to be, which is why expensive

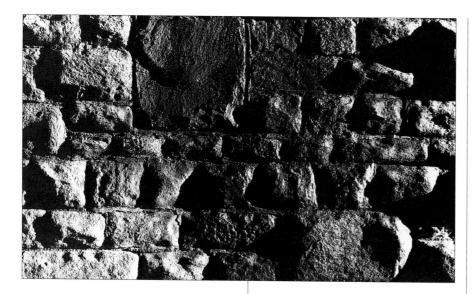

Wet wall

This is not an exciting picture, but it is an excellent illustration of the difference between sharpness and contrast. It was shot with an uncoated 50mm f/1.5 Summarit on a 1930s Leica: a lens notorious for its low contrast. The subject, however, gave the lens a unique chance to exhibit its maximum performance. Wet masonry, illustrated by the glancing light of the setting sun, exhibited tremendous contrast to begin with. The contrast was accentuated by shooting on slow film (Ilford Pan F, rated at ISO 32) and by printing on grade 5 paper. The result is a remarkable rendition of texture which would do any lens credit: at a 7x enlargement, everything still seems pin-sharp. (RWH)

lenses can get away with many more glass-air surfaces; but it is worth pointing out that with, say, one per cent reflectivity, a lens with twelve glass/air interfaces will still 'lose' rather over eleven per cent of the light to internal reflections. That eleven per cent of scattered light leads to an overall flattening of contrast, which always makes a lens look less sharp.

With one-half per cent reflectivity, incidentally, the figure falls to just under six per cent overall; and one-quarter of one per cent at each surface still entails three per cent.

Coating, Multi-coating and Lens Hoods

Coating uses 'interference' – a property of the wave nature of light – to reduce reflection: the thickness of the lens coating must be one-quarter of the wavelength of the light for which it is to suppress reflection. Obviously, a single coating can only be designed for a single wavelength of light.

Multi-coating is exactly what its

Lens shade

A perennial problem with zooms is that the lens hood must be made so that it does not vignette even with the lens at its widest angle. This normally means that the hood is of little use even in the middle of the zoom range, and is substantially useless at the long end. An ingenious solution, here exemplified by Sigma, is to mount the hood separately from the filters, so that the front of the lens moves up and down inside the hood as shown. At the 28mm setting, the hood is effectively very shallow; at 70mm, it is somewhat deeper.

name suggests: a stack of coatings, which can reduce reflection in several wavelengths of light. Despite the song and dance made by some other manufacturers, Leitz seems to have been the first company to introduce multi-coating, in the late 1950s.

Coating and multi-coating mean that lens hoods (lens shades) are less important than they used to be, but there are still some circumstances where a good lens hood can make all the difference between a picture that 'sparkles' and one that is flat and dull. The ideal lens hood matches the format of the image – for 35mm it is in the 2:3 proportion of the 24x36mm format – and is adjustable to suit the focal length in use. 'Ideal' lens hoods of this type are more common in medium format and large format than in 35mm, but there are a few proprietary models which are quite good. Alternatively, some photographers adapt hoods from medium-format cameras for use on 35mm camera lenses.

BUILD QUALITY

No matter how cleverly you design a lens, and no matter what it can do in theory, it will not work properly unless it is made properly. Precision in film-to-lens registration, the most obvious factor, is one of the easiest to meet. In addition, the lenses must be ground with almost unimaginable precision; the glasses that are to be cemented together must be perfectly aligned; and then all the individual lenses and lens groups must be perfectly aligned in the lens mount. They must be strongly held in place, or their alignment may be destroyed if the lens is dropped or knocked. An expensive lens will be

assembled with enormous care, and repeatedly checked and tested at every stage. A cheap lens, on the other hand, may or may not be perfectly aligned when it leaves the factory. Even if it is perfect, a knock in everyday use may ruin its alignment.

The machining of the focusing mount must be as precise as possible. You can cover up a multitude of sins with long-chain lithium greases, but as the lubricants dry up, or as they mix with dust to form a very efficient grinding paste, an inferior lens mount will begin to show its defects.

All the mechanical parts of the lens must be durable, and the moving parts must move freely – the auto-diaphragm mechanism, the diaphragm itself and any other linkages, for metering or autofocus. Electrical contacts must be corrosion-free and positive.

All screws and retaining rings must be tight, and must remain so. Cheap lenses are more prone than expensive ones to loosening, though a lot depends on how you look after the lens. Long journeys by motorcycle, for example, are not good for any lens.

MATERIALS

The actual materials from which a lens mount is made are less important than the way they are used. Even plastic is fine, provided it is not used as a bearing surface and provided it is solid enough to resist everyday stresses and strains. Light alloys can replace brass, provided they are adequately finished (usually by anodising), but steel (other than stainless steel) should be used sparingly if there is any risk of corrosion. For mating surfaces, especially the lens mount, something hard like stainless

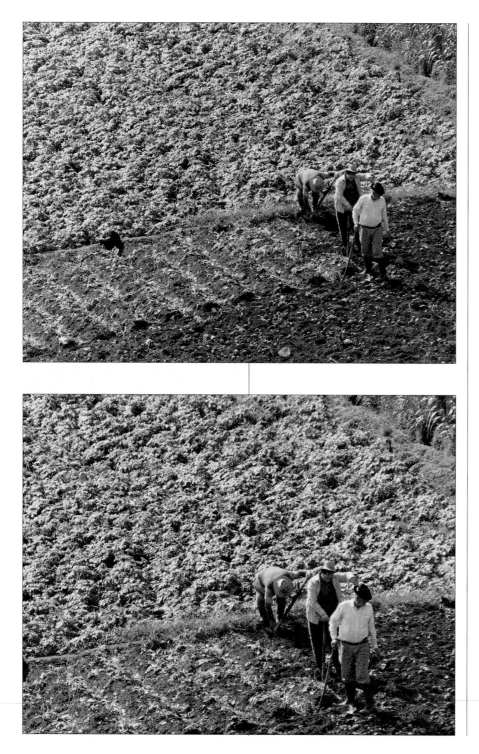

Farmers, Gran Canaria

In theory, you should be able to go on making bigger and bigger enlargements, but eventually even the sharpest lenses and the finest-grained films must give up the unequal struggle. The 'all-in' version of this picture was blown up 6x from the original negative; as reproduced here, it is at about 3.5x. Intrigued by the gesture of the second farmer – he appears to be about to grab the first farmer's hat – Frances blew the picture up further, to 12x in the original print. Finally, at 18x magnification, the picture became unacceptably soft. Even at this magnification, you could however still distinguish the texture in the rearmost farmer's sweater, and the fine lines in the shirt of the front farmer were clearly visible in the original print. Those lines are approximately 0.25mm (¹/₁₀₀in) across in the final print, which means that they were 0.014mm across in the negative: about one-half of one-thousandth of an inch, equivalent to 80 1p/mm or better. What is all the more astounding is that this was shot on ISO 400 film, Ilford XP-2. The camera was a tripod-mounted Nikon F, with a 200mm f/3 Vivitar Series One lens. (FES)

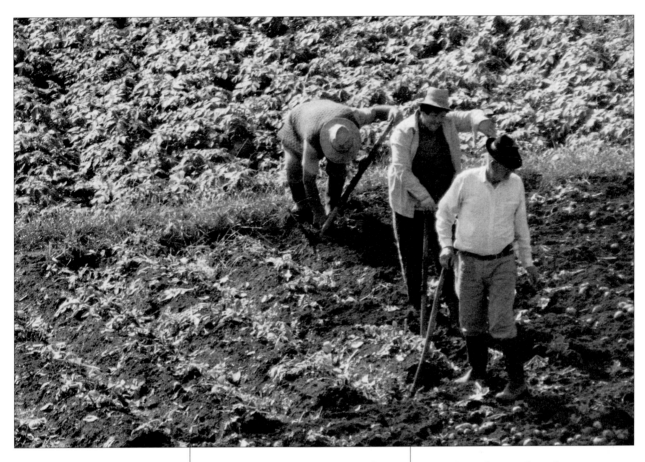

steel or thickly plated brass is clearly preferable to unprotected brass or (worse still) light alloy.

As a general rule, durability implies weight, though there are plenty of ways of making a long-lasting lens without using the huge quantities of solid brass which were in vogue before World War Two. A really well-made lens will take decades of normal wear and tear, even in professional use, and will stand up to the most appalling abuse. A cheaply made lens, even if it is set up perfectly to begin with, will not retain its sharpness for anything like as long.

But wait a moment: what do we really mean by 'sharpness' anyway? The answer is, unfortunately, rather complex. You may prefer to skip the rest of this chapter for now – you can always come back to it later – but if you really want to understand what determines the optical quality of a lens, you ought to read on.

RESOLUTION

Resolution – the amount of detail which a lens can 'see' – is obviously very important, and it is quite easy to establish sharpness criteria, based on average eyesight and picture sizes.

A person with normally acute eyesight (wearing glasses if necessary)

can resolve about one minute of arc; equivalent, roughly, to seeing a dark human hair on a white tile at 10ft (3m). This equates, in conventional photographic terms, to 8 line pairs per millimetre (lp/mm) on a print viewed at 25cm (10in). From this, it is easy to see that if we make a contact print from a negative and view it from 10in (25cm), a resolution of 8 lp/mm on the negative is adequate. In practice, because modern pictures are almost invariably enlargements, we can get a rough idea of the resolution required on the negative if we multiply our figure of 8 lp/mm by the degree of enlargement. For example, the common 4x6in (10x15cm) enlargement from a mini-lab is a 4x enlargement, so we need 4x8 = 32 lp/mm on the negative. For a 6x enlargement (which is 35mm 'all in' on a sheet of 8x10in/20x25cm paper, with a border), we need 6x8 = 48 lp/mm.

'Lost' or 'Spare' Resolution

In practice, we need a bit more resolution than these figures imply because there is inevitably some loss in the enlarging process; and the greater the enlargement, the more 'spare' sharpness we need. Thus, if theory required an undemanding 32 lp/mm, you would be all right with 35–40 lp/mm on the film in real life; but if our theoretical on-film requirement was 64 lp/mm, we would probably need close to 80 lp/mm in actual on-the-film resolution. A lot depends on the enlarger lens, and how carefully it is focused; and with 'scanned' images, as reproduced in print, the scanner functions very nearly as a perfect enlarger, so less sharpness is lost in the translation between the film and the final image. A great deal also depends

on the film: slow, fine-grained films have a higher resolving power than fast, grainy films.

Diffraction-limited Resolution

There are, however, absolute theoretical limits to the sharpness which can be achieved on the film; and without going into excessive theory, a good rule of thumb is that the diffraction limit for resolution – the point at which the diffraction of light itself limits resolution – in lp/mm for fifty per cent contrast is $1000/n$, where n is the aperture. Thus, an f/2 lens is diffraction limited at 500 lp/mm; an f/4 lens is diffraction limited at 250 lp/mm; and an f/8 lens is diffraction limited at 125 lp/mm. In practice, about 100 lp/mm or a little better is the best that can be recorded on modern general-purpose films, even if they are specially selected for maximum sharpness.

The $1000/n$ rule of thumb explains why so few lenses for 35mm cameras stop down below f/16, because this equates to a diffraction-limited resolution of 62.5 lp/mm. At f/22, you would be down to 45 lp/mm; at f/32 the diffraction limit is 31 lp/mm.

On the other hand, it is possible to pay too much attention to these figures. In the real world, even 45 lp/mm gives a very acceptable 6x9in or even 18x24cm print, though you do start to see the difference at anything less. Also, the $1000/n$ rule can be attacked on theoretical grounds as being too demanding: even $1500/n$ is an adequate guideline in many circumstances.

Resolution and Viewing Distance

In order to make (for example) a 16x20in (40x50cm) print, a 35mm

Fireworks, Malta

The Feast of St Joseph, March 19th, is also Frances's birthday, so we try to be in Malta, where they celebrate the festa with three days of fireworks. Perhaps surprisingly, almost any lens will do to shoot fireworks, because they are very bright. The only advantage of a faster lens (like this 50mm f/1.2 Nikkor) is that it enables you to 'freeze' the sparks in mid-air. The penalty of a fast lens and an enormous contrast range is however an inevitable degree of flare, as seen here. The film was Fuji 100, because faster films do not give the same colour saturation. (RWH)

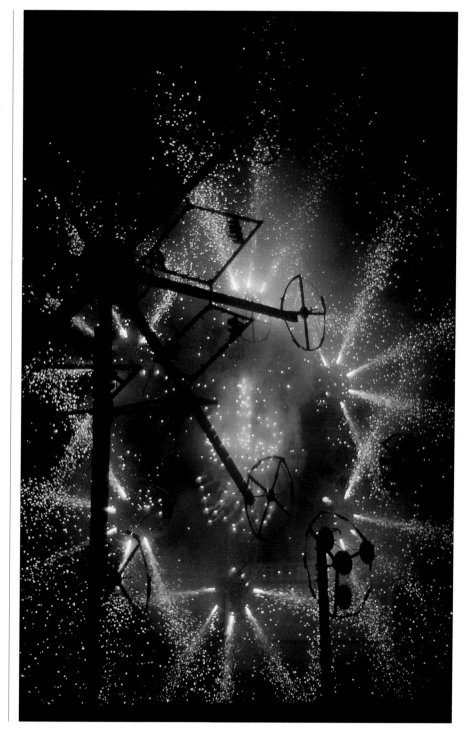

negative has to be enlarged 16x – an impossible 128 lp/mm on the film, assuming a perfect enlarger. But, normally, a print of this size would not be viewed from 10in (25cm): it is more likely that you would look at it from at least twice as far away. This relaxes the standard of resolution in accordance with the viewing distance: twice as far away means that half the resolution is required, a mere 64 lp/mm. It is easy to see, therefore, why 35mm has become so popular: it just about matches 'real-world' requirements, in all circumstances.

Resolution and Format

Sticking with the 16x20in (40x50cm) example given above, a 6x7cm (2^1/4x2^3/4in) negative has to be enlarged only about 7x. Even if we still insist on 8 lp/mm on the print, this means that the negative need only have 56 lp/mm; and if we can accept the 4 lp/mm which is acceptable for viewing a print at 20in (50cm), the on-the-film resolution can be as low as 28 lp/mm.

If we moved up to 4x5in film, the enlargement is only 4x. This means either 32 lp/mm on the film (if we adopt the stricter standard), or 16 lp/mm (if we accept 4 lp/mm on the print). Not only does this dramatically demonstrate the advantages of larger formats, it also explains why lenses for larger formats can be stopped down further than lenses for 35mm. If we can live with 16 lp/mm, the diffraction limit on 4x5 film is not reached until about f/64. Yet another thing which it explains is how some lenses are suitable for both 35mm and rollfilm. When they are mounted for 35mm, you are using only the central area of the lens's

coverage, which is the sharpest area. When they are mounted for rollfilm, the resolution further out may not be quite as good, but it is still good enough for the larger image area.

Armed with these figures, you can now make a lot more sense of resolution charts; but resolution cannot be considered in isolation.

CONTRAST

Imagine two lenses, side by side on identical cameras. Both resolve (let us say) 64 lp/mm. One, though, is much contrastier than the other: each of those 64 line pairs is a clear black and white, while the other lens renders them as light grey and dark grey. The contrastier lens, as described above, will appear sharper than the less contrasty one.

This is no surprise. What may be a surprise, though, is the way that the contrasty lens will appear sharper, even if the less contrasty lens has better actual resolution – say, 80 lp/mm as against 64 lp/mm. As already mentioned, in the 1930s Leica lenses were optimised for resolution, while Contax lenses displayed higher contrast, which led to battles royal between supporters of the two great rival systems. Both sides claimed that their lenses were 'sharper', and, of course, both sides were right – or wrong.

Mainly because of coating, but also because of new glasses and in some cases because of improved designs, modern lenses have both higher resolution and more contrast than older ones. Even so, resolution and contrast still have to be traded off to a certain extent. Again as a rule of thumb, the

more elements there are in a lens, the lower the contrast will be, for the reasons already given.

FLARE AND GHOSTING

'Flare' can mean two things. Some lenses are called 'flary' because of the kind of internal reflection problems just described. Generally, though, flare refers to internal reflections which remain visible in their own right, instead of giving rise to general degradation of the image. Typically, flare will cause a highlight to spread out, so that light areas are surrounded with a sort of glow; but there are also lenses which will give both a main image and a secondary 'ghost' image of, for instance, a fluorescent tube or a street light. With modern coated lenses this is far less of a problem than it was, but it is still occasionally encountered, especially with cheap zooms and ultra-fast lenses. Removing filters when photographing in adverse conditions helps to minimise problems like this.

A particular kind of internal reflection is caused by light shining directly into the lens and creating an image of the lens diaphragm, which is then reflected in the elements of the lens. Some people like this effect; others hate it.

As with internal reflections, a properly designed deep lens hood can greatly reduce flare and ghosting.

FIELD CURVATURE

Very few lenses throw a flat image on to a flat field. Instead, they throw a curved or dish-shaped image: the centre is furthest from the lens, and the edges are closer. Some cameras, including the Minox sub-miniature as well as many simple box cameras, simply have a curved film plane to accommodate this. In general, though, designers try to flatten the field so that it will project an acceptable image on to the (fairly) flat film.

Field curvature is one reason why lens performance deteriorates as you move away from the centre of the image, and the deterioration is generally worst with ultra-fast lenses and with zooms. With a reflex camera, where the photographer almost always focuses on the middle of the picture, the edges may go soft – but this may not matter, if there is nothing of interest towards the edges. Some of the old Novoflex telephotos were built like this: the centre was wonderful, ideal for wildlife or sport or anything of the kind, but the edges were not too impressive; which is, after all, the way we see things – focusing on what is important and ignoring what isn't.

Film Flatness

A couple of paragraphs back, we referred to 'fairly' flat film, because some cameras hold the film very much flatter than others; and besides, the departure from flatness may actually *assist* sharpness. If you load a camera with a scrap film, remove the lens, set the shutter to B or T, and open the shutter to examine the film, you can often see from the reflections in it that the film is very slightly concave. By great good fortune, this matches the 'bowl' or 'dish' shape of a curved field. This is probably why the old pre-war Leica was far sharper than it deserved to be: the film was not held very flat, but then, the Elmar lens had a curved field, and the two curves seem often to

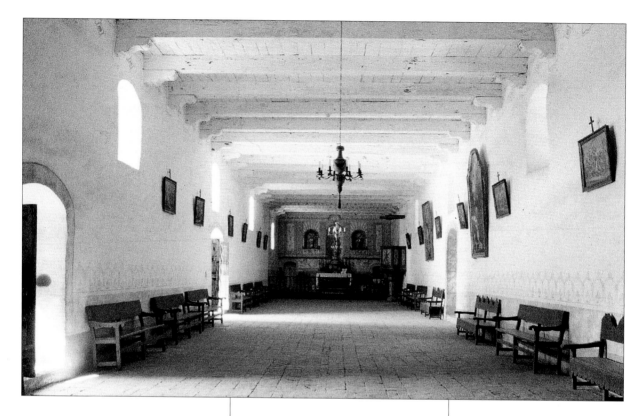

have matched perfectly. Some cameras held the film flatter than others, though, which is why the performance of old Leicas is so variable.

DISTORTION

The two main kinds of distortion are 'barrel' distortion (where the sides of a square bulge outwards, like the sides of a barrel) and 'pincushion' distortion, where the sides of a square curve inwards like a pincushion. Traditionally, barrel distortion is an affliction of wide-angles – fish-eye lenses are examples of institutionalised barrel distortion – and pincushion distortion is associated with telephotos; a cheap (or old) zoom may exhibit both, barrel at the wide-angle end and pincushion at the long end.

If you photograph a subject with straight lines near the edge of the picture, distortion is easy to spot. You cannot always see it in the viewfinder: sometimes, the viewfinder's own optical system introduces *apparent* distortion, but the distortion does not appear on the print. Gross distortion will, however, be visible in the viewfinder.

Wide-angle Distortion

With ultra-wide-angle lenses, 24mm and wider, circles towards the edge of the field are elongated into ovals. This is disturbing enough when it is demonstrated with tennis balls, which is the usual thing in photographic books; but when someone's head is distorted in this way, it can be downright horrific.

Missión de la Purísima Concepción, Lompoc, California
Straight lines near the edge of a picture are a stiff test of any wide-angle lens – a test which this 17mm f/3.5 Tamron SP passes with flying colours. In this chapel, an inferior lens would have caused the roof beam nearest the top of the picture to appear to be curved upwards like a barrel-stave. The camera was tripod mounted and levelled with a spirit level, and the film was Scotch 1000, Exposure determination was by Lunasix (Lunapro) in incident-light mode; it was probably 1/15 or 1/30 second at f/11 or f/16, though we would have bracketed the exposures at least a stop either side. This exposure best captures the sun streaming into the cool, whitewashed interior. (RWH)

Surrender House,
Appomattox Court House

True wide-angle distortion occurs when a recognisable shape is 'pulled out' because it is near the edge of the frame – like the corner of the table in this historic house where General Robert E Lee surrendered to Grant after the War Between the States. What is surprising, though, is that despite the extreme angle of view (this was shot with the Sigma 14mm f/3.5), there is no detectable darkening in the corners: a consequence, in large measure, of the retrofocus design of the lens, which effectively removes cos^4 problems. As usual when we are using ultra-wides, the camera was carefully levelled on a tripod. (RWH)

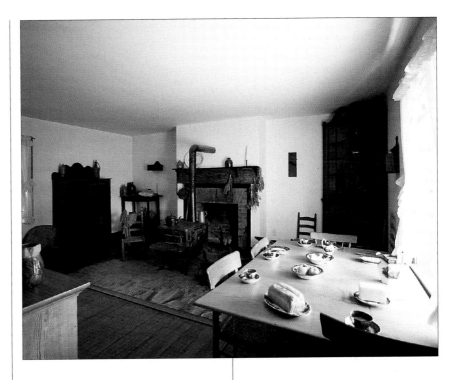

Valetta and Grand Harbour, Malta,
from the Baraccas Gardens

With the 35mm PC-Nikkor at the limit of its movement, the corners of the image may darken slightly. Nikon recommends that you do not move the lens too far off-centre, and the recommendations for different camera orientations are marked on the lens; but many photographers find that with a blue sky, the slight darkening is exactly what they want. In any case, stopping down eliminates mechanical vignetting (see overleaf), leaving only cos^4 vignetting, so in practice the full movement of the lens can be used. (RWH)

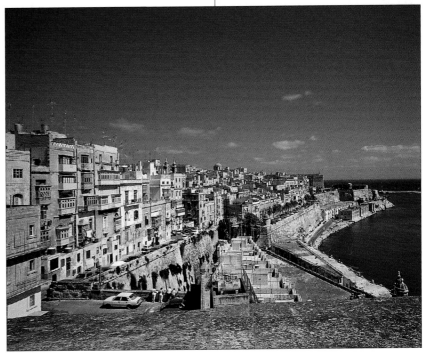

There is absolutely nothing you can do about this type of distortion, which is caused by the increasingly acute angle at which the image-forming light strikes the film. A curved film plane would remove the problem, but curving the film in more than one plane is difficult. Most designers have opted instead for trying to correct curvature of field (see above), preferring to live with wide-angle distortion as a lesser evil.

ILLUMINATION

In a perfect lens, the illumination would be absolutely even all across the field. With a plain (non-retrofocus) long-focus lens the variation in illumination may not be detectable; but with wide-angles, and with some zooms at some focal lengths, it may be quite obvious.

There are two ways in which light falls off towards the edge of the image. One is mechanical vignetting, which is caused by the construction of the lens: the more oblique the light entering the lens, the greater the amount that is intercepted by the edges of the lens elements, by the lens mount, and (if they are not well designed) by internal baffles. Big front and rear elements can reduce this type of vignetting, which is why some zooms suffer so badly from it: in the interests of compactness and convenience, serious trade-offs are made in the area of image illumination.

The other cause of light fall-off is \cos^4 vignetting, so called because the energy of a beam of light striking a plane surface is proportional to the fourth power of the cosine (cos 4) of the angle of incidence. With extreme wide-angles of conventional (non-retrofocus) design, the angle of incidence at the extreme edge of a picture is very steep indeed, and illumination is consequently reduced. The only 'solution' to \cos^4 vignetting is a graduated filter, darker in the middle and lighter at the edges. To the best of our knowledge, only one lens for 35mm has ever used this system, the 15mm Zeiss Hologon – a vanishingly rare collectors' item.

THE 'X' FACTOR

Even after you have considered all the above factors, together with others that are mind-bogglingly technical, there is still a small degree of magic in lens manufacture. There are all kinds of expressions which have been used. Our grandfathers used to talk about the 'plastic rendition' of some lenses, meaning that they seemed to give a three-dimensional effect (the meaning of 'plastic' at that time). Today, we may say that a particular lens exhibits wonderful 'gradation' – though, if pressed, we may find ourselves hard put to explain what we mean by that. It is indisputable, though, that there are some lenses which have a particular magic, and some that we have owned have included a 21mm f/4 'mirror-up' Nikkor; another 21mm, an f/4.5 Zeiss Biogon; a 58mm f/1.4, the first f/1.4 ever made for the Nikon F; two out of three 35–85mm f/2.8 Vivitar Series One varifocals; and (in large format) a 150mm f/6.3 Tessar. This 'magic' is not even guaranteed to be consistent from one example of the lens to the next, but when you find it, you will recognise it.

Tombstone, All Souls' Church, Birchington
Carved white marble, covered in lichens and illuminated by a weak winter sun, is not a contrasty subject. Here, Frances relied on the superb gradation of Ilford XP-2 and on the inherent contrastiness of her 90mm f/2.5 Vivitar Series One macro lens to capture the subtlety of the subject, printing on harder-than-usual paper (about grade 3–4) for additional detail. A more usual solution would have been to underexpose the subject slightly, by about half a stop, and then to overdevelop by up to fifty per cent to boost contrast. Camera, as usual, was a tripod-mounted Nikon F and exposure was about 1/60 at f/11. (FES)

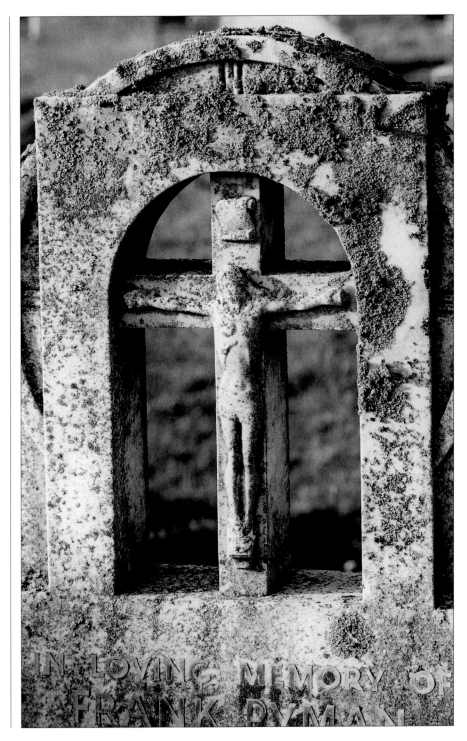

3 GETTING THE MOST FROM YOUR LENSES

Most lenses, regardless of whether they are zooms or wide-angles or telephotos or anything else, are far sharper than their owners normally give them credit for. It is all a question of using the lens in a way that enables it to give its best performance – and most people don't. This applies equally to autofocus and manual-focus lenses; to lenses from the camera maker or to independent lenses; and to new lenses as well as second hand. Later in this chapter we shall look at each of these choices in turn, and at how to test lenses, but for the moment we shall look at how to get the best out of any lens.

USE A TRIPOD

Tripods are awkward and inconvenient. On the other hand, their potential for improving sharpness with any lens is immense, and the greater the focal length of the lens the more you need a tripod. Even at 'safe' shutter speeds such as 1/125 with a standard 50mm lens, many photographers find that tripod shots have an extra edge or 'bite' when compared with hand-held pictures. Also, the way in which a tripod forces you to slow down is often useful: because you have to take more time to consider your pictures, they turn out better. Admittedly this is a counsel of perfection, and there are times when the greater mobility and speed of action of a hand-held camera will give you better pictures. There are certainly some photographers who use a tripod too much, but there are many, many more who use a tripod too little!

Only if you use a tripod are you likely to notice the advantages of the next two techniques, which are choosing the optimum aperture and choosing the optimum shutter speed.

USE THE OPTIMUM APERTURE

There are two rules of thumb for selecting the sharpest aperture on any lens. One is to stop down two stops below maximum aperture, and the other is to stop down as far as possible. Both are useful rules of thumb, and neither is entirely accurate.

The advice to 'go down two stops' mostly dates from the days when most lenses had an f/3.5 to f/4.5 maximum aperture, so following the rule of thumb would have meant stopping

Staircase, Alabama State Capitol

Tripods can be as important with ultra-wides as with ultra-teles. This spiral staircase was shot with a 17mm f/3.5 Tamron SP on a Nikon F, carefully levelled with a spirit level; the head was a Kennett (Benbo/UniLoc) ball and socket. As we usually do with wide-angles, we focused by scale. Once the camera was set up, we waited until there were no people visible on the staircase, as they spoiled the symmetry and formality of the shot. Film was Fuji 50 and exposure determination was by LunaPro/Lunasix F in incident-light mode. The very light subject would of course have fooled most in-camera meters. Although we bracketed, the middle (metered) exposure was the one we used; we chose f/11 as the optimum aperture, and set the shutter speed as necessary. It was about 1/15 second. (RWH)

Bourton-on-the-Water

If you look at holiday brochures and Chamber of Commerce advertising material, you will often find 'snapshots' like this Cotswolds village. At first sight there is nothing remarkable about them; but the more carefully you look at them, the more you realise that they are technically of excellent quality, and that they are far more carefully composed than the average snapshot. More than anything else, this is due to the photographer taking time to find the right viewpoint. What lifts this shot out of the ordinary is the use of sun and shade, and the implication that weather in the Cotswolds is so warm that cooling streams and shade trees are useful – not something which is always the case in England! (RWH)

down to about f/8. Likewise, the advice to stop down as far as possible was fine in the days of half-plate ($4^3/4$x$6^1/2$in) or 13x18cm field cameras, where diffraction-limited resolution wasn't a problem; but as we saw in the last chapter, there is a limit to how far you should stop down lenses for 35mm cameras.

An even simpler rule of thumb, therefore, is that almost any lens for a 35mm camera will give its very best performance at f/8, when its performance should be at or close to the diffraction-limited resolution. At f/5.6, it should be very nearly as good, but at f/4 you will almost certainly see some deterioration except in the finest available lenses. In the other direction f/11 should be all but indistinguishable from f/8, and the difference at f/16 will only be detectable under the most demanding conditions. You should, however, be wary of using f/22 or even smaller apertures.

The principal exceptions to this rule of thumb are cheap zooms and cheap ultra-wides, which may well continue to improve right down to their minimum aperture. Also, if you habitually need and use faster apertures, look at the entry on fast lenses on page 123.

USE THE OPTIMUM SHUTTER SPEED

Some studies have shown that the commonly used mid-range shutter speeds, namely 1/30, 1/60 and 1/125, are actually the least sharp for some SLRs. At 1/250 or less, the argument runs, any mirror- or shutter-induced vibration is minimised, while at 1/15 or more those same vibrations die away and the majority of the exposure is

vibration free.

If this is true at all (and the evidence is far from clear), the effect probably varies quite widely between different models, and if the camera has a mirror lock, that must also influence matters. We certainly cannot confirm or refute it from personal experience. On the other hand, it is worth knowing that some people reckon it can be significant.

FOCUS CAREFULLY

This is not as strange an exhortation as it looks. If you want to see how much variation there can be in focusing a lens, a simple experiment will convince, and perhaps frighten, you.

Windsurfer
Anyone who tries to use mirror lenses without a tripod is inviting trouble. This was shot in Minnis Bay in Kent with a 600mm f/8 Vivitar Series One Solid Cat, and even at 1/1000 second there is slight unsharpness. This is due to the difficulty of focusing long slow lenses on moving subjects; to minimal depth of field; to subject movement; to atmospheric haze; and to vibration. The only tripod which we can confidently use with this lens is the massive Linhof, which is far too big and heavy to carry far. (RWH)

Anchor, Key West, Florida

The right lens is sometimes less important than the right exposure and knowing how to print. This anchor could equally well have been photographed with a 35mm or a 50mm lens. The trick lay in getting detail in both sides of the exposed fluke, without one side being unacceptably light and the other side unacceptably dark. Frances used a 'split contrast' technique on Ilford Multigrade paper, giving 15 seconds at Grade 1 and 5 seconds at Grade 4. Otherwise, the choice was between 'soot and whitewash' contrast, or a flat, grey print. She also gave the lower left-hand corner of the print an extra stop of exposure to make it darker; otherwise, it would have been a glaring light patch. (FES)

Focusing experiment

This is the result of an actual test with a standard 50mm f/2 lens on a Russian camera we borrowed. As described in the text, Roger focused repeatedly on the same object, and marked the focusing ring accordingly. As you can see, the range of focused distances is quite considerable and would hardly be covered up by depth of field at f/2.8. Admittedly, the light was poor – we did that deliberately, to make it harder to focus – and the focusing screen was not the brightest available, but, even so, the results are somewhat alarming. Once you are older than, say, forty, it may be that autofocus has something to offer after all. (RWH)

Sit in a comfortable chair with your camera in your hand, and focus on something – for example, a table lamp or the TV set. With a soft pencil, draw a line beside the focusing index mark. Reset the lens to infinity. Focus on the same thing. Draw another mark (we can virtually guarantee that it won't be in the same place as the first mark). Reset the lens to its nearest focusing distance. Focus on the same thing again. Draw another mark. Repeat until you get bored. Repeat with other

lenses, if you have them. Depending on the lens, and the camera, and the focusing screen, and your eyesight, the variation in focusing may be very large indeed. Most of the time, these errors are swallowed up by depth of field: you stop the lens down until minor errors aren't important. If you are working at full aperture, though, you may well find that the variation in focusing is greater than the depth of field at that aperture.

To minimise focusing errors, consider having a brighter screen fitted (if you still have one of the old generation of cameras with dim screens); consider an eyepiece correction lens; and for really critical focusing, where you are using a tripod, consider using a viewfinder magnifier. Most viewfinders effectively magnify the viewing screen by 4x or 5x, and the viewing magnifier doubles this, so an 8x or 10x magnification may not allow you to see the whole screen but it will certainly enable

you to focus more precisely.

This would be the strongest possible argument for autofocus, if only there were not so many things that autofocus cannot focus on either: flat surfaces, repetitive patterns, tiny details or (in many cases) anything that is not in the centre of the field of view.

USE SHARP FILM

Although there are variations between different makes of film of the same speed, there is no doubt that slow films are as a rule sharper than fast films. A lot depends on what sort of film you are using: colour slide, colour print or black and white.

In colour slide, the sharpest general-application film at the time of writing was still Kodachrome 25, but ISO 50 and even ISO 100 films are so sharp that there is little to be gained in sharpness by using Kodachrome. Rather more to the point is the 'colour signature' of the film. Pick the one you

like, because they are all different, and different photographers have different preferences. We use mostly Fuji 50 and its less contrasty sister Fuji 100: the faster film is generally better for pictures of people. Go faster than ISO 100, and you will see a fall-off in

Street scene, New Orleans

To get the best from your lens, use a deep lens shade, or make sure that the whole lens is in shade, and get the light behind you, as here. Then choose a subject that is well lit by strongly directional light; sunlight is ideal. It helps if the subject has plenty of fine detail, and a good range of colour contrasts, like this New Orleans street scene. Mount the camera on a tripod, and use slow, sharp, contrasty film (this is Fuji 50). If you say plaintively, 'But you can't always arrange things like that', we say, 'Precisely'. The point is that you cannot expect pictures taken under less than ideal conditions to have the same quality as ones taken under ideal conditions. (RWH/FES)

Viewfinder magnifier

Our Nikons are now fitted as a matter of course with -2.00 dioptre eyesight correction lenses: a useful compromise for our eyesight. They greatly improve both the accuracy and the consistency of focusing. On the older cameras, where the correction lenses will not screw directly into the eyepiece, we use adapters. You can get eyesight correction lenses and adapters either from the manufacturer of your camera, or from accessory manufacturers such as Hama. Where focusing is really critical, though, and where time is not a problem, we use a 2x critical focusing magnifier which shows only the centre of the screen. It flips out of the way for composing.

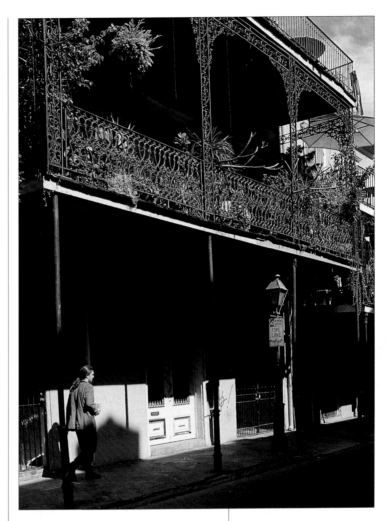

sharpness as well as a loss of contrast and colour saturation.

In colour print, you should see detectably greater sharpness with ISO 25 and ISO 50 films than with the usual ISO 100 films, and at ISO 200 you will see detectably less sharpness than with the slower films. At ISO 400 and above, you will see real grain. While ISO 100 and even ISO 200 are fine for most applications, if you make even 8x10in or 18x24cm enlargements, you need the slower films.

Of course, if you use colour print film, a great deal depends on how the film is printed. Some mini-labs deliberately set the printing heads of their machines slightly out of focus to mask dirt and fingerprints on the film, while others arrive at the same result through lack of care in setting up. At the 4x6in (10x15cm) standard mini-lab size, the quality loss is barely detectable – until you stand the print next to a sharp print from the same negative. If you do not do your own darkroom work, it is worth hunting around until you find a good lab, and it is important to remember that price and quality are not always as intimately linked as you might expect.

As for black and white, at the time of writing Ilford had just introduced their Delta 100, which had been widely acclaimed as the best, sharpest, finest-grained film on the market, competing even with Ilford's own Pan F Plus (ISO 50) and with Kodak's Technical Pan. In practice, Delta 400 and XP-2 (also ISO 400) were so good that lens resolution would be a limiting factor with all but the finest lenses and the biggest blow-ups.

THE ADVANTAGES (OR OTHERWISE) OF AUTOFOCUS

The choice between autofocus and manual-focus lenses is not entirely rational: it is almost akin to religious belief. Inherently, there is no reason why either one should be sharper than the other, and it is said that some of the latest autofocus lenses are among the sharpest ever made. On the other hand, there are two buckets of cold water which should be thrown over those who swear unreservedly that autofocus

represents unmitigated progress.

The first is that the focusing mechanism has nothing to do with the sharpness of the lens. No matter how sharp you can make an autofocus lens, you can make a non-autofocus lens that is at least equally sharp.

The second is that many (though far from all) autofocus lenses are not designed for the photographer seeking ultimate sharpness. Rather, they are for the convenience of the amateur who shoots only colour print film and orders modestly sized enlargements. For this application, ultimate sharpness is not necessary, so it is not built in. This is why an old lens, like the 1970s-vintage

Doorway in Fort, Key West, Florida

With a sharp lens used at its optimum aperture, old fortifications are a wonderfully rewarding subject. The brickwork creates a tremendous impression of sharpness, which is then borne out by the texture of the brick when you examine the picture more closely. Black and white film is all but essential if you want to capture the full tonal range. Roger shot a corridor in one of the Martello towers at Key West with a tripod-mounted Nikon and a 17mm f/3.5 Tamron SP, using an exposure of about one second at f/11. The lower part of the picture was cropped out; the camera had been carefully levelled using a spirit level. Another picture of the same fortifications, from a different angle, appears on page 12. (RWH)

Brick wall

Victorian brick buildings provide a wonderful test target for checking the quality of lenses; this is (once again) one of the Martello forts at Key West, Florida. It was not shot as a lens test, but it makes an excellent illustration of real-world testing. The brick courses are straight, with no trace of either barrel or pincushion distortion, and they are sharp right to the corners. Although it will probably not be clear in reproduction, the texture of the bricks is just about adequate at the corners, and very clear indeed in the middle: texture is one of the harshest tests of resolution. The lens was the 35mm f/2.8 PC-Nikkor, used without any shift, shooting at about f/11 and 1/125 second. (FES)

Vivitar Series One 35–85mm f/2.8, may actually outperform some modern zooms of similar focal length, especially if they are of the variable-aperture type.

A third objection, which is diminishing all the time, is that autofocus introduces a significant delay between pressing the shutter release and taking the picture. While it is probably true that an autofocus lens can focus faster than a manual-focal lens, and usually as precisely, it cannot match a lens which is pre-focused on a given spot and where the shutter can be released as soon as the subject is on the right spot.

Our view is that if you like

autofocus, fine. If you don't like it, that's fine too. We use mostly non-autofocus cameras and lenses, and we know that you cannot easily get results which are sharper, so we see no need to change all our old equipment. If we were buying new today, we might feel differently: but we aren't, so we stick with non-autofocus.

'MARQUE' LENSES AND INDEPENDENTS

'Marque' lenses (from the camera manufacturer) are almost invariably the sharpest, strongest lenses you can buy. Certainly, there are no finer lenses than

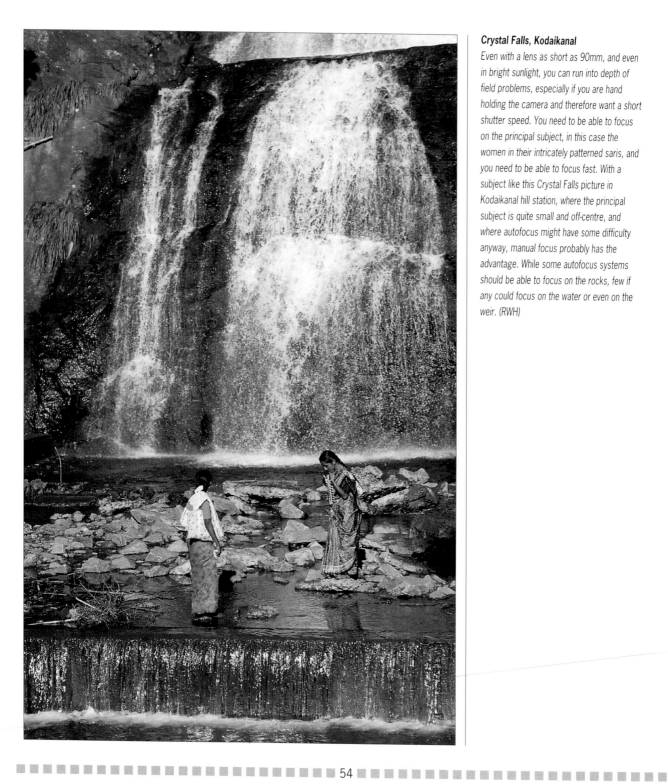

Crystal Falls, Kodaikanal

Even with a lens as short as 90mm, and even in bright sunlight, you can run into depth of field problems, especially if you are hand holding the camera and therefore want a short shutter speed. You need to be able to focus on the principal subject, in this case the women in their intricately patterned saris, and you need to be able to focus fast. With a subject like this Crystal Falls picture in Kodaikanal hill station, where the principal subject is quite small and off-centre, and where autofocus might have some difficulty anyway, manual focus probably has the advantage. While some autofocus systems should be able to focus on the rocks, few if any could focus on the water or even on the weir. (RWH)

Zagorsk Monastery

From time to time people express surprise that we as professionals use lenses other than 'marque' manufacturers' optics. What matters, though, is not the name on the lens: it is the results you get. This picture of Zagorsk, just north of Moscow, was shot with a 17mm f/3.5 Tamron SP, and the results are eminently publishable. Admittedly, we use the lens at modest apertures (mostly f/8 and f/11) and we support it on a tripod; but we do the same whenever we can, even when using our Nikon and Leitz lenses. The Tamron has the remarkable proprietary Adaptall mount mentioned on page 62; our friend Oleg tried it on his Canon F1 via another adapter. (RWH)

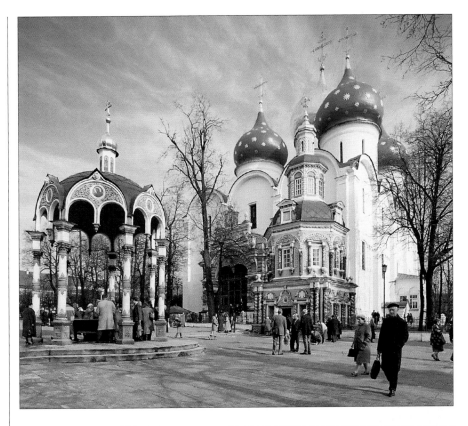

Fungi on rotten log

Vivitar's old 135mm f/2.3 is not a macro lens, but it will still focus down to about one-third life size. This can be very useful when you want to photograph something like these fungi in Blakely's battlefield park in Alabama. They were on a log in the middle of a river with a soft, muddy bottom, so it was impossible (or at least very dangerous) to get too close. The lens was bought second hand in Glasgow for £39 (about US$60–70) in 1988, to replace our previous 135mm f/2.3 which was bought new in the 1970s and stolen in the early 1980s in India. By the time we bought the replacement, the lens was of course no longer available new; but for a combination of compactness, speed, sharpness and modest price, it is unbeatable. (FES)

the finest from Leitz, Zeiss, Nikon, Canon and others.

This does not mean that each lens from one of these *grande marque* manufacturers is the very best you can buy: it may be that Canon is ahead at one focal length while at another it is Nikon, at a third the Zeiss lens wins, and so forth. In general, the differences will be minimal, though any manufacturer may produce the occasional 'dog'. The original 43–86mm Nikkor, for example, was easily the worst lens that Nikon ever made.

The big drawback to marque lenses is however the price, which is not due to quality alone. In part you are paying for the name, and in part you are paying for the relatively limited numbers in which these lenses are made. Inside the photo trade it is a well-known source of amusement that some exotic lenses even from leading manufacturers are literally made by one craftsman, and that if he goes on holiday those lenses have to be back ordered until he returns.

'Independents' on the other hand, are typically made for a wide variety of cameras: the same optical components are mounted in a range of different fittings, sometimes including autofocus and non-autofocus mounts. The economies of scale are obvious. A few independents command the same respect as marque lenses, and are priced accordingly: Schneider and Novoflex in Germany and Angénieux in France are obvious examples. Other independents are well known to compete on price alone. In between, though, there are several manufacturers who produce a range of lenses which includes at least some absolute bargains – lenses which are as sharp and strong as anything the *grandes marques* make, and a good deal cheaper to boot.

Leitz 400mm f/5 Telyt on Nikon F

Telephoto lenses are often the easiest to adapt for use on other cameras. This is a 400mm f/5 Telyt, mounted on a Nikon F via a home-made adapter that was cobbled together out of a mixture of Nikon extension tubes, a Leitz 16466 ring, and a broken 52mm filter with the glass removed. The extraordinary thing is that infinity focus is still at a marked infinity on the focusing scale. Normally, adapted lenses for reflex cameras are made to focus a little 'beyond' infinity, and the focusing scale is no longer valid. The advantage of the Telyt is that it has a very long flange to film distance, because it was designed for use on the Visoflex reflex attachment for the Leica rangefinder camera.

Lens throats

The enormous increase in complexity of modern lenses and exposure automation is clearly shown in these two shots of the lens throats of a Nikkormat and a Pentax Z1/PZ-1. The Nikkormat has just two linkages, the auto-diaphragm stop down on the left and the meter-coupling pin above, outside the throat. A Nikon F does not even have the meter-coupling pin. The Pentax has a similar stop-down mechanism, but also has linkages for maximum aperture information; exposure automation; power-zoom automation; and more. It would probably be impossible to approach the versatility of the Pentax using only mechanical linkages: electric tellers like these are the wave of the future, and they should in theory make cross-adaptation of lenses easier – provided you are good at micro-soldering.

The problem for the buyer is that the situation is constantly varying. For example, Vivitar's original Series One lenses were 'state of the art', but they were understandably expensive and were therefore commercial failures. Most or all of these lenses now command cult status, long after being discontinued: the 28/1.9; the 35–85/2.8 varifocal; the 90/2.5 macro; the 90–180/4.5 flat field; the 135/2.3; the 200/3 and the 'solid cat' mirror lenses. By contrast, when the Series Ones were the undisputed leaders, few people took Sigma very seriously; but now, Sigma is definitely a force to be reckoned with, and their 14mm f/3.5 is one of our favourite lenses.

Some independent manufacturers acknowledge the fact that some of their lenses are better than others: Vivitar's

Series Ones are clearly distinguished from the 'ordinary' Vivitars, and the same is true of the SP line from Tamron. Other makers do not make any such distinction, though price is a good guide: if most of their lenses are, say, one-third of the price of marque lenses of similar specification, but a few are, say, two-thirds of the price, you can often conclude that the higher-priced lenses constitute their 'premium' group.

While this book was being written, too, Sigma introduced an all-new SLR with a new lens mount, and made all thirty-four of their existing lenses available in that mount. While Sigma had not at the time of writing established themselves as one of the *grandes marques*, they were looking more and more impressive every year.

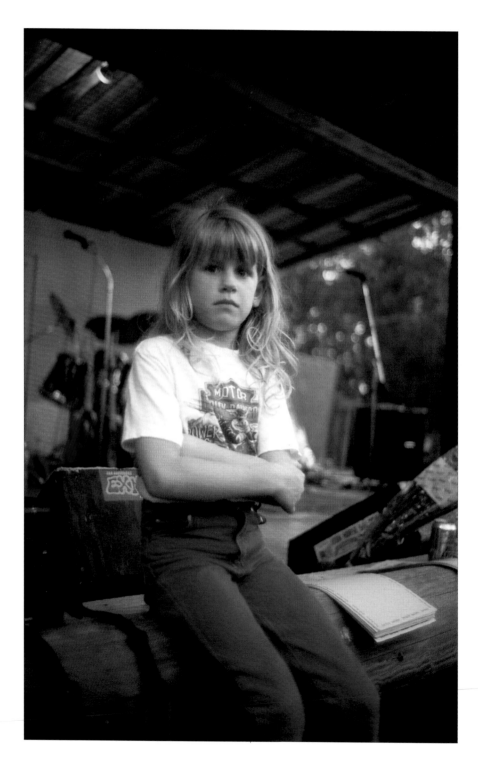

Spectator, Iron Horse Saloon

Even the finest lenses – this was shot with a 35mm f/1.4 Leitz Summilux – can lose their 'edge' if they are allowed to get too dirty. This was shot towards the end of a long day in Daytona, Florida during Cycle Week, and the UV filter which protected the lens had gathered a film of dust from the wood fire which burned at the centre of the enclosure behind the Iron Horse Saloon. The degradation is most obvious in the flare around the edge of the girl's T shirt: the absolute sharpness of the lens is still evident in the resolution of her hair. Over-enthusiastic cleaning has however probably ruined more lenses than any other single cause. The best approach, whenever possible, is to keep the lens clean in the first place. For the record, Frances used the lens wide open at about 1/60 second, shooting hand held on Fuji 50. (FES)

NEW LENSES VERSUS SECOND HAND

There is a myth that professionals never use second-hand lenses. Few things could be further from the truth. Just about every professional I know has used second-hand equipment at some time in his or her career; some still use second-hand equipment to this day.

There is absolutely no doubt that for maximum peace of mind brand-new lenses with a manufacturer's guarantee are highly desirable. But unlike, for example, a car, many lenses receive virtually no use, and they may be sold in almost-new condition even when they are years or decades old. Also, most potential problems in a lens are easy to gauge, even without putting it on a camera. We have no hesitation in buying and using second-hand lenses, though we test them carefully before using them professionally. If your finances dictate it, or if a bargain comes up, you should not be afraid of second-hand lenses either.

The first thing to check is obviously the condition of the glass. If the glass is clean, the lens may perform as well as it did the day it was new, even if the mount is press-corps ugly. Any faults in the glass – scratches, 'cleaning marks', fungus, haze or anything except bubbles (which are not important) – should be grounds for rejection or for a very very significant reduction in price; and, of course, a lens with damaged glass should be tested all the more rigorously.

The next thing to consider is the operation of the focusing mount. A sticky mount is bad enough, because cleaning and lubrication are expensive.

A 'wonky' mount, where you can move one part of the lens relative to another, may be no more than a minor problem requiring tightening up (not very expensive), or it may indicate severe wear or damage; if at all possible, seek the opinion of an expert repairer.

The third thing to check is the operation of the diaphragm. Does it operate smoothly across its entire range, and does it open up and close down quickly and smoothly, without sticking? To make the latter test more severe, put the lens in a plastic bag and stick it in the freezer for a quarter of an hour: lubricants which are still just about acceptable in a warm room may give up the ghost under icy conditions.

Also check that the filter thread has not been 'dinged' (evidence that the lens has been dropped or badly knocked), and check all visible screw heads and retaining rings: burred or turned-over threads, or scratches beside a retaining ring, argue that the lens has been apart before, and that it was probably not stripped and reassembled by an expert.

LENS TESTING

Testing is equally applicable to new lenses and to second-hand, but we have a confession to make: we no longer test lenses formally, using test charts to determine lines per millimetre, colour correction, coma, astigmatism, and all the other things you read about in lens tests. If you want to do that, then by all means buy the Paterson optical lens test chart. Otherwise, the following 'real world' lens test will tell you just about all you need to know.

First, load the camera with your usual film – or better still, with an ISO

50 colour slide film. Use a tripod if you want really meaningful results; switch to hand-held shots only towards the end of the film.

Shoot a brick wall from 3m (10ft) or so. If you can find a big enough brick wall, shoot from further away! If you can, shoot wide open: with a shaded wall, even on a sunny day, you should be able to shoot at 1/1000 at f/2. With a faster lens, one stop of overexposure when you shoot at f/1.4 should not greatly affect sharpness. Also shoot at f/5.6 and f/8, and at minimum aperture.

After the brick wall, find a tree with branches silhouetted against the sky. If you are in an urban jungle, the wires at the top of a telephone pole are almost as good. Again, shoot at as wide an aperture as possible; at a middling aperture; and at minimum aperture. Do not try this on a windy day, as subject movement will affect the results.

Next, shoot a few pictures into the sun, at varying apertures. Make sure the sun is in the picture, and do not use a lens hood. Alternate these shots with 'sun over the shoulder' pictures, where the lens is in shade.

Then shoot a sheet of newspaper at about 1m (3ft) (or the closest focusing distance, if you are using a lens which will not focus that close). Choose a page with plenty of text on it, and tape the newspaper to the wall. Take care to line the camera up fair and square. Use a tripod!

Use up the rest of the film shooting hand-held snapshots, including (if appropriate) some indoors with the lens wide open. The subject does not matter – we have shot the interiors of many camera shops – but what is important is to use the camera in the sort of lighting conditions which you will encounter in the real world. We do a lot of low-light reportage, so we need to test the lens in low light.

Have the film processed, but not mounted. Compare the unmounted, sleeved slides on a light table, using a powerful magnifier: at least 10x, and preferably 20x or 25x. Anything more than 30x is likely to prove excessive.

T-mount and filter

Changing filters on the Vivitar Series One 'solid cats' is a nightmare. First, you have to remove the camera body. Then you unscrew the T-mount. Then you remove the filter ... While we were working on this book, Roger dropped the UV filter from this lens and cracked it straight across. Given that the lens has to be used with a filter in the light path (it is part of the optical design), this put the lens out of commission until a replacement 35.5mm filter could be found. This picture does however show just how easy it is to make an adapter for a lens with no linkages, not even an auto-diaphragm: the old T-mount is a simple, but very precise, piece of engineering. We keep half a dozen of them, bought second-hand for next to nothing, for making up adapters.

The brick wall will show you whether the lens has excessive barrel distortion or pincushion distortion, and gives you a good idea of the central and edge sharpness of the lens.

The tree will tell you a lot about contrast. The more clearly you can see the twigs silhouetted against the sky, the better. If the edges of the twigs are soft and hazy, the lens lacks contrast.

The sun/shade pictures will tell you more about contrast and flare. Very few lenses will fail to produce ghost images if they are pointed into the sun, but how flat does the rest of the image look? Excessive flatness may be caused by dirt, scratches, haze or damaged coatings, or simply by poor coating on a cheap or elderly lens with too many glasses.

The newspaper will tell you about resolution, both centrally and at the edge, and the final pictures will show you how the lens is likely to behave in use. Only after this informal test would we bother to shoot a lens test chart; and when we realised that in the real world we got all the information we needed from the informal test, we just stopped doing the formal tests. The only time we use the test charts now is to confirm suspicions (such as the fact that the awful old Canon f/1.2 rangefinder lens is only awful at wider than f/2, and is very good after f/4), or to provide comparative information when we are writing articles for magazines.

Repolishing and Recoating

There are still a few companies who will strip, repolish, recoat and recement damaged lenses. In general, the game is not worth the candle. The work is expensive, and the reassembled lens is rarely as good as it was when it was new. For most 35mm lenses, repolishing and recoating are best avoided; only with a few large-format lenses is it normally worth bothering.

ADAPTERS AND CONVERSIONS

It may surprise you to learn how many professionals use lenses that were intended for one camera on another, either via adapters or by having the lens professionally converted from one mount to another.

The main thing which governs whether or not a lens can be adapted or converted is the flange to film distance. Suppose, for example, that the flange to film distance on one camera is 45mm, while on another it is 40mm. It should be a fairly simple matter to make up an adapter in one direction – all you need is a fairly fancy 5mm spacer – but in the other direction you are not going to get infinity focus unless you remove a part of the back of the lens. Even if this is possible – and it may not be – it is likely to be expensive. If you do have to carve up a lens, it is as well if you can keep the parts so that it can be converted back to its original mount.

In practice, a few lenses have been available from their manufacturers in both 35mm and rollfilm mountings, and in general these are the easiest to adapt for any 35mm camera. Also, the Leitz lenses for the Visoflex are very easy to adapt: the Visoflex is an add-on mirror box which converts the rangefinder Leica into a single-lens reflex, so the flange to film distance is enormous.

There have also been some conversions which are so commonplace that off-the-shelf adapters have been made: Leica screw to Leica bayonet; or

Pentax screw to Pentax bayonet. In the days of the Olympus Pen F half-frame reflex, Olympus supplied adapters for a number of other makers' lenses; I have had both Exakta and Nikon adapters. You can also buy off-the-shelf adapters for Hasselblad (medium format) to Nikon, and Herr Zorkendorfer's 'Zork' adapters permit the use of almost any medium-format lens on almost any 35mm SLR.

Likewise, there are a few other conversions or adapters which are sufficiently common that they are 'semi-standard' offerings from specialist repairers: Del's Camera in Santa Barbara, California, used to offer a standard conversion for the Canon 35mm T/S lens to Nikon mount. Otherwise, you will need to telephone around if you want an adapter made or a conversion done. A good place to start is with a specialist repairer, who will probably be a good deal more helpful than the manufacturer.

For lenses where flange to film distances would otherwise make adaptation impossible, you can sometimes buy adapters which have optical correction built in. Effectively, these are about 1.1x teleconverters, so they increase the effective focal length of the lens by about ten per cent (a 50mm becomes a 55mm, a 200mm a 220mm), and they cause an inevitable loss of optical quality. For the most part, they are unsuitable for critical use where big enlargements are going to be made.

Diaphragm and Other Linkages

Normally, you lose all mechanical linkages between the camera and the lens when you use an adapter: you have to open the lens up, and stop it down, manually. With modern electrical linkages, it is much easier in theory to preserve the linkage, but in practice adapters are hard to find. There are however a few – a very few – adapters which preserve mechanical linkages.

T-Mounts and Tamron Adaptalls

One way around the problem of adapters is to make a lens with a standardised rear end, and then sell a variety of adapters which allow it to be used on a wide range of cameras. Sold as 'socket' lenses as far back as the 1950s, this system has never been very successful and is currently encountered in only two common forms.

The first is the T-mount, a simple adapter with a female screw thread (to accept the lens) and a male camera mount. There are no linkages, so this system can only be used for pre-set lenses; for mirror lenses which have no diaphragm anyway; and for systems where there is normally no linkage, such as bellows units and microscope adapters.

The second is the very much more ingenious Tamron Adaptall mount, which preserves diaphragm automation and (apparently in all cases) also exposure automation. From personal experience we can confirm as nonsense all the complaints about the lack of precision inherent in such a system; it works as well as any fixed-mount lens, and indeed it is all but impossible to distinguish the lens from a fixed-mount version when it is assembled. On the other hand, the theoretical advantage of the system – that the lens can be used on several cameras – does not affect us, because like most professionals we stick with a single SLR mount, in our case Nikon.

Kathkali dancer, Ernakulam

Impact does not always depend on technical quality. This picture of a South Indian dancer suffers slightly from camera shake – even with ISO 1000 film and a 90mm f/2 lens used wide open, shutter speeds ran around 1/30 to 1/60. This is quite simply longer than you should consider with a 90mm lens. Incredibly shallow depth of field, which would have been even worse with an f/1.4 lens, made focusing on the face ultra-critical. On the other hand, the choice was simple: take shots where we knew there was a risk of technical shortcomings, or take no shots at all. A basic rule of photography is, 'If you don't play, you can't win', so even if you have not got quite the right equipment or film, always shoot anyway. (RWH)

4 ZOOMS

Today, many cameras are sold with a zoom as the original lens; and if the camera does not come with a zoom, then a zoom is the first lens that most people consider buying when they are looking to extend the usefulness of their camera. This is why we opted to discuss zooms before going on to 'prime' lenses, even though logically zooms are only a special type of telephoto or wide-angle lens. There are of course many more examples of telephoto and wide-angle shots in the appropriate chapters, and you may find it worth while to look at those before deciding either that you need a zoom at all, or that you need a particular kind of zoom.

The advantages of a zoom are obvious. Without changing your position – indeed, when you cannot change your position – you can still choose the correct focal length to frame a subject precisely. Instead of carrying two or even three prime lenses, and wasting time changing between them, a zoom allows you to keep one lens on your camera, ready for action at all times.

It also allows you to pick precisely the focal length you need, instead of one that is close enough. For example, a 35–85mm zoom would replace at least a 35mm and an 85mm, and probably a 50mm as well – but what if you wanted a 60mm or a 75mm? The zoom gives you the choice; the prime lenses do not.

Also, you can replace all the lenses that many people own with just two zooms. Both 28–80mm and 70–210mm or 80–200mm can be found at a reasonably affordable price, covering a full range of the most useful focal lengths available with only a single

Mardi Gras masks in the Old Market, New Orleans

This was shot with a 35mm f/2.8 prime lens in the Old Market in New Orleans. It was used wide open, and depth of field is only just adequate, so a faster lens would have been wasted. Arguably, the 28–80mm f/2.8 Sigma would have been better, but, unfortunately, we did not have that lens at that time: the great advantage of the zoom would have been that we would not have had to crop the image – this is about three-quarters of the full frame. It would admittedly have been possible just to move a little closer, and fill the frame with just the 35mm lens; but no one gets it perfectly right, every time ... (FES)

Passion Play, Guadalupe, Alta California
Every year, under the direction of Fr Julio Roman, La Hermosa Ciudad de Guadalupe stages a passion play which attracts thousands of people from all over California and beyond. With the exception of a handful of the main actors – including the Christ, shown here – the players are all from Guadalupe, a predominantly Mexican, Catholic village of about 5500 people. On Good Friday, as the light falls, you need faster and faster lenses (or faster and faster film) to capture the Passion, but even with slow films such as Fuji 50, chosen here for its extreme colour saturation, an f/2.8 lens is just fast enough to catch the rays of the dying sun. Anything slower would be too slow. (RWH)

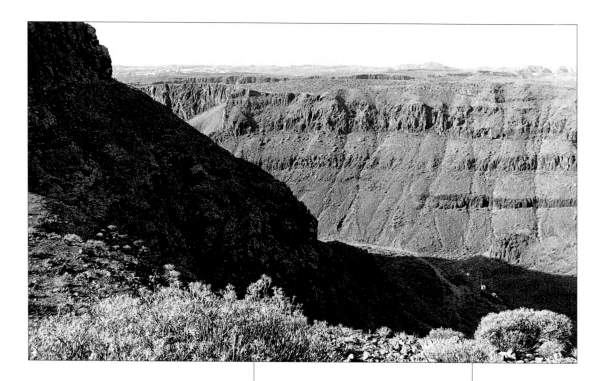

change of lens. Despite these clear advantages, though, there are plenty of photographers who are still firmly wedded to fixed-focal-length lenses.

THE GREAT DEBATE

Perhaps surprisingly, most photographers tend to be either fiercely pro-zoom or fiercely anti-zoom. Rational argument is the exception rather than the rule. In part, this partisanship is a result of the fact that zooms suit some photographers, and some styles of photography, far better than they suit others. This is, however, only a partial explanation, because some photographers are irrationally anti-zoom even where a zoom would be useful, while others are equally irrationally pro-zoom and use them even where they are not really suitable.

To sum up, the pro-zoomers' argument is that a zoom is supremely convenient. Also, thanks to modern computer-aided design, the quality it delivers is likely to be substantially better than that of the zooms of the past. Before the mid-1970s, zooms were almost never encountered in professional usage, but now they are used increasingly.

The anti-zoomer counters that in return for this sublime convenience, there are a number of prices to be paid, and some of them are quite heavy; in their view, unacceptably heavy. Zooms are almost always slower than prime lenses; they are inevitably less sharp than the finest prime lenses (though the best zooms are very good indeed); many are big and heavy; they may not focus very close; and good ones are very expensive indeed. Also, although

Landscape, Gran Canaria

The 200mm focal length can be surprisingly useful for landscapes. This was shot with our old Vivitar Series One 200mm f/3, but a 70–210 zoom would have been equally suitable. You will, however, need a clear day if you are to avoid the kind of haze which wrecks the impression of sharpness. This was shot early in the morning, after an uncharacteristically rainy spell on Gran Canaria. The level of airborne dust was very low, as was the level of haze, but the more distant cliffs are clearly very much softer and hazier than the flowers in the foreground. Exposure (on XP-2) was probably 1/250 at f/16. Small buildings on the right, in the shadowed part of the picture just above the right-hand clump of flowers, give some idea of the scale of the scene. (RWH)

Ku Klux Klan outfit

It is unlikely to be legible in reproduction, but the typewritten museum label on the hood reads 'Ku Klux Klan outfit worn by prominent Nevadan in 1930s' – the Bushwhacker Museum, by whose kind permission this appears, is in Nevada, Missouri. The type is approximately 0.6mm (1/50in) high in the print; maybe 0.1mm, or about 1/250in on the negative. And yet, this was not shot with a macro lens but with a second-hand zoom which was well over a decade old at the time: a 35–85mm f/2.8 Vivitar Series One, mounted on a twenty-year-old Nikon F. It was used on a tripod, at about f/8 to f/11, with a shutter speed of perhaps 1/125 second on Ilford XP-1 rated at EI 250-320. Most lenses are far sharper than their owners ever give them credit for... (RWH/FES)

advocates of zooms like to say that a zoom replaces 'up to half a dozen' lenses, the truth is that it normally replaces two or maybe three. And to cap it all, the front element of many zooms rotates, making it inconvenient to use some 'system' filters or other front-of-lens attachments.

Speed
Most 80–200mm zooms have a maximum aperture of around f/4. Now, a 200mm f/4 is pretty acceptable. A 135mm f/4 is, however, a stop slower than even the usual modestly priced 135mm f/2.8; and an 80mm f/4 is a veritable joke, because most 80 to 90mm lenses are f/2 or faster – two whole stops faster than the zoom.

Of course, you can buy an 80–200mm f/2.8, but it will cost you anything from two to five times as much, and it will be enormous. At that point, you have a reasonably fast 200mm lens, and an average-speed 135mm; but the 80mm is still deadly slow compared to prime lenses of similar focal length.

The real difficulty lies in maintaining the maximum aperture at the longest focal length, and the way that more and more manufacturers get around this is by making variable-aperture lenses. The problem here is that maximum apertures remain modest, even at the wider end, and they can become very slow indeed at the longer end. For example, Canon's cheapest 80–200mm runs from f/4.5 at 80mm to f/5.6 at 200mm.

Also, if you prefer to use a separate hand-held meter, you need to guess the effective aperture of your lens at the focal length you are using. The variation is not great, and can be guessed with more than adequate accuracy. With a through-lens meter, this problem is of course unimportant.

Vulcan Bomber

The Vulcan was the longest lived of all V-bombers, and it is amazing that such a deadly weapon of mass destruction should be so beautiful. It was designed to carry a nuclear payload, in that very bomb-bay whose doors gape in this picture. This was shot at RAF Manston in 1992, on the very last day that the Vulcan was scheduled to fly, ever: keeping it in the air would reputedly cost £500,000 a year. This picture was taken with a 200mm lens, as the pilot threw this huge aeroplane around the sky as if it were a fighter, coming astonishingly close to earth. This sort of display – in good light, with a wide variety of subjects at widely varying distances – would be an ideal subject for a 70–210mm zoom or even for an extended-range zoom such as a 50–300mm, though a monopod and pistol-grip tripod head (see page 140) would be advisable to take the weight of an extended-range zoom. (FES)

Sharpness

For the reasons already discussed in Chapter 2, zooms are never as sharp as prime lenses of equivalent quality. Certainly, a good zoom lens may well be better than a middle-range prime lens, but that is hardly a fair comparison.

It is however possible to make too much of a fetish of sharpness. If you normally shoot colour print film, and if 8x10in or 18x24cm enlargements are as large as you normally go, you can be very happy with even the most modestly priced zooms. For photojournalism, high-quality zooms are perfectly acceptable: either the pictures are run comparatively small on good paper stock (few magazines use pictures larger than about 7x10in/18x25cm, which should be well within the capabilities of most zooms), or the paper stock is so bad and the screen is so coarse that any deficiencies in the lens would not be apparent even in a giant blow-up.

For other applications, though – advertising, stock photography, and to some extent book illustration and other editorial work – the picture would need to be of unusual artistic merit or of an exceptionally interesting subject in order to overcome the disadvantages of reduced sharpness as compared with a picture shot with a prime lens. For exhibition photography, where the final result is a large original print (11x14in or 20x24cm or above) zooms are not usually a good idea.

Size and Weight

This is much less of a problem than it used to be. Many modern zooms are surprisingly small and light, though the smallest and lightest zooms are rarely the sharpest, fastest, or most durable. If you want a sharp zoom with reasonable speed, then you are looking at a big, heavy lens. In extreme cases, a single zoom may be very nearly as big, heavy and expensive as the prime lenses it replaces; and unlike a two- or three-lens outfit, where part of the weight is in your camera bag (or pockets) and part is round your neck on the camera, the whole weight is round your neck.

Close Focusing

Do not be taken in by the term 'macro zoom'. There has never been a true macro zoom; that is, one which allows you to photograph small objects at life size or larger on the film. There has only ever been one zoom which meets even the modern, relaxed criteria for macro throughout its focusing range while retaining good image quality: the Vivitar Series One 90–180mm f/4.5 CF Flat Field, which focuses to half life size at 180mm and one-quarter life size at 90mm. Our 90–180 CF was used for

almost all the technical illustrations in this book.

For many zooms, though, the minimum focusing distance may be as much as 6ft (2m). Other zooms may require you to operate a 'macro switch' or 'macro ring', in order to get them to focus close, typically at only one end of the zoom range. And almost all zooms deliver indifferent quality when they are used in the so-called 'macro' range: certainly, they cannot hold a candle to a prime macro lens. The old Vivitar 90–180 achieved its extraordinary performance by being slow, heavy, and expensive, with a modest 2:1 zoom range.

Before buying any zoom, check the closest focusing distance at all focal lengths, and do not expect very much from the macro facility if it has one.

Price

Effectively, the quality of zooms has risen while their price (in real terms) has fallen. Even so, they are not cheap, and if you favour wide-angles instead of longer lenses, the prices can be hair raising: at the time of writing, the price of Canon's 20–35mm f/2.8 would pay for a 20mm f/2.8, a 24mm f/2.8, a 28mm f/2.8 and a 35mm f/2, all from Canon, and still leave you with a little change.

What is more, regardless of focal length or price range, you need to buy good, modern zooms: very few pre-1980 zooms are much good, though there are some noble exceptions. Second-hand zooms, unless they are very recent, are mostly a poor risk.

How Many Lenses does it Replace?

Although (for example) an 80–200mm lens theoretically replaces 80mm,

85mm, 90mm, 105mm, 135mm, 180mm and 200mm, few people would actually carry all those focal lengths. In fact, most people use a zoom at one end of its range or the other, rarely in between, so it really only replaces an 85mm and a 200mm, or (at most) an 80mm, 135mm and 200mm. Likewise, a 35–85mm replaces a 35mm and an 85mm; with those two, few people would bother also to carry a 50mm.

Rotating Front Elements

The vast majority of modern prime lenses, and some zooms, have what are called 'rectilinear' focusing mounts: the front of the lens moves in and out in a straight line, without rotating. Many zooms, on the other hand, are like old-fashioned rangefinder-camera lenses: the front element rotates as the lens is focused (and sometimes as it is zoomed as well).

Normally, this is totally unimportant. Filters are round and lens hoods are round (and you should always use a lens hood on a zoom). If, however, you are using graduated filters of the Cokin type, or if you are using an adjustable bellows-type lens hood, the rotation of the front element means that you have to realign everything each time you refocus. This is hardly a problem at all, because you can usually see through the viewfinder if there are any problems. Some people find it difficult, though. If you frequently use graduated filters, you may want to consider this point when you buy a lens.

ONE-TOUCH AND TWO-TOUCH

Amazingly, the pro-zoom/anti-zoom debate is not the only one to divide the

USS Alabama

The battleship USS Alabama in Mobile was one of the first places we took our 'orphan', the second hand 35–85mm f/2.8 Vivitar Series One which we found in 1990 in Del's Camera in Santa Barbara, California. It was languishing unloved and unwanted – and even unpriced. After brief dickering, a deal was struck at $85 (under £50 at the time). It was our third lens of this model. The first was bought new, and was stolen. The second, bought second hand, was not sharp enough for professional use, but a friend who wanted it for family snapshots was delighted to take it for what we paid for it. Then there was this one, which was just as sharp as the first. This was a hand-held shot at about 75mm; film was Ilford XP-1, probably at 1/1000 at f/8. (RWH)

ranks of photographers; the other, which affects only the pro-zoom camp, concerns 'one-touch' and 'two-touch' lenses.

A 'one-touch' zoom uses the same ring to control both focus and focal length: it is twisted in the conventional way for focus, and pushed or pulled to vary the focal length. Other names for one-touch lenses include 'trombone' lenses and 'slide-zoom' lenses.

A 'two-touch' zoom uses one ring to control focus, and another ring to control focal length. Proponents of two-touch zooms point to the advantage of being able to change focal length and focus independently, without disturbing one when you change the other. Advocates of the one-touch system point out that a single ring is quicker to operate and, besides,

when you operate the ring, you are looking through the lens, so where is the problem in adjusting focus and focal length simultaneously?

The debate – which in our opinion is a storm in a teacup – can grow quite acrimonious. One side accuses the other of sloppiness: this is countered with gibes about people who cannot chew gum and walk at the same time. You may find that 'one-touch' versus 'two-touch' is really, really important to you; or more likely, you will wonder what all the fuss is about. For the record, we own both types of zoom. The one-touch type is indeed more convenient for rapid-action photography, while the two-touch is more convenient when the camera is on a tripod; but it really does not matter very much.

Power Zoom

There is in fact yet another option – or rather, a variant on the two-touch. This is the Power Zoom, introduced by Pentax. Although at first sight this looks like a completely useless gimmick, nothing more than a power-assisted zoom ring, it does in fact allow those cameras which use it to do some clever tricks. The most useful one is to vary focal length in response to focus, so that the subject is kept at a constant size in the viewfinder. Thus, for example, you can photograph a child running towards you and, as the child gets nearer, the zoom will reduce in focal length so that the child's height is always, say, one-half of the picture height. You can also set it to

'remember' focal lengths, and to do a number of other things such as zooming during exposure.

With or without power assistance, one-touch or two-touch, fast or slow, which zoom (if any) is for you? The choice is as follows, in order of popularity: telephoto zooms; 'standard' zooms; wide-angle zooms; and ultra-long and extended-range zooms.

TELEPHOTO ZOOMS

The first accessory zoom lens that most people consider is something like a 70–210mm or an 80–200mm, typically with a maximum aperture of around f/4: some current models feature a variable maximum aperture from f/3.5

Landscape, Gran Canaria

The often-despised 135mm focal length is, like the 200mm, surprisingly often ideal for 'pulling up' a detail from a landscape. Even though we would not recommend 135mm as a high priority as a prime lens, you may be surprised at how often you use a focal length in this range when you are using a 70–210mm or 80–200mm zoom. For landscapes, speed is obviously less important than for many other applications, and if you use the lens on a tripod (as we did here) you can shoot at f/8 most of the time: an aperture at which any half-decent lens should be sharp. Roger waited until a shaft of sunlight illuminated the cave-storehouse against a background of stormy cloud. Slight underexposure heightens the mood. (RWH)

Passion play, Guadalupe

If it comes to a competition between depth of field and camera shake, it is generally better to go for a shallow depth of field and reduce the risk of camera shake. With a 35–85mm f/2.8 zoom, rapidly failing light and slow film (Fuji 50), an exposure of 1/125 wide open allowed the actress to be held razor sharp, while the Roman soldiers in the background remain recognisable, if out of focus. To get the soldiers sharp, something like f/8 would have been required, and then, even if the camera had been supported on a tripod to permit the 1/15 exposure that was needed, subject movement would have been a significant risk. (RWH)

Christ praying in Gethsemane

While the disciples sleep, Jesus prays as he awaits the arrival of Judas Iscariot. Normally, for reproduction, the designer would specify that the yellow police-line tape at the top of the picture should be cropped out, and there would also be a temptation to 'lose' a little of the foreground. Remember: pictures as published are not always the same as pictures as shot! The old Vivitar 35–85mm zoom is at the limit of its ability here. Something like the Tamron 35–105mm f/2.8 would clearly be even more versatile, enabling the photographer to focus on the Christ alone. (RWH)

to f/4.5, or something similar. This is an extremely useful range of focal lengths, ranging from the sort of short tele that is needed to pull a face out of a crowd, to the longest focal length that can really be hand held. Fortunately, these are also the easiest of all zooms to make: remember, longer focal lengths are easier than shorter ones, and modest speeds are easier than fast ones. This, together with strong demand, means that modest telephoto zooms are generally of surprisingly high quality, even at quite modest prices.

The only real drawback to these lenses is that they are slow. As already mentioned, making the jump to f/2.8 (which is fast enough for most purposes) means spending at least twice as much money as you would need for the slower lens from the same manufacturer, as well as considerable extra bulk. Also, many people find that an 85mm or 90mm f/2 or even f/1.4 is an excellent lens for available-light photography: by contrast, an 80mm f/2.8 is barely acceptable, and an 80mm f/3.5 is just too slow for most purposes. Depending on what you want to do, you might find that you would be happier with a fast 'short tele' or a modest-aperture 200mm, or even with one of each.

Remember too that there are plenty of excellent prime lenses around on the used market, while used current-model zooms are much harder to come by: for about half the price of a good, used 80–200mm f/2.8, you should be able to buy an excellent used 85mm f/2 or f/1.8, *and* an excellent used 200mm f/4.

If you go outside the 70–210mm or 80–200mm range, you will usually find that the lenses are slower or more expensive or both. Ranges like

An example of a possible application is in some kinds of sports or wildlife photography – which is where speed and contrast are often essential. If you need one of these lenses, you will know about it; and most people do not need them.

EXTENDED-RANGE ZOOMS

The original 50–300mm f/4.5 Nikkor is the classic extended-range zoom, with its twenty glasses in thirteen groups, its 95mm filter size, and its all-up weight of 2.27kg (¹/₂oz under 5lb). Like extended-range zooms, above, its usefulness was limited. Some sports

photographers liked it because they could cover anything from the whole field down to one or two players, and it found limited popularity among the press. It did not focus very close, though; it was rather flat and lacking in contrast; and its substantial size and weight also told against it – it was rather over 1ft long (303.5mm, appropriately enough) at the 300mm setting.

Again, very few manufacturers have ever made lenses of this type, and even fewer still make them. They are certainly not lenses to consider as an early acquisition, unless you have a very specific application in mind.

Two-lens outfit

Like many modern 'high-end' SLRs, the Pentax Z-1 (PZ-1 in the United States) is sold with a choice of standard zooms: this is the 28–80mm f/3.5 to f/4.5. If you then want to 'pull in' more distant subjects, a tele zoom such as 70–210mm would be the next logical choice. With these two lenses alone, you cover everything from 28mm wide-angle to 210mm telephoto. Anything wider than 28mm can produce perspective effects which are too violent for some people, while anything longer than 210mm really ought to be used on a tripod, so this is the full range of 'everyday' lenses – all two of them!

5 WIDE-ANGLES

Wide-angles seem to affect some photographers (including one of the authors) like a drug of addiction: you need more and more, just to achieve the same euphoria. You start off with a 35mm or a 28mm, because you want to get more in than the standard 50mm lens can manage. Then, you move to a 24mm: the extra coverage and steeper perspective mean that you can do still more sweeping interiors, still more dramatic photojournalism. A 20 or 21mm comes next – the logical extension of the search for a lens that can capture more and more of the world around you. After that, a 17mm

Confederate Museum, New Orleans

The 14mm f/3.5 Sigma is the definitive wide-angle. The immense depth of field stretches from a few inches away from the camera – the cannon is less than a foot (30cm) from the lens – to the door some twenty metres (sixty or seventy feet) away. There is the slightest hint of unsharpness in the cannon and the lace runner, but beyond the rail behind the cannon everything is sharp. The amount of flare is remarkably small for such a fast lens, especially given the tremendous contrast range. Exposure was something like 1/2 second at f/16. You can see how some of the people in the museum have moved during the exposure, though others remained remarkably still. (RWH)

Montmartre, Paris

Both of us regard the 35mm as our standard lens, though Roger favours the 35mm f/1.4 Summilux, and Frances prefers the 35mm f/2.8 PC-Nikkor. The PC-Nikkor is probably the finest general-purpose lens available for considered photography, but its pre-set diaphragm and finicky focusing mean that when Frances needs speed of operation she often switches to the 35–85mm f/2.8 zoom. Roger's Summilux, with which this Montmartre grab shot was taken, is of course a supremely fast-handling lens. When he needs to take more considered shots he borrows the PC-Nikkor. Quite a lot of flare from the sun shining straight into the (rather dirty) lens is visible in this picture. (RWH)

Main Street, Daytona, during Cycle Week
Although we use a tripod whenever possible, there are times when we want to take hand-held low-light pictures, and they are much easier with a fast wide-angle. This was shot with a 35mm f/1.4, wide open, braced against a lamppost, shutter speed was 1/30second. Some people have moved during the exposure, but as a general guide, 1/30 second is a brief enough exposure to capture most pedestrians without movement. Anything longer is likely, however, to show some subject movement. (RWH)

widens your horizons still further; and eventually, like an opium addict chasing the dragon, you end up with a 15mm, 14mm or 13mm, the widest angle of coverage you can buy, anywhere, without going to the distortions of a fish-eye.

The great thing about a wide-angle, in the eyes of a wide-angle addict, is that it places the centre of attention slap in the middle of things. In order to get a good composition with a wide-angle, you generally have to be close to the subject you are photographing. With a telephoto, by contrast, there is a degree of 'stand-offishness'. This is, however, the view of a wide-angle *aficionado*. For an equally enthusiastic appreciation of telephoto lenses, you need only to turn to the beginning of

Chapter 6. To save you the trouble of checking the captions to see who uses which lenses, Roger is the wide-angle addict, and Frances is the telephoto fancier.

LONGER HAND-HELD EXPOSURES

Another advantage of wide-angles is that they can be hand held for longer exposures than would be possible with longer focal lengths. The rule of thumb for hand held exposures is 'one over focal length', where the exposure is a fraction of a second and the focal length is in millimetres. Thus, for example, a 50mm lens should not be hand held for exposures longer than 1/50 second (1/60 on most shutters), and a 200mm lens should not be hand

Belfry, Châlons-sur-Marne

Never mind the perspective, the aesthetics, or anything else, sometimes an extreme wide-angle is the only way to get everything in. These bells were shot with a 14mm because a 14mm was the only way to get everything in. The only mistake lay in hand holding the camera. Camera shake is not the problem so much as the fact that the lens is slightly 'flat' and flary wide open. Frances would have done much better to set up the tripod, stop down to f/11, and shoot at maybe a full second, rather than going for 1/15 at f/3.5. With any extreme wide-angle, regardless of price, full aperture should be regarded principally as an aid to focusing. (FES)

Mission de la Purísima Concepción, Lompoc, California

This is, like the soft-focus pictures in Chapter 7, one of the few occasions when we have 'cheated' and not used a 35mm camera. The picture was actually shot with a Corfield WA-67, a superb medium-format camera with a fixed 47mm f/5.6 Super Angulon (roughly the equivalent of 21mm on 35mm), but with the possibility of a few centimetres of rise or shift. It can be hand held; the viewfinder (it is a non-reflex) compensates for the shift movement; and as this picture on XP-2 shows, image quality is gorgeous. For the price of this camera you could however buy a top-of-the-line Canon SLR and a 24mm Canon shift lens – and probably have some change. (RWH)

held for exposures longer than 1/200 second (1/250 on most shutters). It's a good rule of thumb, but it is too generous when it comes to long lenses, and too mean when it comes to wide-angles. Thus a 35mm lens can in most cases be hand held with confidence for exposures of 1/30 second, and a 20mm or 21mm or even 24mm lens will usually produce entirely acceptable results at 1/15 second while 1/8 second

may be all right at a pinch.

If you want to try this, though, you may want to try another trick which makes it even easier. It is this: use an old-fashioned separate optical viewfinder during the exposure. The lack of mirror black-out will make it easier to see if you move the camera, or if the subject moves during the exposure. This trick can be used with standard lenses or telephotos, but it seems to work best

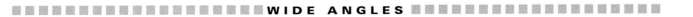

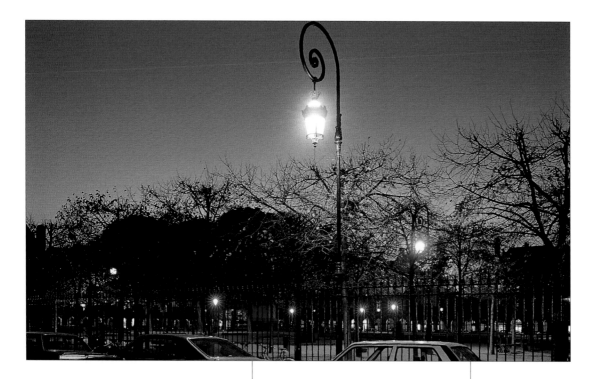

with wide-angles, where the risk of camera shake is least anyway.

THE TRADE-OFFS

In return for 'getting everything in', there are inevitable trade-offs. Wide-angles are rarely as sharp as longer lenses, and the wider they get, the more this is true. Flare can be a problem. They are rarely as fast as standard lenses. Older or less expensive wide-angles may suffer from barrel distortion, and ultra-wides will inevitably exhibit wide-angle distortion. Filters and lens hoods need to be carefully designed if they are not to cut into the corners of the image. Finally, illumination across the field will not be even, because of vignetting and because of \cos^4 light losses, though retrofocus designs greatly reduce \cos^4 vignetting as

compared with non-retrofocus designs.

Because each of these problems grows steadily more severe as the focal length decreases, there is no point in dealing with them as if they all applied to wide-angles in general. Instead, it makes much more sense to look at each focal length or group of focal lengths in turn.

HARDLY A WIDE-ANGLE AT ALL: 35MM

Traditionally, the 'standard' lens for any format is one with a focal length equal to the diagonal of the negative. This gives natural-looking perspective on contact prints that are viewed at normal distances of about 25cm or 10in. For the 24x36mm (1x1^1/2in) negative of 35mm film, the diagonal is 43.27mm. Admittedly, the print is

Place des Vosges, Paris

The attraction of this shot lies in colour alone; the subject matter (parked cars and railings) is hardly promising. After taking a meter reading and realising that the exposure would be about 1/60 at f/1.4, Roger opted to set up the camera on a tripod and shoot at a more modest aperture; the exposure used was 1/4 at f/5.6. Not only was the picture sharper and more saturated, but a bonus appeared in the shape of the starbursts reflecting off the blades of the lens diaphragm. (RWH)

War memorial, Moscow–Zagorsk road
The 35mm standard lens allows quick, easy snapshots. We spotted this memorial to the Second Great Patriotic War as our friend Oleg was driving us back to Moscow from Zagorsk. With just a 35mm f/1.4 prime lens, it was the work of a few seconds to jump out of the car, compose the picture and create this image. Would it have been better if Roger had used a tripod, and stopped down? Possibly; but there are times when the evening light is failing so fast that it would be foolish to risk the delay. (RWH)

always enlarged, but for a whole-plate (6^1/2x8^1/2in/165x216mm) print viewed at 25cm (10in), the rule still holds good.

Because it is easier to design a longer-than-standard lens to give good coverage, and possibly because some cine lenses of around 2in (50.8mm) focal length were already suitable for the new 24x36mm (1x1^1/2in) format, early standard lenses were almost all longer than 43mm. As recently as the 1960s, it was quite common to find 55mm and 58mm standard lenses – which were, of course, around thirty per cent longer than a true standard. For that matter, Nikon's super-fast aspheric f/1.2 Noct-Nikkor was still a 58mm at the time of writing. Compared with the 43mm standard, a 35mm lens is about twenty per cent short.

Suppose, however, that we enlarge

the negative a little more, while still looking at it from the same distance. Now, we need a wider lens to maintain the same apparent perspective. At the common 8x10in size, or still more at 24x30cm, the 35mm actually becomes the standard.

This, and the desire to get it all in, explains why so many compact cameras have 35mm lenses; by the time modern compacts were invented, it was easy to make sharp 35mm lenses for them. And the preponderance of 35mm lenses on compact cameras explains why so many people feel slightly uncomfortable when they 'move up' to an SLR, and find that with a 50mm lens they can't get everything in like they used to.

The Professional's 'Standard'
The 35mm focal length is regarded by many professionals as their standard,

with the 50mm relegated to a very unimportant position. From a given position, a 35mm lens covers about twice the area (1.4 times the linear coverage) of a 50mm lens, so the extra coverage is very significant; do not believe anyone who tells you that a 35mm is 'too close' to 50mm.

On the other hand, to get the full benefit from a 35mm, you really need a fast 35mm. Admittedly, the way that you can hand hold a 35mm lens for longer exposures than a 50mm lens is some compensation, but if you are serious about using 35mm as a standard, you ought really to buy an f/2 or (if you can afford it and if one is available for your camera) an f/1.4.

Also, few if any independent manufacturers still make 35mm prime lenses, so you will need to buy marque lenses from the camera manufacturer. If you cannot afford a new 35/2 or 35/1.4,

you will find that good fast prime 35mm lenses are relatively affordable on the used market.

Older Lenses

The good news is that older 35mm f/2 lenses from the major manufacturers are still very good indeed, but they have depreciated far more than they should. The same is equally true of faster lenses, if you can find them. In particular, the Nikon 35mm f/1.4 is reputed never to have been redesigned, and you may be able to find an old, cosmetically ugly example with good glass for a very modest outlay – less than even a middle-range wide-angle zoom. Also good news is that old marque 35mm f/2.8 lenses are very cheap indeed, and very good indeed.

The bad news is that older independent lenses vary widely. The best may (if you are lucky) be as good as

Métro Station, Place de la Concorde
If Roger did not have his 35mm f/1.4, it is extremely likely that we would use our 28mm f/1.9 much more extensively as a reportage lens. Although the Vivitar Series One 28mm f/1.9 is no longer available new, the Sigma 28mm f/1.8 is the modern alternative: a first-class ultra-fast wide-angle at an affordable price. This was a hand held shot, probably at 1/30 wide open, on XP-2: the Leica with black and white film in it needed to be reloaded, but the black and white Nikon did not. Even the corner resolution is remarkably good, and flare is arguably better controlled than in the 35mm f/1.4 Summilux. (RWH)

CONCORDE

N E T R O U B L E P A S L O R D
R E P U B L I C E T A B L I P A
R L A L O I N U L N E D O I T E
T R E I N Q U I E T E P O U R S
E S O P I N I O N S M E M E R E
L I G I E U S E S P O U R V U Q
U E L E U R M A N I F E S T A T
I O N N E T R O U B L E P A S L
O R D R E P U B L I C E T A B L

Métro Station, Place de la Concorde

Like the across-the-tracks shot, this was shot with the 28mm f/1.9 Vivitar Series One, hand held at about 1/30 wide open on Ilford XP-2. In the confined spaces of the Métro, the 28mm is probably a more useful lens that the 35mm. A gridded screen makes it easier to align wide-angles, even when you are working with a hand held camera. The most difficult thing was shooting quickly, before the train came, rather than trying to figure out NE TROUBLE PAS L'ORDRE PUBLIC ETABLI PAR LA LOI NUL NE DOIT ETRE INQUIETE POUR SES OPINIONS ... etcetéra. This is a wonderful snapshot of the Gallic mentality; an insight into the intellectual games the French love to play. (RWH)

marque lenses, but the worst are frankly bad: flat, flary, unsharp and with severe barrel distortion.

Verdict

You can hardly go wrong with a good 35mm lens. Buy a fast one, f/2 or f/1.4, and you have a new standard – especially useful if you also have a standard zoom and wish for more speed. Buy an f/2.8 and you have a sharp lens which costs you very little. The only reasons not to buy a 35mm are if you already have a standard zoom and never feel the lack of speed, or if you just don't want a wide-angle anyway.

BETWIXT AND BETWEEN: 28MM

Once regarded as an 'extreme wide-angle', the 28mm now attracts few adherents, sitting uneasily as it does between the almost-standard 35mm and the truly wide-angle 24mm. From a given viewpoint, it covers about 55 per cent more area than a 35mm (1.25x linear), or about three times the area of a 50mm (1.8x linear).

Most modern 28mm lenses are f/2.8 or faster; f/2 or even f/1.9 and f/1.8 are quite common. Unlike 35mm, which has pretty much been abandoned by independent lens makers, there are still 28mm lenses around in various qualities, from very good to fairly bad. The cheaper ones are very cheap indeed, and even the good ones are not very expensive.

The perspective of the 28mm is slightly exaggerated, it is true, and you need to take some care in holding the camera dead level in order to avoid drunkenly converging verticals. On the other hand, modern photographers have now become so accustomed to

Restaurant in the Marais, Paris

At night, even when you do not need the extra speed of a fast lens, it makes reflex focusing much easier. This was shot with the 28mm f/1.9 Vivitar Series One, on Scotch/3M ISO 1000 film. Even though the camera was on a tripod and the exposure could have been something like 1/30 (or at least 1/15) wide open, we preferred to stop down to f/5.6 and shoot at 1/4 second. It is surprising how little people move during even very long exposures like this, especially at night. During the day, 1/4 second would probably result in some movement if you were shooting a busy street scene. (RWH)

Dancing girls

Even a 21mm, used properly, can be a useful lens for reportage. This was shot at the Guadalupe Passion Play described on page 65: the girls are Herod's dancing-girls, village maidens all, who probably look very like the kind of girls Herod would have found pleasing. The effect is however somewhat spoiled by the insistence of one of the Roman soldiers on retaining his spectacles. The great thing about a 21mm is that it gets it all in, showing things in context instead of pulling them out in isolation. The exposure was almost certainly 1/125 at f/8 on Fuji 100: at that aperture depth of field is so immense you can pre-set the focus. (RWH)

pictures taken with wide-angles that we are not as shocked as our ancestors by 'violent perspective'.

An Aside on Perspective

Strictly, perspective depends only on viewpoint. In the real world it also depends on the degree of enlargement and the distance from which the print is viewed. In order to preserve 'natural' perspective, a picture should only be enlarged in proportion to the focal length chosen – or alternatively, the viewing distance should be adjusted accordingly. In practice, viewing distances tend to remain roughly constant, and enlargements tend to be to suit layouts or other requirements

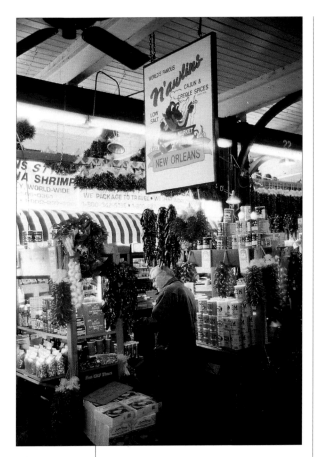

French market, New Orleans

Even at f/1.4, the depth of field of a 35mm lens at normal working distances is considerable: certainly enough to cover up small errors in focusing, and usually enough to provide satisfactory depth of field as well, as you can see here. A reasonably safe hand-holding speed is 1/30, so compared with a 50mm f/1.4 you have gained a full stop of effective, usable speed. Compared with a big, heavy f/2.8 standard zoom, you have gained two or three stops, and compared with an f/3.5–f/4.5 standard zoom you are up to four stops ahead. If you like natural-looking photojournalism without flash, the 35mm f/1.4 really should be pretty high on your list of priorities. (RWH)

rather than to suit optical theory, so perspective varies with focal length.

For example, if 35mm is 'normal' for an 8x10in print viewed at 25cm (10in), then a picture shot with a 28mm lens should be enlarged to 10x12in (24x30cm) and one shot with a 24mm should be enlarged to 12x16in (30x40cm). A picture taken with a 14mm lens should be enlarged to an impressive 20x24in (50x60cm) – all for the same viewing distance!

Older Lenses

Most 28mm lenses made since the late 1970s are pretty good, even the cheap ones; the days of horrendous barrel

distortion are over. One of the authors recalls looking at a building through the viewfinder of a camera fitted with a cheap, old 28mm and stepping back in alarm: the building appeared to be bellying out and collapsing!

More money will, however, mean more sharpness, and for critical use you want either a marque lens or a newer (or older premium) lens from one of the independent manufacturers. Older 'cooking' lenses, even from the better-respected independents, are not always very sharp.

Verdict

We own a fast 28mm lens which we thought might be useful for reportage, but we find that it has limited application; usually, the more restrained 35mm or a more dramatic ultra-wide is more useful. On the other hand, if you already own a standard zoom you might want to consider a 28mm as a fast wide-angle; even f/2.8 is two-thirds of a stop to a stop and a third faster than most zooms, and Sigma's f/1.8 is up to three stops faster. By and large, though, 28mm is a 'fill in' focal length which you buy because you find you need it to round out an outfit, rather than being an early acquisition.

THE FIRST REAL WIDE-ANGLES: 24MM AND 25MM

Exactly why 24mm supplanted 25mm as the more common focal length is hard to judge. A few companies (most notably Zeiss) preferred 25mm, but today 24mm is really the standard. At either focal length, the increase in coverage compared with a 50mm or even a 35mm lens is impressive: four times the area of 50mm (2x linear) and

Kitchen of Mission de la Purísima Concepción

The Mission de la Purísima Concepción near Lompoc on California's central coast is a beautiful place: a restoration, but one that is loving and faithful, instead of being a commercial catchpenny operation. The kitchen is periodically rearranged, and every arrangement makes a perfect, painterly composition. We have shot this many times, always from the same restricted viewpoint (railings keep you out of the kitchen) and always using ultra-wide lenses: first 21mm, then 17mm, and then 14mm. Quite honestly, we are not sure which this one is, but we think it is the 21mm shot. The film is Scotch ISO 1000. The camera was of course tripod mounted and carefully levelled, to avoid drunkenly converging verticals. (RWH)

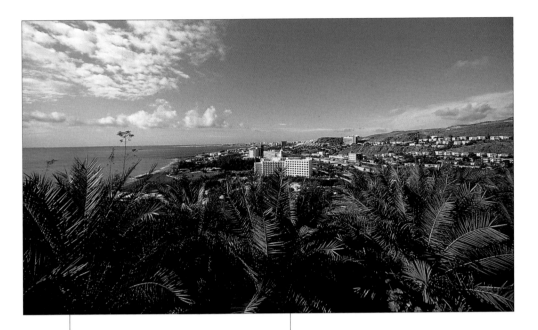

Playa del Inglés, Gran Canaria

Playa del Inglés on Gran Canaria is not a particularly attractive resort. Endless barrack-like hotels process visitors from all over northern Europe, principally Germans, Britons and Scandinavians. By 'smothering' the resort with lush greenery in the foreground we managed to suggest the attractions of Gran Canaria while still using the background to show some of the better hotels. Quite honestly, we have forgotten what lens this was taken with, but the depth of field and perspective suggest it was a 28mm or wider, used at about f/11, thereby giving acceptable sharpness from a foot or two (30–60cm) to infinity. (RWH)

standard, but in the past it was 21mm, and there have always been a few 19mm lenses. The difference in angular coverage between the three focal lengths is not very significant – a 20mm covers ten per cent more area than a 21mm, and a 19mm covers about ten per cent more again, or 22 per cent more than 21mm – but a 20mm lens covers 45 per cent more area than a 24mm (1.25x linear), three times the area of a 35mm (1.75x linear) and more than six times the area of a 50mm lens (2.5x linear).

With most modern marque lenses, the standard speed at this focal length is f/2.8. No one makes anything faster, though some independent makers do offer slower lenses: Vivitar makes a 19mm f/3.8, for example. The Vivitar is a bargain-priced lens, but spending the extra money on a marque lens will buy you more sharpness and, from limited personal experience, more contrast. The extra money in question is

however considerable: four or five *times* as much. The Vivitar is such a relative bargain that you might decide to buy one just to see if you like this kind of ultra-wide.

Older Lenses

Perhaps surprisingly, there are more old 19mm, 20mm and 21mm lenses around than old 24mm lenses – but most of the good ones are not what you might expect. They are non-retrofocus 'mirror-up' lenses, which protrude so far into the camera body that they have to be used with the mirror locked up and a separate optical viewfinder.

Although these lenses are very inconvenient, they also deliver superb quality. The viewfinders vary from bad to rotten, with moderate to severe barrel distortion and considerable problems in trying to determine precise framing, but the lenses are super sharp and very contrasty. As already mentioned, the superior quality of

non-retrofocus wide-angles is why Hasselblad still offer the 38mm f/4.5 Biogon on the non-reflex SWC/M, as well as a 40mm reflex-viewing lens for the normal Hasselblads. Lenses for 35mm cameras range from f/3.4 (Schneider 21mm Super Angulon for Leicaflex) to f/4.5 (Zeiss 21mm Biogon) via f/3.5 (Canon 19mm) and f/4 (Nikon 21mm). Most of them are 21mm, though one or two other makers may have offered 19mm as well as Canon.

If you decide to take this route – and it is one we can heartily recommend – then make sure that you buy the lens *with a finder*. Finders for 21mm lenses are very hard to come by and horribly expensive, which is why they are sometimes 'borrowed' and the lens is offered for sale without them.

As for older retrofocus lenses in this range, the news is less encouraging. After all, why do you suppose the major makers offered non-retrofocus lenses? Since the 1970s, the *grandes marques* have been very acceptable, and used prices are not too bad – maybe twice as much as for a new Vivitar 19mm – but lesser names are not always too brilliant. You may be surprised at how good some of them are, but they are prone to flare and internal reflections, and many of them are not very sharp. This is definitely an area where you need to try before you buy.

Verdict

As we have already said, most people tend either to love this focal length or to be totally indifferent to it. If you are always finding that you need more coverage, with your back to the wall, then you will love it. If you haven't noticed such a problem, you have absolutely no need of 20mm lens.

ULTRA-WIDES: 18MM AND BEYOND

The different between 18mm and 19mm is obviously negligible: about eleven per cent in area or 1.05x linear; but we had to draw the line somewhere. There is also a significant price jump at this focal length, which is another reason for choosing it as a break point. Yet a third reason is that now you are entering the realms where you have to distinguish between fish-eyes (which are covered in Chapter 7) and rectilinear lenses. The original Pentax fish-eye was an 18mm lens.

In fact, there are not many 18mm lenses, though Nikon offers one (at

Hitching-post, New Orleans
Formerly, these horse-headed posts were used for tying up horses: today, they are used to keep motor vehicles off the sidewalk. Most people see them as rather pretty, but Frances's 17mm shot (using the Tamron SP) is oddly disturbing: the head in the foreground is threatening, like an out-of-scale chess piece, while the ones in the background are barely visible. This is why people often refer to the perspective obtained with ultra-wides as being 'violent': there is a feeling of violence here. (FES)

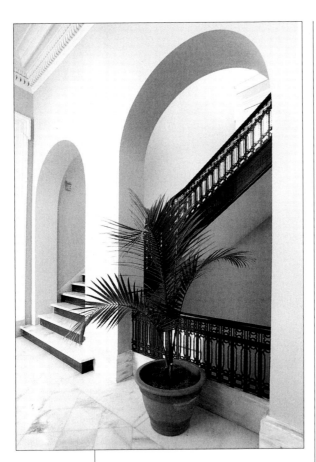

Stairway, Alabama State Capitol

If you can get a high enough viewpoint you do not need a shift lens. This was shot inside the Alabama State Capitol using a 17mm f/3.5 Tamron SP on a Nikon F, using Ilford XP-2 film. The tripod was a Manfrotto with a Kennett Engineering (Benbo/Uni-Loc) ball and socket head – our standard tripod and head for lightweight travelling. The maximum height achievable with this combination is approximately 1.6m, which is just about adequate. Besides, this tripod and head weigh just over 2kg (under 5lb). The big Linhof can top 2m with ease (almost 7ft), but it weighs about five times as much. In any case, there is little point in carrying a tripod which can hold the camera higher than you can see through. (RWH)

almost twice the price of the 20mm!), and there may have been a few others. The 17mm focal length is, however, quite popular, with marque lenses from Canon and a number of other manufacturers, as well as independent offerings of widely varying quality. The coverage of a 17mm lens is spectacular: more than fifty per cent greater than a 21mm; more than four times greater than 35mm; and just under nine times greater than 50mm (1.24x, 2x and almost 3x linear). Prices tend to be high, with only Vivitar offering a bargain-priced 17mm f/2.8; Tamron's 17mm f/3.5 SP is about twice the price of the Vivitar, and a 17mm f/4 Canon

would double that again. The maximum apertures are fairly irrelevant: these are lenses you would normally stop down to f/5.6 to f/11 whenever possible.

The 17mm focal length is the last one where conventional filters can be used. Normally, wider lenses than this will have a filter turret built in, or use rear-mounted filters.

As with 18mm, 16mm is unusual– most 16mm lenses are full-frame fish-eyes – but there have been several 15mm lenses, all from marque manufacturers as far as we are aware: Leitz, Nikon, Zeiss, and possibly others. They are expensive lenses, typically costing more than a top-of-the-line SLR body. The coverage of a 15mm is twenty-eight per cent more than that of a 17mm (1.13x linear); almost eighty per cent greater than that of a 20mm (1.33x linear); more than five times greater than 35mm (2.33x linear); and over eleven times that of a 50mm lens (3.33x linear).

At 14mm, the surprise entrant is Sigma, with a lens that may not be cheap, but which is certainly a bargain – it's about a quarter of the price of the Canon 14mm f/3.5, or a quarter of the price of Nikon's 15mm, and about a twentieth of the price of a Nikon 13mm. At this focal length, you are going to run into flare and internal reflections with any lens, so careful shading is essential and you may still get patches of light in unexpected places. Distortion is however astonishingly low. The Canon is alleged to be a better lens, but so it ought to be at the price! We can't afford a Nikon 15mm, and we certainly can't afford a Nikon 13mm, but the Sigma is a lens which we can afford and

Interior of GUM

Moscow's GUM is often described as a 'department store', but a more accurate description would be that it is a whole series of different shops, in the former Imperial Stables; the most handsome mall in the world, in fact. The principal difficulty in photographing it lies in getting a lens that is wide enough. You need at least a 17mm, and preferably a 14mm, which is what this was taken with. There is severe wide-angle distortion at the corners, and the long exposure (about 1/4 second) means that some of the people are blurred; but in a sense, the blur just adds to the busyness of the scene. (FES)

Dedo de Dios Bay, Gran Canaria

Ultra-wides are only rarely suitable for landscapes. Normally, they push the background (which often contains the principal interest of the picture) into obscurity. Only when you have a strong foreground, like the sunlit pebbles here, can you get away with an ultra-wide. This was actually shot with a 14mm f/3.5 Sigma, though it has been cropped on the right for reproduction. In the original, there was rather an ugly quay and crane, and the lens had to be shaded with one hand to get rid of some spectacular flare from the sun, which was in shot. Exposure on Fuji 100 was about 1/15 at f/11; the picture was taken maybe three-quarters of an hour before sunset. (RWH)

which we would hate to be without. We normally use it on a tripod at f/8 or f/11, and the results have been published widely. Filters are pretty inconvenient, though: you need to cut tiny squares of gelatine filter, and slip

them into a carrier at the very back of the lens.

Finally, the outright winner in the wide-angle stakes at the time of writing was clearly the Nikon 13mm, but at the price of quite a nice small car, so it

needed to be! The coverage is more than twice as great as a 20mm (almost 1.5x linear); more than seven times as great as 35mm (2.7x linear); and close to fifteen times as great as 50mm (3.8x linear). It is worth remarking that 14mm and 13mm offer the widest angular coverage (for rectilinear lenses) for any lens on any format: the widest lenses you can get for rollfilm and cut-film formats equate to about 15mm or even 16mm on 35mm.

Older Lenses

Mostly, there are none; it is only with the arrival of computer-aided design and the current generation of glasses that it has become feasible to design lenses with such a relatively limited appeal, let alone manufacturing them. In general, you need to buy state-of-the-art lenses at these focal lengths:

even if you buy, for instance, the older Tamron 17mm SP, you may notice a difference. We cannot vouch for this personally, because we have only used the newer lens (in fact, we use it professionally), but this is what other professional friends tell us.

Verdict

Lenses wider than 24mm are not something you need to buy early in your career, but once you have chosen your direction you may well decide that you need serious wide-angles – and these lenses are very serious indeed. They are expensive, and they have to be used with care, but they will give you results which you simply could not obtain in any other way.

And now, from the extremes of ultra-wides, we shall turn our attention to telephotos and long-focus lenses.

John Brown's tumbril

On this wagon, the notorious abolitionist and Yankee John Brown was taken to his hanging; it can be seen yet in a superb museum in Charleston in what is now West Virginia. The only way to photograph it, though, is from very close up, which is where a 14mm lens (the Sigma f/3.5) comes in very handy. Hold this picture at arm's length, and it looks wildly distorted, but the closer you hold it to your eye the less unnatural it looks. If your eyesight is good enough to focus on it from two or three inches (5–8cm) away, it looks quite natural. This is because perspective depends purely on viewpoint, and the viewpoint from which this was shot was very close to the wagon. (RWH)

6 LONG-FOCUS AND TELEPHOTO LENSES

The great attraction of long-focus lenses is their selectivity; from the chaos of life, you can pick out the subjects that interest you, isolate them, and capture them on film. The usefulness of a long-focus lens does not necessarily depend on its focal length. In fact, many photographers find that the most modest focal lengths – 85mm to 105mm – are the most useful. With a lens in this range, you can pick a person out of a crowd; isolate a detail in a landscape; come in close, almost like a macro lens (in fact, one of the authors uses a 90mm macro as one of her two principal lenses); or create a powerful portrait.

Go for a rather longer lens, a 180mm or 200mm, and you have a lens which is short enough to be hand held, but which still has enough 'pulling power' to make distant subjects seem close; go longer still, and you have the ability to focus on a single athlete, an animal in the wild, an architectural detail that would go unnoticed in a normal picture.

Also, as we have already seen, sharpness is relatively easy to achieve: the narrower the angle that a lens is required to cover shortly, the easier it is to design and to make.

THE TRADE-OFFS

As with other lenses, there is inevitably a price to be paid for the advantages of the long-focus and telephoto lens. The first is speed, because long, fast lenses rapidly become very unwieldy and expensive. While a used 200/4 can be purchased very cheaply (even if you buy a leading make like Nikon), and a 200mm f/2.8 from a marque manufacturer is quite an expensive lens

costing about the same as a middle-ranking SLR, a 200mm f/2 or f/1.8 is very expensive indeed: two or three times the price of a top-of-the-range SLR.

Speed means bulk and weight, which is inconvenient when you have to carry the lenses, and big front glasses mean big, expensive filters, so some lenses use behind-the-lens filters – which also tend to be very expensive, because they

Rock-face, Gran Canaria

We spotted this attractive combination of
textures by the side of the road in Gran
Canaria, and pulled off to photograph it. Rock
is however one of the most difficult things to
photograph satisfactorily with 35mm: the
texture always looks slightly soft, because the
micro-detail is right on the edge of resolution.
Although the picture is fine at normal viewing
distances, the texture invites you to look
closer and closer – and suddenly, it isn't there.
This picture will look better in reproduction
than in the original print, because the
photomechanical reproduction process will
conceal this lack of ultimate sharpness. It was
shot with the 90mm f/2.5 Vivitar Series One.
(FES)

Tiger Hill

Sunrise on Tiger Hill, just outside Darjeeling at
about 13,000ft (4000m) in the Himalayas, is
exceptionally beautiful. You need to use a
reasonably long lens, though, or the sun is
reduced to a tiny speck and the overall picture
lacks a centre of interest. This was shot with a
90mm Summicron, which allowed a
reasonable combination of sun, cloud and
landscape. Shots taken with wider lenses were
disappointing (we tried!), but a 135mm would
probably be the longest you could use. This is
equally true in less exotic locations, too.
(RWH)

may be available only from the manufacturer of the lens.

Despite the weight and bulk, though, speed is still valuable. If you have to hand hold the lens it reduces the risk of camera shake, and if the camera is on a tripod it means that there is a better chance of using higher speeds for stopping action. And although speed means reduced depth of field, it also means easier focusing. Having used both fast and slow lenses, there are only two situations where we can recommend slower ones. One is where you need to save money, and the other is where you need to save space or weight.

INTERNAL FOCUSING

More and more long-focus lenses advertise themselves as 'internal focusing' or IF. The traditional way to focus a lens is to move the whole lens to and fro, but another way of focusing it is to vary the focal length by moving one lens group (or more than one lens group, for that matter) while leaving the rest of the lens stationary. This is not actually anything very new: several lenses for the 35mm Voigtländer Prominent of the late 1940s and 1950s used true internal focusing.

Many zooms use internal focusing, often in conjunction with conventional focusing, but the reason why internal focusing is so highly touted in telephoto lenses is because it greatly reduces the focusing effort. Instead of winding a great big lens head out on a long, slow focusing helical, a relatively small and quick movement of the lens elements is used instead. This is virtually essential if you want to build a fast-responding autofocus lens, but it is handy with manual focus too. Certainly, the Sigma 300mm f/2.8 is much quicker and easier to focus than our old 400mm f/5 Telyt, but, contrary to popular belief, there is nothing about

200mm and 300mm lenses
On the left is our old 200mm f/3 Vivitar Series One. The unusual aperture of f/3 is only one-sixth of a stop slower than f/2.8: a negligible difference, and one which a less honest manufacturer might simply have ignored, and called the lens an f/2.8 anyway. On the right is a 300mm f/2.8 Sigma: a wonderful lens, but rather large. The wide aperture does however mean that it is vastly easier to focus than a slower lens, especially in marginal light; that it can be hand-held with more confidence; and that when it is mounted on a tripod (as it normally should be) you can use faster shutter speeds for action stopping. The internal focusing also makes it much faster handling.

internal focusing which means that internally focused lenses are inherently sharper than conventionally focused lenses.

INTERCHANGEABLE AND FAST-FOCUS MOUNTS

A very few manufacturers have sold lens heads and lens mounts separately, and in at least two cases (Novoflex and Leitz), the heads and mounts have embodied a rapid-action 'squeeze-focus' mount. The advantages are not hard to see, especially for limited-production long-focus lenses where it is to the factory's advantage to use a common mount. At one time, Nikon offered a 400mm f/4.5; a 600mm f/5.6; an 800mm f/8; and a 1200mm f/11, all with the same focusing mount.

With the rise of low-dispersion glasses and larger maximum apertures, the cost of a simple mount relative to the cost of the whole lens has, however, become less and less significant. Also, internal focusing is not always

compatible with a common mount, though it can be made so. As a result, interchangeable heads on a single mount have become less and less common.

As for the squeeze-mount system, it has its fans but it takes some getting used to. The problem is that at first it is 'counter intuitive', at least for some people. Relaxing your grip means that you focus closer, while squeezing to the stop means that you go to infinity. When it comes to follow-focusing sporting events, or in wildlife photography, an experienced user of a squeeze-focus lens can probably out perform an autofocus camera; but, increasingly, autofocus is where it's at.

TELECONVERTERS

A teleconverter – a small accessory lens system which fits between the prime lens and the camera body – is effectively a telephoto group that is put behind a prime lens. While a teleconverter is a wonderfully small,

Land-Rover racing

Racing four-wheel-drive vehicles is a fascinating sport, but not one that you want to get too close to with a camera: muddy water, and just plain mud, gets everywhere. With reasonably fast film you do not need particularly fast lenses – both of these pictures were shot on Ilford HP5 rated at EI 650 and developed in Microphen – so the 300mm f/4 that was used here is perfectly adequate, but a modern lens like the Sigma 300mm f/2.8 is enormously faster handling than the old East German Zeiss lens that Roger used in those days. Flying mud, and wheels at improbable angles, help to capture the energy of off-road racing. Exposures were probably 1/500 at f/8 or f/11, while with Fuji 100, exposures of 1/500 at f/4 or so would have been needed. (RWH)

Kathkali dancer

A short, fast tele or long-focus lens is ideal for reportage, though it is disputable whether the extra speed of an f/1.4 lens compensates for the additional depth-of-field problems when compared with an f/1.8 or f/2, to say nothing of the extra bulk and expense, both of which can be considerable. On the other hand, anything much slower than f/2 is likely to prove too slow: we certainly do not consider our 90mm f/2.5 to be a good lens for low-light reportage. This picture of a Kathkali dancer in Ernakulam, southern India, was shot on Scotch ISO 1000 with a 90mm f/2 Summicron, wide open, with a shutter speed of 1/30 or 1/60. (RWH)

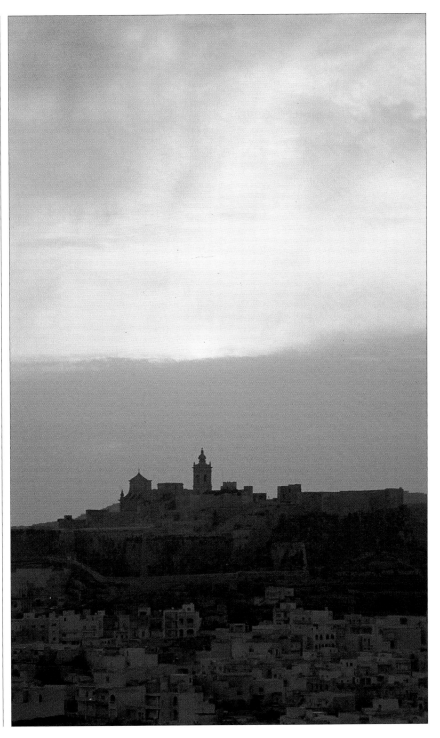

Farmhouse, Gran Canaria

Even quite modest haze, and even quite modest telephotos, can run you into problems. Roger shot this with a 200mm lens on Gran Canaria on a hazy but sunny afternoon, and the haze has flattened both colour and contrast to an extent which we find unacceptable. If you want to use lenses longer than about 135mm, you need to be constantly aware of haze, and with lenses over 300mm you will find that haze is a problem more often than not. This is why we no longer own any lenses longer than 600mm. Exposure was probably 1/250 at f/5.6 or f/8; the camera was on a tripod. (RWH)

Victoria, Gozo

The only good viewpoint for this shot of the ancient citadel of Gozo was from half-way up a hill; on the level, we just could not see enough of the fortress to make it worthwhile. This placed severe constraints on the choice of focal length. The 300mm f/2.8 Sigma would have been ideal – but this was before we got it. The 280mm f/4.8 Telyt would also have been perfect, but we were not carrying it. What we actually used was the 135mm f/2.3 Vivitar Series One with a 2x teleconverter, to give a 270mm f/4.6 which we used (on a tripod) at a marked f/8, ie a true f/16. (RWH)

light, convenient and (relatively) economical way of getting extra use out of most or all of your lenses, by increasing their focal length, it also has all the inherent disadvantages of a telephoto as compared with a prime lens: principally, reduced sharpness and the possibility of introducing pincushion distortion.

Although the optical theory behind teleconverters is surprisingly complicated, it is not too unreasonable to make the following brutal simplification: a teleconverter magnifies the defects of a lens in the same proportion as it magnifies the image. In fact, a bad teleconverter will do a lot worse than that. This is why so many modern teleconverters are only 1.4x instead of 2x; they still give a useful increase in focal length, with a 200mm becoming a 280mm and a 500mm becoming a 700mm, but the loss in image quality is less.

The other drawback of a teleconverter, along with the degradation of image quality, is that it also reduces the effective aperture of the lens. This time, it is no simplification to say that the aperture is multiplied by the power of the converter, so (for example) a 100mm f/2 lens with a 1.4x converter will become a 140mm f/2.8, while if you use it with a 2x converter it will become a 200mm f/4. If you were rash enough to use it with a 3x converter, it would become a 300mm f/6, but 3x converters are very rare today. The simple reason for this is that the quality loss when you use a 3x converter is usually so great that you can see it even on an album-sized print.

Even so, the very best teleconverters are still worth having, and even a good

but less than first-rate teleconverter can deliver acceptable image quality compared with making a sectional blow-up from part of an image. Many professionals own teleconverters, usually five-glass, six-glass or seven-glass models (cheap teleconverters may use as few as three glasses, though four would be more usual), and they use them as a way of getting out of trouble – though a professional who knew he was going to need a 400mm lens would probably buy or rent one, rather than using a 200mm with a teleconverter. The best models from independent manufacturers are normally entirely acceptable: it was the ever-increasing

Dragster, Selma raceway
A drag strip is the classic location where a fast zoom is what you need. Unfortunately, we did not have one. The 135mm was too long for most shots, but (as can be seen here) the 90mm was too short. The obvious solution is to crop the picture in enlargement, as shown by the dotted lines, but this is really only feasible if you do your own printing. With commercial prints, or with colour slides, you need the right lens. It is arguably the enormous increase in the use of editorial colour which has led professionals to embrace zooms like the 70–210mm f/2.8 Sigma Apo. Yes, zooms give a slight quality loss compared with prime lenses; but heavy cropping gives even more quality loss. (RWH)

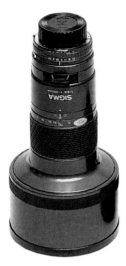

Conventional lens and mirror lens

The enormous size advantage of a mirror lens is clearly seen in this comparison of the 300mm f/2.8 Sigma and the 600mm f/8 Vivitar Series One. Because the Vivitar can be stuck in a (large) pocket, it receives disproportionately more use than the Sigma, even though the Sigma is both more useful and easier to use, to say nothing of producing a far higher percentage of usable pictures. This is no reflection on the design or build quality of either lens; it is simply inherent in the designs.

Catadioptric design

This is one of the original mirror-lens designs, a Schmidt-Cassegrain type with an aspheric front corrector plate. As far as we know, no current photographic objectives use this design (which gives an image in a reverse-curved plane, as shown by the dotted line), but the 'folded' light path is clear. It is this folding which gives mirror lenses their compactness.

quality of these which prompted the camera manufacturers to come out with their own teleconverters.

When using any lens with a teleconverter, it is generally a good idea to stop down as far as you dare. With a 200mm f/2.8 and a 2x teleconverter, you would effectively have a 400mm f/5.6 lens, and it would be a good idea to stop down to f/11 (marked f/5.6) or even f/16 (marked f/8) if you had enough light.

Zooms and Teleconverters

If at all possible, you should not use a zoom with a teleconverter, because the results will be disproportionately worse than they would be with a prime lens. Also, the slow speed of many zooms means that you rapidly run into speed problems: an f/4.5 zoom with a 2x converter will have a maximum aperture of f/9, and stopping down as recommended above would run you into f/16 or so, still with rotten results. If you must use a teleconverter and a zoom, try if you can to get a teleconverter specifically matched to the zoom in use, and use a 1.4x converter rather than a 2x if you get the choice. If you have an 80–200mm zoom, you will usually get better results by setting it to 200mm and using a 1.4x converter, rather than by setting it to 140mm and using a 2x converter.

On the other hand, a cheap teleconverter used at full aperture can provide a soft, romantic image which can be especially effective when combined with a moody, grainy film. For really soft results, combine a cheap teleconverter with a cheap zoom.

MIRROR LENSES

Although we have already described 'straight' long-focus lenses and telephotos, there is in fact a third way of building lenses with long focal lengths. Mirror lenses are exactly what their name suggests: they use a shaped mirror to create an image, just as a conventional lens uses shaped lenses. Because the light path is 'folded' as shown in the illustration below, they can be made very much more compact even than telephoto lenses. Actually, most so-called mirror lenses also use conventional refracting elements for additional correction, which is why they are called 'catadioptric' lenses. An objective which uses only refracting (conventional) elements is dioptric ('through-seeing'); an objective which uses only reflecting elements would be catoptric ('reflected-seeing'); and a lens which uses both is therefore catadioptric.

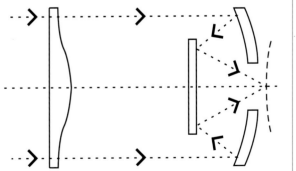

Despite their wonderful compactness, mirror lenses suffer from several disadvantages. The first is that the aperture is fixed: the few attempts to make variable-aperture mirror lenses have not been successful. The second is that they are commonly up to a stop slower than their marked aperture. The third is that out-of-focus images appear as those familiar 'doughnut' highlights, which most people hate, though there are some people who actually like them. By careful composition, this problem can however be avoided in many cases. The fourth problem is that mirror lenses are normally designed to be used with rear filters, and they *must* have a filter in the light path, even if it is only a clear ultra-violet filter. Changing the filters can be inconvenient, but what is really inconvenient is if you buy a second-hand lens and the filters are not supplied.

Although the 'doughnuts' and filters require no further explanation, the implications of the fixed aperture need to be explored a little further. This also bears upon the question of apertures being slower than marked.

Fixed Apertures

It is perfectly easy (though fairly expensive) to build fast mirror lenses: Zeiss even offers a massive 1000mm f/5.6, and experimental mirror lenses have been built with apertures of f/1 or more. The problem with fast mirror lenses is, however, the negligible depth of field. With no way of stopping down, this is even more of a problem, because it means that depth of field is effectively set at the factory. This is why mirror lenses have tended to get slower over the years. Nikon, for example, replaced its 500mm f/5 and 1000mm f/6.3

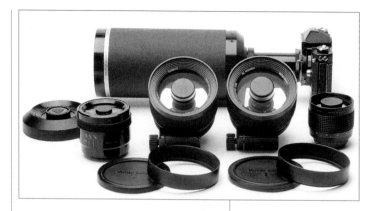

mirror lenses with a 500mm f/8 and a 1000mm f/11.

Also, depth of field is even worse than you might think, because the centre of the main mirror is blocked by the secondary mirror. To begin with, this means that the effective speed of the lens (sometimes called its transmission speed or T/number) is less than its marked aperture, and in the second place it means that you are working with a wide aperture which means reduced depth of field: you are effectively working with, say, a T/11 lens with an f/8 depth of field. You could of course compensate for the light loss by increasing the actual aperture, but depth of field suffers still further. Typically, the effective aperture of a mirror lens is a stop less than the marked aperture: f/11 for f/8; f/16 for f/11.

So much for the technicalities of lens design. What about the actual lenses?

SHORT TELES – THE 'PORTRAIT' LENS: 75MM TO 105MM

'Short tele' lenses are very highly regarded by many professionals, but they are among the least popular

Mirror lenses

The naming of cats, as T S Eliot reminded us, is a serious matter. At the back is a 1200mm f/12 Bausch and Lomb, while from left to right are a 680mm f/12 Perkin Elmer 'solid cat' prototype; a 600mm f/8 Vivitar Series One; an 800mm f/11 Series One; and a 300mm f/5.6 'generic' mirror lens bought for $75 at a photo show. The only one of this whole array that we still own and use is the 600mm f/8. The 1200 was too long and too slow; the 680 is more of a collectors' piece; the 800 was too slow, and too close to the 600 in focal length; and the 300 just did not deliver very good quality. Perkin Elmer built the Series One 'solid cats' for Vivitar; the 600mm f/8 is the only recent American-manufactured lens that we own.

Virginia Military Institute

A fast 180mm or 200mm lens is delightful for reportage, as it allows you to pick details from a scene while still hand holding the camera. On a bright day like this parade at the VMI, you can stop down for a bit more depth of field: this was probably shot at 1/500 or 1/1000 at f/4 to f/5.6. When you really begin to appreciate the extra speed is on a dull day, when you are shooting at 1/250 at f/2.8 – though the inevitable flattening of contrast that you get from using a long lens on a dull day may mean that you can get away with faster film, without the loss of quality being quite so obvious. Kodachrome 200 or Fuji 100, pushed to 200, gives a useful boost to your speed. (RWH)

choices for amateurs buying their first extra lens. This is because they are nothing like as dramatic as even a 135mm lens, let alone a 200mm, and the inexperienced photographer makes the not unreasonable assumption that longer is better – especially when the longer lenses may even be cheaper than the shorter one.

Strictly, most lenses in this group are conventional long-focus lenses: there is simply no need to use telephoto construction unless the aim is the smallest possible lens. This is why we have put 'short tele' in quotation marks. Those lenses which do use telephoto construction can be made very small indeed, but there is not much sense in this unless they are also quite slow: a 90mm f/2.8 or even an f/4. Faster

Cleaner, GUM

The 90mm f/2.5 Vivitar Series One would not really be fast enough for indoor reportage in colour, but with fast black and white film (this is Ilford XP-2) it is just about adequate. The exposure for this cleaning lady inside Moscow's GUM was probably 1/60 at maximum aperture, and the negative is a little thin. An 85mm f/2 or f/1.8 (or the 90mm f/2 for the Leicas) would have been more useful. Going the other way, an f/2.8 standard zoom would be the very slowest lens you could conveniently use; one of the slower variable-aperture lenses would have been altogether too slow. (FES)

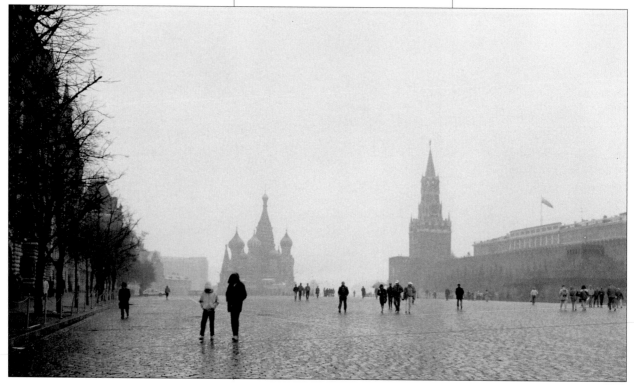

Pump

A particular advantage of a long lens is that it enables the photographer to keep his (or in this case, her) shadow out of the picture. Frances spotted this old cast-iron pump (which still works) at Blakely's Battlefield State Park in Alabama, and shot it with her 90mm f/2.5. The shadow is an integral part of the composition, and it would have been very awkward if she had introduced her shadow as well. Exposure was probably 1/250 at f/8 to f/11. (FES)

Red Square

Faced with the enormous expanse of Krasnoya Plotschad (Red Square), the natural inclination of most people is to reach for a wide-angle. As Frances demonstrates with this picture, though, a longer lens can be a great deal more effective. She shot with a 90mm lens from just in front of GUM. The domes of St Basilius and the clock-tower over the main entrance to the Kremlin would have been reduced to insignificance had she used a wide-angle. Also, the 90mm beautifully captures the greyness of the start of the Russian winter: the aerial perspective and the shiny wet cobbles capture the way Red Square feels in November. (FES)

lenses are going to be fairly fat anyway and, besides, building a fast, short telephoto is more trouble than it is worth.

At the shorter end of the range, 75mm to 85mm, it is quite common to find fast or very fast lenses: f/1.4 or even f/1.2 may be available, and few lenses are slower than f/2. Overwhelmingly the most common focal length today is 85mm, though 75mm lenses have been made (principally for rangefinder cameras) and there are also some 80mm lenses. By 90mm, f/1.8 or f/2 is more usual, or even f/2.8; and 100mm and 105mm lenses are much the same, with f/2.5 or f/2.8 predominating. If you find anything slower, it will either be very old, or a macro lens: macro lenses are covered in the next chapter.

Almost all lenses in this range are very sharp indeed, and to some extent they may be taken to be the optimum

combination of speed and focal length. Because they are significantly longer than 'standard', it is easy to make them sharp, and because they are not so long that high speed would make them unwieldy, they are easy to make fast.

Despite their reputation as portrait lenses, they are useful for many other subjects. Photojournalists use them extensively, and it is surprising to learn how many landscape photographers use longer than standard lenses.

Because they are not particularly popular lenses for the mass market, most short tele lenses made today tend to come from camera manufacturers, with the exception of a few macro lenses.

Older Lenses

In general, older short teles are a bargain. They may not be as fast as their modern counterparts, but they are mostly very sharp and very modestly priced: the old 105/2.5 Nikkor, for example, can sometimes be found absurdly cheap, and neither the 85/2 nor the 85/1.8 Nikkor is particularly expensive on the second hand market. The only commonly encountered short tele which is less than excellent is the old 85mm f/2 Jupiter Russian lens, which is pretty much a pre-World War Two Zeiss Sonnar. Stopped down, it is quite sharp; wide open, it makes a very good portrait lens.

Verdict

Some people cannot imagine life without short teles while others use them very seldom. The authors represent both camps. Roger uses them less than his 35mm and 21mm lenses, while Frances uses her 90mm f/2.5 Vivitar Series One all the time. If you

find yourself constantly wanting to pick out details, a short tele can be an excellent alternative to either a standard zoom or to the usual 70–210mm or 80–200mm tele zoom; smaller, lighter, handier, sharper and faster – *especially* sharper and faster.

You may also find that instead of the old photojournalist's trinity of 35mm–50mm–90mm, you get on very well with a real wide-angle (20/21mm or 24mm), a fast 35mm and a fast 85mm.

NEITHER ONE THING NOR THE OTHER: 135MM

The 135mm lens almost certainly owes its popularity to the fact that 135mm was the longest which could be reliably coupled to a rangefinder camera. When reflexes took over, it was an easy matter in most cases to transfer the 135mm lens to a reflex mount, and to continue to use it. Most 135mm lenses are true telephotos, though a few are straightforward long-focus designs.

Because this focal length is so easy to design and to build, even moderately priced 135mm lenses can deliver excellent quality. The only problem is likely to be speed: f/2.8 is commonplace, but if you start to go much faster, there is an alarmingly rapid rise in size, weight and cost.

Frances

Although 135mm is frequently described as a 'blah' focal length, it does have its uses; and one of the best of them is for 'large head' or at most 'head-and-shoulders' portraits. A simple lighting set-up, consisting of one lamp and a reflector, is enough to create portraits to be proud of – or at least, ones that the sitter can live with. Admittedly, if you own a 70–210 or similar zoom, you have no need to buy a separate 135mm lens: this was shot with the Sigma 70–210, and the actual focal length selected was about 145mm. An inferior zoom might be more flattering, though; there can be such a thing as too much sharpness in some portraits. (RWH)

Hotel, Gran Canaria

Frances normally travels with her 35mm f/2.8 PC-Nikkor on one camera body, and her 90mm f/2.5 Vivitar Series One on the other. This is a 90mm shot taken in Puerto Rico on Gran Canaria. While 35mm and 90mm are the classic reportage lenses for 35mm, she finds that the added versatility of her two lenses (the perspective-correction facility and the macro facility) are worth more to her than raw speed. Roger, on the other hand, uses a 35mm f/1.4 Summilux and a 90mm f/2 Summicron. Yet a third option, which would be very economical indeed, would be a second hand 35mm f/2.8 Nikkor and a second hand 105mm f/2.5 Nikkor, both of which are unfashionable, old, and very sharp. (FES)

Parascender, Three Rivers, California

Sometimes, having the right focal length for a particular shot is a matter of sheer luck. We saw this parascender in Central California, and the only long-focus lens we had with us was also the longest we owned at the time: a 280mm f/4.8. Our viewpoint was severely constrained, because there was a great deal of reservoir between us and the boat, but the 280mm was just about perfect. It enabled us to capture the boat, the parascender, and just enough background to give it all context. Now, we would probably use a 200mm lens with a 1.4x converter or (if we had set out with a full complement of lenses) the magnificent 300mm f/2.8 Sigma. (RWH)

Very occasionally, you may find 127mm (5in) and 150mm lenses, usually in older mounts for cameras like Exakta. Much the same applies to these as to 135mm, except that they are usually even slower. One of the most common 150mm lenses, for example, is an f/5.5 Schneider.

Older Lenses

Because 135mm is such a 'blah' focal length, and because the 135mm prime lens has to a large extent been replaced by zooms, used 135mm lenses are a drug on the market. Even big names like Nikon and Canon are not expensive: the f/2.8 models are modestly priced, and the f/3.5 versions are super-sharp but very unloved. Even among cheaper lenses, you are likely to

encounter excellent results unless the lens has been very badly knocked, or unless you buy one of the older fast (f/1.8) independent lenses. These are, quite honestly, soft. If you want a sharp, fast lens it is going to be expensive, reflecting its limited appeal; few are sold new, so few appear on the used market. A very good buy, though, can be the old Vivitar Series One 135mm f/2.3. The improbable f/2.3 aperture is only a third of a stop slower than f/2, and the lens remains reasonably sized and reasonably priced. It also focuses to about one-third life size.

Verdict

Most photographers find that a 135mm lacks both the handiness and intimacy of a short tele and the real pulling

power of a 180mm or 200mm lens. While it is a lens for which you will find uses if you own it, it is certainly not a lens to buy too early in your photographic career. You may however find a second hand 135mm lens at a price you cannot resist. Go ahead. Buy it. As we say, you'll find a use for it (they are good for large-head portraits, for example). But it is not a lens that most people really need.

THE LONGEST HAND-HELD LENSES: 180MM AND 200MM

Most 180mm and 200mm lenses are designed as true telephotos (as distinct from being long-focus designs) in the interests of compactness. They can be made reasonably fast, up to about f/2.8, without either the price or the weight becoming impractical, and they can be very useful for general photography. We use our 200mm lens for landscapes and cityscapes (picking out details again); for reportage (picking out celebrities); and to compress perspective, for a dramatic 'stacked' effect.

For some reason, 180mm lenses are commonly f/2.8 – probably a result of tradition, because the 180/2.8 Olympic Sonnar was the first fast 180. The Olympics in question were the 1936 Berlin games… At 200mm there are some f/2.8 lenses, but there is also an older tradition of f/3.5, f/4 or even f/4.5 lenses. Because of the 'sex appeal' of the newer, faster lenses you can sometimes find older lenses like the excellent 200mm f/4 Nikkor at very good prices.

Of course, if you really want serious speed, you can buy a 200mm f/2 or even a 200mm f/1.8, but it will cost you two or three times as much as a top-of-

the-line SLR, which explains why most of these 'glamour bottles' are bought by newspapers and magazines. Most people, though, do not need this kind of speed: after all, most 200mm lenses are used out of doors, and even f/4 is fast enough for most applications.

Older Lenses

As with 135mm lenses, you can find some bargain-priced lenses from independent manufacturers which are very sharp indeed, though they will be more susceptible to knocks and bumps than their dearer brethren. Today, with zooms of roughly equal speed replacing the older prime lenses, the prime lenses may be very cheap indeed. The only 180mm lens or 200mm lens which has ever really disappointed us is the old East German 180mm f/2.8 – which again is not surprising, given that it is that very same 1936 Olympic Sonnar, albeit coated!

Verdict

While it is true that there are many things you can do more effectively and dramatically with yet longer lenses, the great advantage of the 180mm and 200mm is that they can be hand held with confidence in many situations. Longer lenses may offer more pulling power, but unless you use a tripod, you are inviting unsharpness due to camera shake.

Unless you need the speed, an ordinary, good 80–200mm zoom is probably a more useful lens than a slow 200mm prime lens, and the only reason to buy a 200mm prime lens is to get that extra speed; a 200mm f/2.8 prime lens will be sharper and lighter than an 80–200mm f/2.8 zoom, and maybe half the price.

Drawbridge counterweights

A long-focus lens which focuses reasonably close will sometimes enable you to 'see' details which would otherwise escape. This was shot at the fort at St Augustine in Florida, using the 135mm f/2.3 Vivitar Series One; it is part of the counterweight system for the drawbridge. There are always going to be depth of field problems when you are shooting relatively close-up subjects with a lens of this focal length, even if you stop well down. This was probably shot at f/11, with a shutter speed of 1/250 or 1/500 second. (FES)

Banks of the Ganges

When you are shooting from a boat you do not normally want to use excessively long lenses: the risk of camera shake is simply too great. Frances almost certainly shot these bathers on the banks of the Ganges with our original 135mm f/2.3 Vivitar Series One, a few days before it was stolen on the Delhi-Dehra Dun train, and the longest lens we used on that trip was a 200mm. She was probably shooting at about 1/1000 at f/2.8 to f/4, in order to reduce camera shake to a minimum, which led (as you can see) to depth of field problems: she focused on the shimmering reflections, and thereby 'lost' the actual bathers slightly. A faster film than Kodachrome 64 would have allowed a smaller aperture at the same shutter speed, but colours would not have been so saturated. (FES)

LONG TELES: 280MM TO 400MM

Once again, unless you want tremendous speed, these lenses are easy to make: one of the authors has used a 300mm f/5.6 'no name' lens which was astonishingly good, despite its very low original price. The big problem is speed: at 280 or 300mm, anything much faster than about f/4 is likely to be enormous and expensive, and at 400mm even f/4.5 is pretty massive.

Gettysburg

There is no doubt that conventional lenses give better results, under most circumstances, than mirror lenses – but they are extremely bulky. These two shots are both of Little Round Top at Gettysburg, the turning point in the War Between the States. If the Yankees had been half an hour later in securing this high ground, the northern line would have been rolled up and the South would have won. One shot was taken with the 200mm f/4.8 Telyt, and the other with a 400mm f/5 Telyt. Both exhibit excellent edge-to-edge sharpness, but you are looking at about 5kg (11lb) of lenses. There is a picture of the 400mm on page 56. (RWH)

Air Day, RNAS Yeovilton *(left)*

Air day displays are extremely hard to photograph. If you want to show the planes in detail you normally need very long lenses, and you find that you have a choice between detail in the plane and a washed-out sky, or a rich blue sky and a plane reduced to a silhouette (as here). This was probably taken with a 200mm lens, because it was the longest that Roger owned at the time, but using the smoke trails as a part of the composition means that the picture is both dramatic and clearly recognisable. It is all too easy to underestimate the focal length you will need to provide real pulling power when you are photographing distant subjects. (RWH)

Sure, you can buy a 300mm f/2 and a 400mm f/2.8, but if you bought the pair, you could have a car instead for the same money.

A couple of independent makers offer 300mm f/2.8 lenses, which can be used with matched teleconverters to give a 450mm f/4 or a 600mm f/5.6 – an extremely good idea. Provided the teleconverters are specifically designed for the lens in question, results can be very acceptable, and the high speed of the basic 300mm lens is very attractive. You can put together similar outfits from some marque manufacturers, but the prices are terrifying: even the independent lenses cost more than a top-of-the-line SLR.

Contrast and Lens Design

By the time you get to 300mm, a common problem is atmospheric haze. Unless you are shooting a nearby subject, or unless it is a sparkling-clear morning, you may well end up with flat, dull-looking pictures. Often, the lens is blamed for this when the atmosphere is the real culprit. On the other hand, a simple high-contrast lens may well give better results than a fast, complex true telephoto. This is why old Novoflex lenses are so highly regarded: edge sharpness is frankly poor, but central sharpness is excellent and contrast is very high. The lenses are very simple indeed: the 400mm f/5.6 is

St Mary's, Reculver

The ruined towers of St Mary's at Reculver in Kent are about three or four miles from where this picture was taken, using the Vivitar Series One 600mm f/8. The camera was mounted on a massive Linhof tripod, weighing about 10kg (22lb). There is very little contrast in this picture, even though a yellow (x2) filter was used to cut through the haze. Exposure with the yellow filter was 1/500; with a red filter and an exposure of 1/250, atmospheric shimmer (together possibly with vibration at the longer shutter speed) took the edge off the sharpness. Admittedly, it is just about possible to recover the contrast in black and white by careful processing and printing, but in colour your only choice is to use a slow, contrasty film. The problem then arises that with a slow film you need a slow shutter speed: 1/60, or at best 1/125, with Kodachrome 25 in bright sunlight. Then you are back into problems with vibration and atmospheric shimmer. The problems are nothing to do with the lens itself; they are simply a consequence of trying to photograph a subject several miles away. (RWH)

just a cemented doublet. Leitz followed the same route for their long lenses. Nikon's long-gone 500mm f/5 non-mirror lens was a straightforward three-glass, three-group design: a Cooke Triplet, in effect.

Older Lenses

Until the 1980s, very few people bought lenses in these focal lengths, which means that there are not very many older ones about. The ones that you do encounter are however likely to be eminently acceptable. There have been some East German lenses which were disappointing, it is true, but they were pre-World War Two designs: just about anything designed since then is likely to be fine.

Occasionally, you may find dinky little 300mm f/5.6 mirror lenses. These are wonderfully compact, but most of them are cheap lenses which have not stood up well to wear and tear: they are often not sharp. Also, the temptation to hand hold them is irresistible, and it just isn't a good idea.

Verdict

Although they are interesting to use, the majority of lenses in these focal lengths are so big and heavy and expensive that you really need to be a specialist sports or wildlife photographer in order to justify owning one. We have owned both 280mm (f/4.8 Telyt) and 400mm (f/5 Telyt), both adapted for Nikons, but we sold them because we used them so little. For our purposes a 600mm mirror lens

Perspective compression

This picture of the Minnis pub was taken from the same vantage point, and with the same set-up, as the picture of Reculver towers on page 116. The extreme compression of perspective is typical of very long-focus lenses. The contrast and resolution are, however, quite acceptable for a picture taken across a distance of about half a mile, say 800 metres. In the original 6x enlargement you can read the sign on the side of the Minnis: 'Hot and Cold Bar Food'. The writing is 0.8mm (about $^1/_{30}$ inch) high in the print, so in the negative it is about 0.13mm or $^1/_{180}$ inch high. When you put it like that, the resolution of any modern lens is astonishing. (RWH)

(see below) and a 2x converter on a 200mm lens suffice. If we could get one at the right price, we might buy a 300mm f/2.8, but it is a big thing to lug around. Alternatively, a clutch of Novoflex lenses (240/4.5, 300/5.6, 400/5.6 and 640/9) would be conveniently light, if a little bulky, and much contrastier than the 400/5 Telyt, though the 280/4.8 Telyt was more acceptable in that respect.

ULTRA-LONG LENSES: 500MM AND ABOVE

Paradoxically, a 500mm mirror lens is likely to be more useful, to more people, than a conventional long or ultra-long lens. Certainly, it is more affordable. The conventional lens is

more versatile, and it may well be sharper; but the compactness of the mirror is a great attraction. These lenses are not very expensive, and they take up very little room, so when you want to shoot a detail, you can do it. Cheap 500mm mirrors may prove dangerously fragile, but all camera manufacturers and several independents make solid, reliable mirror lenses at comparatively modest prices – and used prices are even more reasonable. Almost all 500mm mirror lenses made today are f/8, for the reasons given at the beginning of the chapter.

Instead of 500mm, some manufacturers go to 600mm, and the difference is not very great. By the time you get to 800mm, though, you are generally looking at f/11 lenses, and

this is inconveniently slow for many applications. The same is true of 1000mm lenses.

There have even been longer lenses, but they bring still more problems. We used to own a 1200mm f/12 Bausch and Lomb, but even with the camera mounted on a first-class tripod, atmospheric shimmer destroyed sharpness, except in still, cool air. Not haze; just the movement of clear air. You sometimes see the same sort of shimmer in movies, when they shoot the setting sun with a long telephoto lens. It does nothing for sharpness! We sold the lens, and on the rare occasions when we need that sort of focal length, we put up with the incredible sloth of our 600mm f/8 together with a 2x teleconverter.

The problem with 'conventional' (dioptric) lenses of reasonable speed is that price and weight will rule them out for most people: Nikon's 500mm f/4 is a wonderful lens, but weighs about 3kg (6½lb) and costs almost twice as much as a top-of-the-line camera. The 600mm f/4 weighs about 6kg (13¼lb) and costs as much as a cheap new car. There are however plenty of low-priced 500mm f/8 'no-name' lenses around and, as with other slow, simple lenses, they can be very good indeed or, if quality control failed or they got knocked once too often, they can be very bad. They are worth buying *if you can test before you buy*.

Older Designs

One classic mirror design is the Vivitar

Cyclist, Minnis Bay

At modest distances, even a 600mm lens can give surprisingly good contrast under ideal conditions. This cyclist, resting on the sands of Minnis Bay in Kent, was shot with a Vivitar Series One 'solid cat' at its fixed f/8 aperture and probably 1/250 on Fuji 100. Going to Fuji 50 would have allowed even better contrast (at the expense of going to 1/125 second), but there would still have been a problem with depth of field. You can see the out-of-focus 'doughnuts' in the background. Also, even with a Manfrotto tripod and Slik squeeze-action tripod head, there is some degradation of image quality due to vibration. To get a really sharp shot with this lens, we really need to use our big Linhof tripod and NPC ProBall head. And who wants to carry 10kg (22lb) of tripod? (RWH)

Onion domes in the Kremlin

Ultra-long lenses can be unexpectedly useful for architectural details. Most people do not even realise that around the base of some of the famous 'onion domes' of the churches in the Kremlin there is writing in a very archaic script. This was actually taken with an 800mm f/11 Vivitar Series One, and (as so often) the tripod was not heavy enough. There is image degradation due to vibration. Locking the mirror up helps (it was not done on this occasion), but it does not remove the problem. We were surprised to be allowed to carry a tripod and a full range of lenses (17mm to 800mm) into the Kremlin, but the first time we did it, no-one batted an eyelid. Then, when we tried it again without a Russian-speaking friend, we were told it was not permitted. (RWH)

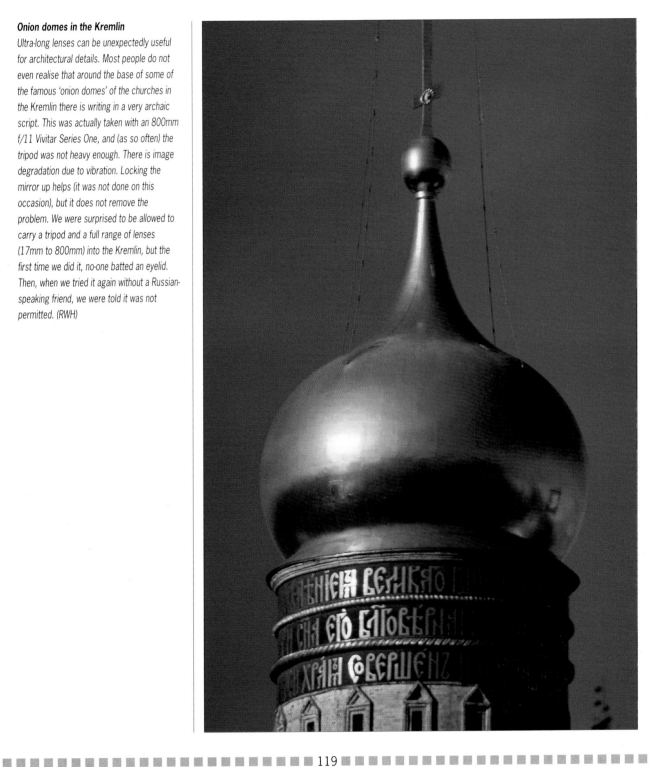

'solid cat', so called because the entire light path is enclosed in glass. These heavy, chunky, very compact lenses were built in the USA by Perkin Elmer and command a cult following today.

The other vintage design, as already touched upon, is the old Novoflex series of interchangeable-head lenses. Most were sharp only at the centre (where they were very sharp indeed), and while the 640mm f/9 is sharp across the whole field, it is also painfully slow. Sometimes you will find whole sets of these lenses, as described above; we wish we had bought the last one we saw!

Otherwise, there are very few older lenses of 500mm and above, and the few that you do encounter are usually by major marque manufacturers. Prices are likely to be high, and so is quality, but bear in mind what was said above about contrast.

Verdict

Ultra-long lenses, just like ultra-wide lenses, are mostly very specialised tools. If you really, really need one, you will know about it; and if you really, really need one, the chances are that you need one of the fast 'glamour bottles' for sports or wildlife. Although you can do an astonishing amount with the old Novoflexes, in the final analysis today's top professionals have to use today's top lenses; and that means serious

money. A modestly priced 500mm f/8 mirror lens may, however, prove more useful (or less useful!) than you expected; our advice would be to buy a used one, at the sort of price where you can resell it without taking too much of a loss. If you later decide that such a lens is important to you, you can either buy a new one or look out for a 'solid cat'.

GUNSTOCKS: A WARNING

'Gunstock' or 'rifle' mounts, which allow you to aim and steady a long-focus lens like a rifle, are very useful; but in the wrong circumstances they can be dangerous. As early as the 1930s the original Leitz gunstock (the Leitz catalogue code word was RIFLE) was effectively banned in Germany, because there were too many people who were less interested in shooting the Führer on film than in shooting him through the head; and in our modern terrorist-ridden days, there may still be guards who are inclined to shoot first and investigate afterwards. For wildlife and sports, gunstocks are rarely a problem; but for news photography, it is a good idea to notify the police and security services first, and possibly even to emulate the example of the photographer who paints his ultra-long lenses bright orange and wears an orange tabard with PRESS written on it.

7 SPECIAL PURPOSE LENSES

Macro lens

Easily the most convenient form of macro lens is the purpose-built lens in a continuous focusing mount, like this old 90mm f/2.5 Vivitar Series One. It focuses to half life size (1:2) at 40cm/15in subject distance, as shown, and is used with a matched optical unit (not shown) to focus from half life size to 1:1 at 35.3cm or 13.8in. In practice, we find that we very rarely need the range between 1:1 and 1:2. We normally use the bellows unit for larger magnifications than 1:2 (especially for slide duplicating) and the macro lens for smaller magnifications.

Warehouse interior

The principal use of a circular-image fish-eye in normal photography is to jazz up a dull subject. Even something like this Bristol warehouse gains a certain interest: the shapes are dramatic and interesting. Tilting the camera slightly makes the composition even more dynamic; there is no need to worry about converging verticals, of course! The lens in question was the remarkable 8mm f/2.8 Nikkor, with its huge curved front element. The high speed means that hand holding the lens is entirely feasible, and resolution at full aperture is astonishingly good: this was shot on HP5 rated at EI 650 and developed in Microphen. Roger's feet are visible at the bottom of the picture. This was one of his first attempts to use a fish-eye, in the late 1970s. (RWH)

Zooms, telephotos and wide-angles are the only lenses that most people ever consider – but there are a number of other special-purpose lenses which professionals use in order to get results or effects which are either unobtainable in any other way, or which are much easier to obtain with these lenses. They include macro lenses; ultra-fast lenses; shift lenses; fish-eye lenses; soft-focus lenses; and, surprisingly enough, really bad lenses. There is also a residual category of lenses which are rarely used professionally (or by anyone else!), including pan-focal lenses, pinholes, flash lenses and variable-field curvature

lenses. These are covered at the end of the chapter; but for now, let's examine the extraordinary statement that some professionals deliberately use bad lenses.

REALLY BAD LENSES

More than one professional has built a distinctive style on a single really bad lens – one that is soft, flary, and would be rejected out of hand by most photographers. Used with the right film stock and the right exposure and the right processing, this lens can produce a trade-mark style that is, at

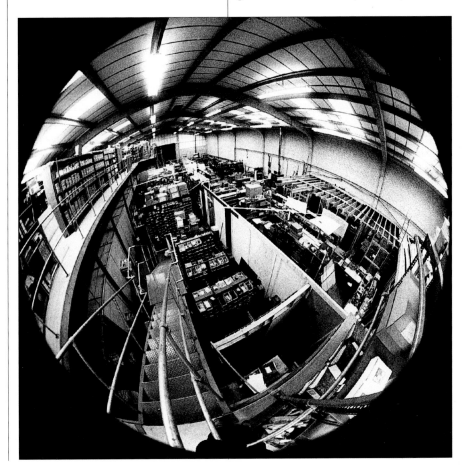

least for a while, greatly sought after by art directors, advertising agencies and clients. Generally, these lenses are either very cheap zooms, or they have been damaged in some way. One London photographer, for example, made his name with a Hasselblad 150mm Sonnar which looked as if it had been cleaned with wire wool.

A few 'trade-mark' lenses are merely old: for example, we own an old 50mm f/1.2 Canon rangefinder lens, probably dating from the 1950s, which is truly awful wide open. You cannot use it on a reflex body, of course, but you can use it on a cheap Russian rangefinder camera or (with an adapter) on an M-series Leica, and it produces results which are all but impossible to duplicate. Another lens that is sought after is the original 58mm f/1.4 for the Nikon F: centrally sharp, but with impressive field curvature and significant flare. The slightly longer than standard focal length forces a particular way of 'seeing' which can be exploited by the right photographer.

Because the way in which these lenses are used is so personal, it is impossible to make any hard and fast generalisations about them. We use the old Canon (and a Russian 85mm f/2 that is nearly as bad) with fast, grainy Scotch/3M films. When used with ISO 1000 daylight and ISO 640 tungsten film these two lenses create wonderfully soft, romantic images. Other photographers overexpose and underdevelop transparency films, 'pulling' instead of 'pushing' in order to get flat yet curiously rich colours, reminiscent of old paintings. Yet others use badly corrected lenses with infrared film. The possibilities are endless. The only reason for mentioning such

lenses here is to alert you to the potential which can exist even in lenses which are normally regarded as poor. If you find a cheap, bad lens, by all means experiment with it to see if it will create some sort of unique effect that you like.

Cheap Teleconverters
A cheap teleconverter can have the same effect as a bad lens – and if you use the two together, you can get almost unbelievably poor quality.

Neutral-density Filters
Many 'bad' lenses lose their desirably bad characteristics when they are used at modest apertures. Our old f/1.2 Canon, for example, is remarkably good between f/2 and f/11, though at f/16 it begins to deteriorate and by f/22 it is awful again.

If this is a problem, remember that you can get neutral density (ND) filters in a very wide range of strengths. The widest range probably comes from B+W: their 1000x filter allows you to

Julie Dunsford
We cheated on this: it was shot with a 150mm soft-focus lens on a Mamiya RB67, roughly the equivalent of 70mm on 35mm. You can see how a true soft-focus image differs from out of focus (or from camera shake!) by the way that fine detail such as the model's hair behind her face is held; a sort of halo of light appears around all the highlights. We have only very limited experience with soft-focus lenses for 35mm, but we have found that they are even trickier to master than soft-focus lenses for medium and large format. (RWH)

Paris
There are two or three other pictures in this book which were taken with our favourite 'rotten lens', the 1950s-vintage 50mm f/1.2 Canon rangefinder lens which fits via an adapter on to our Leicas. In this one, the flare and the rain, and the softness and the grain of the ISO 1000 film seem all to work together to sum up Paris on a rainy evening. Some day we plan to go to Paris armed only with our three worst lenses: the Canon and two Russian lenses, a 20mm f/5.6, and an 85mm f/2. Shooting exclusively on Scotch ISO 1000 film, we hope to get some of the best 'bad' pictures anyone could wish for. (RWH)

Supermodel contest, Moscow
The 90mm f/2 Summicron was just fast enough to capture the entertainers at Moscow's supermodel competition (where Roger's 21mm f/2.8 Elmarit-M was stolen), but an 85mm f/1.4 might have been even better; this was about 1/60 wide open on Scotch ISO 1000. Another possibility would have been a 135mm f/2, which would 'pull up' the middle of this picture, but which is a very big and expensive piece of glass and which greatly increases the risk of camera shake. If you regularly find yourself running out of light, ultra-speed lenses may well be worth the extra cost and weight to you. We always find it astonishing when people say, 'I never shoot at wider than f/5.6, therefore no one needs faster lenses'. (RWH)

use ISO 1000 film in bright sunlight with an exposure of 1/250 to 1/500 at f/1.2.

ULTRA-FAST LENSES

At most focal lengths, you have a choice of apertures – and the more speed you want, the more money you are going to have to spend. In *Low-Light and Night Photography*, (David & Charles, 1989), Roger categorised these as normal, fast, and silly money, and it is worth drawing up a similar table here:

Focal Length	Normal	Fast	Silly Money
24mm	f/2.8	f/2	f/1.4
35mm	f/2.8	f/2	f/1.4
50mm	f/1.8 – f/2	f/1.4	f/1 – f/1.2
75mm – 105mm	f/2.5 – f/2.8	f/1.8 – f/2	f/1.2 – f/1.4
180mm – 200mm	f/3.5 – f/4	f/2.8	f/2
280mm – 300mm	f/4.5 – f/5.6	f/2.8	f/2
400mm	f/5.6	f/4	f/2.8

In general, the very fastest 'silly money' lenses are not a practical buy. They are much more expensive than ordinary 'fast' lenses; they are often less sharp (unless they are very expensive indeed); they are typically very big and heavy; and even if all those disadvantages do not put you off, you may well run into severe depth of field problems. A 50mm f/1, for example, cannot hold an eyelash in focus from front to back at 1m (39in).

Unless you have a particular need for an ultra-fast lens, therefore, you may well find that you are better served by an ordinary 'fast' lens – or, for that matter, if you do most of your photography out of doors, by a 'normal' speed lens. The only general exception we would make is the 35mm f/1.4, which (as already hinted) makes a superb all-purpose lens. Even then, a 35mm f/2 is likely to be plenty fast enough for most people.

After the 35mm f/1.4, our next recommendation would be an 85mm f/1.4, *if* you habitually use the lens for reportage in poor light. Not only does the extra speed reduce the likelihood of camera shake, by allowing you to use a shorter shutter speed, it also makes it significantly easier to focus. We repeatedly toy with the idea of buying an 85mm f/1.4 for the Nikons, but we don't really need it.

And although we haven't tried it, because it is available only for Canon cameras, we know people who have used the 24mm f/1.4 and speak very highly of it. Certainly, it sounds like a fascinating and versatile lens for reportage, but at that price, so it

Linda and Greg's wedding

Do not underestimate flash! Rather than buying expensive high-speed lenses, remember that if you use it properly, flash can seem remarkably natural. The important thing is to balance the flash and the ambient light, so that the background does not go completely dark. For this picture, Frances set our Metz 45 CT-1 for auto-exposure at f/2.8, rather than at a smaller aperture, so that the background would not disappear as it would have with more power. On the far right, Linda Tresize unwraps a wedding present, with her husband Greg seated beside her. Between the happy couple stands Roger, with two Leicas and a dishevelled beard. The picture was taken with a 35–85mm f/2.8 Vivitar Series One on Ilford XP-2. (FES)

Tattoo Contest, Iron Horse Saloon
The big advantage of a fast lens over a flashgun comes when you want to photograph several things at widely different distances from the camera. Frances shot this tattoo competition at the Iron Horse saloon at Daytona in Florida, using a 35mm f/1.4 Summilux; exposure was probably 1/60, or possibly 1/30, wide open on Ilford XP-2. With flash there would have been appalling flare off the stuff in the foreground, which would also have been totally burned out and far too bright. With the fast lens, though, depth of field is considerable – you can even read the sticker for EX-NUNS IN DRAG – and the full context of the stage is visible. (FES)

should. Also, given that you can often hand-hold a 24mm lens at speeds as long as 1/15 second and still get sharp results, the need for an f/1.4 is not very great; even an f/2, used with a 1/15 second shutter speed, is the equivalent of a 50mm f/1.4 held at a considerably riskier 1/30.

At 135mm and beyond, 'silly money' lenses are all but indispensable for some kinds of photography – principally sports – but they are an increasingly expensive waste of money for general photography.

Fast Film and Fast Lenses

A common argument is that with modern fast films you don't need fast lenses any more. This is not strictly true. There are at least three very good reasons for preferring fast lenses in certain circumstances.

The first is that while modern fast films are good, modern slow films are even better. If you can use ISO 100 film instead of ISO 400, or even ISO 200, you will get better colour saturation and more sharpness.

The second is that at the limit, a combination of fast film *and* a fast lens is more versatile than fast film and a slow lens.

The third is that if you shoot many low-light pictures, a fast lens can actually save you money as well as delivering better quality, because slow films are cheaper than fast films. At the time of writing, the difference between ISO 100 and ISO 200 Ektachrome (one stop in speed) would pay for the difference in price between a Nikkor 24mm f/2.8 and a Nikkor 24mm f/2

(one stop again) in about two hundred films. That is a lot of film, but it's only four years even at a modest fifty rolls a year. A professional might recoup the cost in a few weeks.

The 'Inferior Quality' of Faster Lenses

As already suggested in Chapter 2, even the fastest lenses from the very best manufacturers are not necessarily inferior to the slower lenses from the same manufacturers: they are just a lot more expensive. When it comes to the ordinary fast lenses (the ones in the middle column in the table on page 123), these are frequently better than the 'normal' ones because of more expensive glasses, more exotic design, and more recent design.

Also, even if there is any inferiority, it does not necessarily matter very much. For example, the non-aspheric 35mm f/1.4 for Leica rangefinder cameras is notoriously less sharp at wide apertures than the 35mm f/2. On the other hand, the two lenses are indistinguishable at f/4 to f/8, which are the normal working apertures in good light, and in poor light there is simply no contest at f/1.4. It is only at f/2 to f/2.8 that there is even a contest.

Older Lenses

Old, fast lenses are rarely as good as new, fast lenses, and some of them, even from major manufacturers, are frankly disastrous. If you want speed, then buy a recent (post 1980) lens.

MACRO LENSES

'Macro' is one of the most abused terms in photography. Strictly, it means photography of subjects at life size or larger on the film. In other words, a beetle 25mm (1in) long in real life should be 25mm (1in) long (or longer) on the film. It is however used to mean 'close focusing' – and once a word is misused it is hard to say when the misuse becomes too great. As a working guide, we suggest that any macro lens should be able to record objects at one-half life size (a 25mm/1in beetle is 12.5mm/1/$_2$in long on the film), while a lens which cannot focus down to one-quarter life size (6.5mm/1/$_4$in for our 25mm/1in beetle) cannot decently be called macro at all.

There are many ways to achieve close focusing, and some are both more

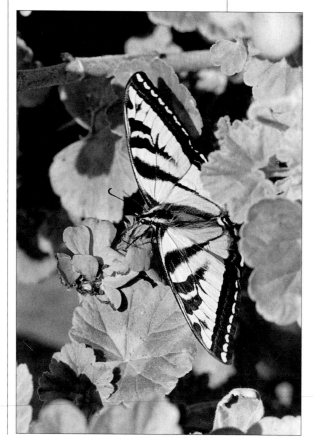

Butterfly

The easiest way to focus in the macro range is to pre-set both focus and aperture, and then move the whole camera to and fro to focus. Depth of field is so shallow that the point of precise focus is not hard to see! This was shot with a 200mm Vivitar Series One, pre-set to its closest focusing distance of about one-quarter life size. Long macro lenses, like Sigma's 180mm f/2.8 and 180mm f/5.6, allow even better close-ups while still preserving a working distance which will not frighten the subject away. The reason this was not shot with a macro lens was that Frances saw the butterfly in the garden; rushed into the house; grabbed the first camera that came to hand; and went out and shot. This a good argument for keeping your camera gear accessible, as well as ready for use. (FES)

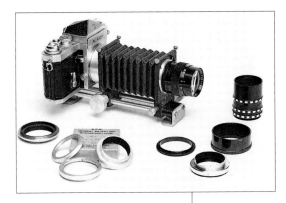

Enlarger lens on bellows

A reasonably long-focus enlarger lens on a bellows is second only to a purpose-made macro lens for convenience and sharpness. This is a 105mm f/4.5 lens on a BPM bellows. The combination will focus continuously from infinity to rather bigger than life size, allowing a reasonable working distance at its closest focus. The only real inconvenience is the click-stop diaphragm. The BPM unit can be fitted with almost any camera and almost any lens; and if you want to get still closer, you can use Nikon extension tubes at one end and Leica-fit extension tubes at the other.

convenient and sharper than others. Beginning with the sharpest and most convenient, there are purpose-made macro lenses in close-focusing mounts. Then come purpose-made macro lenses for bellows use, which are as sharp, but less convenient. So-called macro zooms are as convenient, but usually much less sharp. The other possibilities, which are also worth considering, are the use of camera (or enlarger) lenses on bellows, and the use of supplementary lenses.

MACRO LENSES IN LONG-THROW MOUNTS

The closest focusing distance of most lenses is about equivalent to ten focal lengths: 500mm (20in) for a 50mm lens: 200mm (8in) for a 20mm lens.

The reasons for this are simple. First, the marked speed begins to decrease noticeably as you focus closer: you lose about a third of a stop when you focus closer than ten focal lengths, and the loss rapidly becomes worse. Second, long-throw focusing mounts are necessarily bigger, heavier and more expensive than normal-throw mounts. Third, it is increasingly difficult to retain all optical correction and freedom from aberrations as you focus closer.

This is why macro lenses are bigger, heavier and more expensive than non-macro lenses; why exposure compensation is required (though some old 55mm f/3.5 Micro Nikkors had an ingenious mechanical compensator which physically opened the diaphragm as the lens was focused closer); and why, in order to allow maximum sharpness throughout the focusing range, they are slower than non-macro lenses. For instance, a 105mm f/2.8 Micro Nikkor was at the time of writing roughly comparable in price with a 105mm f/1.8 non-macro lens.

There is however nothing which can give the same combination of sharpness and convenience as a purpose-made macro lens in a long-throw mount. You use it just like an ordinary lens, except that it focuses closer. If you are serious about macro, this is what you need.

Although the sharpness of the 50mm f/3.5 and later 50mm f/2.8 Micro Nikkors is legendary, many people actually prefer longer focal lengths. These allow more stand-off between the photographer and the subject, which is useful if the subject is timid or if it bites or stings. Also, more stand-off generally allows easier lighting. Longer macro lenses are available from 80mm to about 200mm, via at least 90mm, 100mm, 105mm and 180mm, and are extremely sharp at infinity as well as in the macro range.

It is also worth remarking that our 135mm f/2.3 Vivitar Series One focuses to about one-third life size, and the 200mm f/3 Vivitar Series One to about one-quarter life size. While these are not true macro lenses, they focus as close as you need to get in many circumstances, and we have found image quality to be remarkably good. Although these particular lenses are long discontinued, there may be others. If close focusing is important to you, then always check when you are considering a new lens.

Purpose-Made Bellows Lenses

There are a few lenses which are designed to be used only on bellows, and most of them are designed to be used only in the macro range; Zeiss, Leitz, Pentax and others make lenses with focal lengths as short as 10mm, which permits very large magnifications on the film but which precludes infinity focus. There are a few lenses, typically around 100mm in focal length, which can focus to infinity.

While these deliver superb quality, they are hardly convenient and they are very expensive if bought new. If you can find them used, though, they can be surprisingly reasonably priced – a fact which reflects their limited usefulness. Most people who need them are working in research institutions; if you need one of these lenses, you probably already know of their existence. The main reason for mentioning them here is so that you can identify them if you see one for sale.

Macro Zooms

There is one zoom which delivers really high quality in the macro-focusing range, at least under the relaxed definition of 'macro' offered above. It is the long-discontinued Vivitar Series One 90–180mm f/4.5 Close Focusing Flat Field Lens. Slow, heavy, and with a limited zoom range, it focuses to one-half life size at 180mm and one-quarter life size at 90mm. It was a complete flop when it was introduced, and the last few lenses were sold off at about one-quarter of the hair-raising original price. Today, it enjoys cult status and sells for a great deal more than the original price. If you find one at a reasonable price, and if you need a close-focusing lens, buy it!

Other macro zooms range from the acceptable to the abysmal, both in features and in performance. Many operate as macro lenses only at one end of their focusing range; many do not focus very close anyway; some require a separate macro ring or lever to be operated; and you should never buy any of them specifically just for macro use. Nor should you even take the macro claim seriously without testing for yourself. We have never encountered one yet which we would regard as acceptable, though some photographers (especially flower photographers) get on well enough with them. At best, you

Desert rose

Like the butterfly on page 126, this is a 'macro' picture which was not shot with a 'macro' lens. Although we had the 90mm f/2.5 Vivitar Series One macro with us, we also had the 135mm f/2.3 Vivitar Series One which focuses to approximately one-third life size. Depth of field is of course dependent solely on the size of the image on the film, not on focal length, so there was no disadvantage in using the longer lens, and the greater working distance made life easier with the tripod we had with us. For serious macro photography, the Benbo or Uni-Loc is the only sensible choice. (FES)

GN-Nikkor on reversing ring

Reversing rings are exactly what their name suggests. This is a 45mm f/2.8 GN-Nikkor reversed with a Nikon BR-2 ring and used with a Nikon K-ring extension tube set on an old Nikon F. If you want to photograph a lot of things of roughly similar size, a set-up like this is much cheaper than a purpose-built macro lens, and just as sharp for all practical purposes. The disadvantage comes when you need to change magnification ratios, which means swapping extension rings. If you are photographing, for example, coins or stamps or the interiors of pocket-watches, you need to sort your subjects into groups of similar size in order to avoid excessive ring swapping – which can be a nuisance if it means photographing a collection out of sequence.

should regard the macro facility as a (moderately) useful bonus on a lens generally used for other purposes.

Camera and Enlarger Lenses on Bellows and Extension Tubes

If you want high-quality close-ups, through to life size and beyond, consider a bellows. Some camera lenses are very much better on bellows than others: as a general rule, the best are modest-speed lenses of 50 to 105mm, such as a 50mm f/1.8 or f/2, or an old 105mm f/2.5 Nikkor. Because these are neither telephoto nor retrofocus lenses (see page 28), they continue to behave well even when they are used for purposes for which they were not really designed. The worst bets are generally fast lenses or wide-angles, though some wide-angles are surprisingly good on bellows and of course they offer considerably greater magnification. The only way to find out is to experiment.

You can even get bellows with auto-diaphragm operation, or alternatively you can get auto-operation rings which fit on to the lens and allow you to retain diaphragm automation by using a twin-cable release.

Less convenient, but frequently offering better quality than camera lenses (and at a very modest price), enlarger lenses mounted on a bellows are a common professional trick for low-cost close-up photography. Instead of buying marque bellows, look for proprietary models with interchangeable camera and lens mounts: BPM (Butterfield Photographic Manufacturing) in

England make a tremendous range of adapters, and will custom-make even more, to allow the use of virtually any lens with virtually any SLR.

Extension tubes are cheaper and more rigid than bellows, though the optical principle is obviously the same. They are also markedly less convenient: the magnification range you want always seems to fall between two rings, so you are forever changing them. For some applications, though, they are useful.

Reversing Rings

A reversing ring is what its name suggests: it has a male mount on one side, which fits into the camera body, and on the other side it has a screw thread which fits into the filter mount of a camera lens. The lens can therefore be mounted backwards on the camera.

Not only does this function as a modest extension tube, it also gives better image quality with many lenses. The argument is that in normal use the lens is a long way from the subject but very close to the film; so in the close-up range, where the lens is closer to the subject than to the film, it makes sense to reverse the lens. Certainly, with some lenses (such as the 24mm f/2.8 Nikkor) the results can be dramatically improved by reversing them, but with others it seems to make little or no difference. Some people reverse camera lenses when they are used on bellows or extension tubes; this makes it easier to use auto-diaphragm adapter rings and double cable releases, as already described above.

Supplementary Lenses

One of the quickest and easiest ways to get close-up images is to stick a close-up

lens on the front of a prime lens. For the best quality, though, you want two-glass (cemented doublet) close-up lenses, which are very much more expensive than single-glass close-up lenses, as well as being considerably harder to find.

You will also get better quality if you use the close-up lens on a sharp prime lens. Once again, lenses of modest speed in the 50–105mm range are what you want. Finally, in order to get ultimate sharpness, shoot at a modest aperture: f/8 is generally best, though f/5.6 and f/11 are also very acceptable. It may be, of course, that you need to stop well down in order to get adequate depth of field, which will discourage you from using too wide an aperture!

Teleconverters

Although teleconverters are not an ideal way of focusing closer, because of the inevitable loss in quality, it is worth remembering that a 2x teleconverter retains the close-focusing ability of the standard lens while increasing the image size on the film by 2x. Many lenses will go to one-eighth life size unaided; so with a 2x converter, you are running at one-quarter life size.

Older Macro Lenses

In days of yore, macro lenses were available in a considerably more restricted range of focal lengths than today. With that proviso, they were still very sharp for the most part, and they can be used with confidence today. This holds good for lenses in

long-throw mounts and for bellows lenses. Old macro zooms are another matter: the vast majority were even worse than their modern counterparts.

SHIFT LENSES

One of the first things that any photographer learns is that if you tilt a camera upwards in order to photograph a tall building, you get a 'falling over backwards' effect. It is an interesting psychological question why we can accept converging lines in horizontal perspective but not in vertical perspective (in fact, it may be cultural rather than psychological), but, in any case, the shift lens offers a way around it.

The way it works is simple. The lens moves parallel to the film plane, and of course the image moves with it. This is easier to demonstrate with a diagram and with examples than it is to describe in words; so we will waste no more words on it.

How a shift lens works

The artwork shows you how a shift lens works, by allowing you to take a picture of a tall building without tilting the camera backwards. Dead level, the camera would miss out the dome of the church, as shown in the first drawing. Raising the lens, without moving the camera, allows you to get all the church in, as shown in the second drawing. By careful manipulation of the shift lens, it should also be possible (if you wanted) to move the image sideways so that you included the second small tree, but put the church nearer the left side of the image. Our dream lens would be a 14–90mm f/1.4 shift lens ...

PC-Nikkor

Warning: this lens can be seriously habit forming. It is the 35mm PC-Nikkor, which Frances regards as easily her most useful lens. This picture shows clearly how the lens can be decentred, using the lead screw at the bottom. Obviously, moving the lens also moves the image relative to the film. The whole front of the lens also rotates, so you can use rise, fall, cross or a combination of the two. The small numbers in front of the knurled ring next to the camera body indicate the maximum permitted shift at each setting: 11mm when used for 'landscape' shots as shown; as little as 7mm when the lens is shifted diagonally (the lead screw is graduated in millimetres). In practice, we habitually ignore these markings: the only penalty is a slight softness and darkening in the corners.

Cathedral, Mdina

One of these pictures of the cathedral church in Malta's Mdina (Città Notabile) was made in the usual way, by tilting the camera, and the other was made using the shift lens. In one sense, the difference is minor: the degree of 'falling over backwards' is slight. In another sense, the difference is enormous: one shot looks professional, and the other doesn't. Shift lenses are horribly expensive, but if you are serious about photographing architecture, they are the only alternative to going over to a larger format.

All shift lenses are expensive, and many of them do not have meter coupling or even diaphragm automation; the decentring mount makes it all but impossible to retain mechanical linkages, though electronic couplings are easier. They are, however, extremely useful and very habit-forming: most photographers who own them swear by them, which is why used examples are rare and still quite expensive. As well as controlling the falling over backwards effect, shift lenses can be racked sideways or even diagonally to give apparent viewpoints which are otherwise unattainable.

The only independent manufacturer of shift lenses, and then not for many different models, is Schneider; otherwise, you have to buy marque lenses. At the time of writing, Canon offered the best range of shift lenses (24mm, 45mm and 90mm), while Nikon offered only 28mm and 35mm. Many manufacturers did not offer shift lenses at all.

The focal lengths do not tell the whole story, though. Because of the way the lenses are used, the effect is rather akin to using the next wider focal

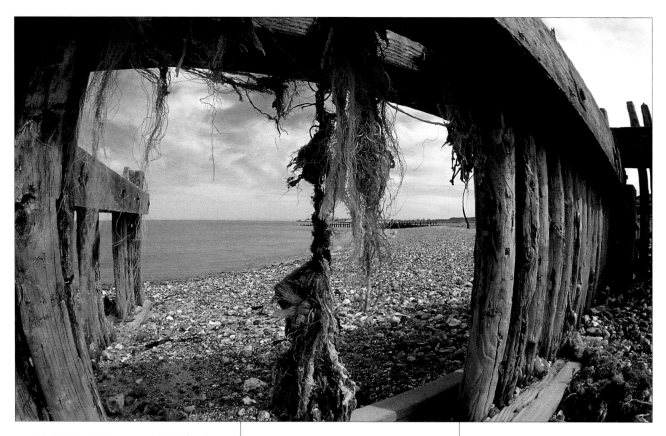

Rosetti's tomb

Dante Gabriel Rosetti is buried in the Parish Church of All Saints in Birchington, near Margate in Kent. This picture of his tomb was taken with a pinhole camera, or, to be more accurate, with a Nikon F fitted with a pinhole. The sharpness is pretty poor at 24x36mm, and blowing it up does nothing to improve matters. If you are serious about pinhole photography, you would probably do better to make the classic 'shoe-box' camera and shoot on 4x5in (9x12cm) film. Alternatively, the Santa Barbara Lensless Camera Co of California makes ready-to-use and very reasonably priced 4x5 pinhole cameras in a variety of 'focal lengths'. (RWH)

Beach, north Kent shore

Full-frame fish-eyes vary considerably in their degree of 'fishiness' or barrel distortion near the edge of the subject. Of the ones we have used, a Russian lens was one of the curviest, and the 15mm f/2.8 Sigma is one of the least curvy. This makes the Sigma (which Roger used for this shot) extremely versatile. By careful choice of subject matter, and careful positioning of the camera, you can dramatically distort part of the subject while leaving other parts looking apparently normal. (RWH)

Jess Turrell

You do not have to shoot conventional portraits with soft-focus lenses. This is much moodier than usual, partly as a result of the sitter's expression and partly because of the subdued background and black clothes. If you are really serious about portraiture, especially about portraiture with soft-focus lenses, we most heartily recommend that you use a Mamiya RB67 and the 150mm soft-focus lens that is made for it. This was shot at f/4.5 on tungsten-balanced film. The key light is a little too bright, and the sitter's face would have benefitted from a little more powder on the forehead. (FES)

camera (or even a 150mm from a 4x5in (9x12cm) on a bellows.

Older Lenses

The only older soft-focus lens for 35mm is the 90mm f/2.2 Leitz Thambar, which commands silly money as a collectors' item. Reputedly, some Rodenstock Imagon lenses were put into focusing mounts for 35mm camera as early as the 1960s, but we have never seen one.

OTHER LENSES

There are several other types of lenses which you may encounter. Some of them have only ever been available for one or two cameras, while others periodically surface as a new 'bright idea', only to sink again when public interest proves limited.

Pan-focal Lenses

These are simply lenses with a very small aperture for enormous depth of field: one example that was widely advertised was a fixed-focus, fixed-aperture 40mm f/40.

While they do offer enormous depth of field, they do so at the expense of sharpness. Using the 1000/n rule described on page 38, an f/40 lens can only deliver 22.5 1p/mm: enough for a small wallet-sized print, but not for much else. Also, with such a tiny aperture, it requires long exposures even in bright sunlight: about 1/15 second with ISO 100 film, and about 1/125 even with ISO 1000.

Pinholes

You can make pictures with a pinhole, and the fascinating thing is that the 'focal length' depends only on the distance of the pinhole from the film. Details of how to make a pinhole are described in the caption to the picture opposite. Use it straight on the body, or with a bellows or extension tube for a longer 'focal length'.

The results are very soft, but this is a cheap, entertaining experiment which every photographer should try sometime.

Flash Lenses

You may occasionally encounter old lenses where the lens diaphragm can be mechanically linked to the focusing ring so that, as you focus closer, the lens is stopped down. These lenses were designed to be used with flashguns in the days before flash automation, when you worked out the required aperture by means of a 'guide number'. The guide number varies with film speed (most are quoted for ISO 100 film) and you have to specify whether you are using metres or feet. Thus, for example, a guide number of 45 (ISO 100, metres) means that with ISO 100 film, a subject at 5 metres needs an aperture of f/9 (near enough f/8), while a subject at 2 metres needs f/22 (strictly, f/22.5). A guide number of 100 (ISO 100, feet) would mean that at 10 feet you would need f/10; in practice, opening up to f/8 would be better than going down to f/11, because few manufacturers understate their guide numbers.

The most interesting version of these lenses was probably the 45mm f/2.8 GN-Nikkor, a simple four-glass Tessar which is remarkably slim: it is sometimes called the 'pancake Nikkor' because it is so thin. Some photographers prize these as a way of making an SLR (relatively) pocketable.

This 'pinhole' is nothing more than a Nikon lens cap with a hole drilled in the middle, and a piece of heavy-duty aluminium foil taped behind it. A smear of olive oil, blackened with a match flame, removes the problem of reflections off the edge of the pinhole. The smear of glue around the front of the hole dates from a previous experiment with pinholes, when a thin copper disc was glued to the cap. The traditional way to make a pinhole was to dimple a small piece of copper or brass, then grind off the dimple, leaving a hole with very thin sides. This is more durable, and possibly superior to the foil approach; but for playing around, the foil is fine.

Zeiss flirted with another kind of flash lens, one with a leaf shutter incorporated to allow flash synchronisation at higher speeds than the focal-plane shutters of the day would permit. With modern ultra-fast shutters, the need for these has greatly diminished. A similar lens (the 'Blitz Summicron') was available for rangefinder Leicas.

Variable-field Curvature Lenses

Minolta once made a lens where the field curvature could be dramatically varied to allow the photography of curved subjects; it also functioned to a limited extent as a tilt lens, though obviously using a completely different optical principle. As with so many other special-application lenses, it is perfect for the application for which it is designed; it is just that most people never need that application.

8 LENS OUTFITS – AND FILTERS

Most experienced photographers, no matter how many lenses they own, have one or two lenses which they use more than any other. Of the authors, Roger uses a 35mm f/1.4 and a 21mm f/4.5 (it used to be an f/2.8, but that was stolen) on his Leicas, and Frances uses a 35mm f/2.8 shift lens and a 90mm f/2.5 macro.

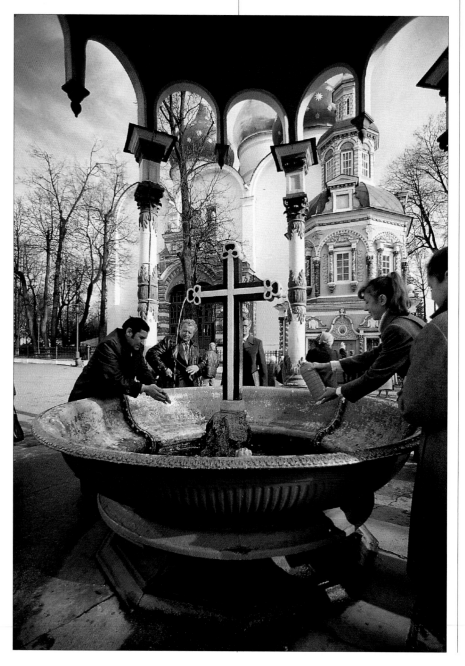

Fountain, Zagorsk monastery

These are pilgrims, filling their water bottles from a holy fountain at Zagorsk, north of Moscow. The picture was shot with a 17mm f/3.5 Tamron SP, principally because the 21mm for the Leica had been stolen. Ultra-wides allow you to get close in to the action, so you can see what is going on without having people in the way, while still permitting you to show the subject in context. Roger's second choice of lens (after 35mm) is normally an ultra-wide, while Frances prefers the more traditional 90mm. (RWH)

Gate and courtyard

You can use a 35mm camera in several different ways. Although we do a fair amount of reportage work, we find that our very best pictures are often the ones where we use 35mm cameras like large format: on a tripod, with careful composition and very careful metering, as if we were using large format. This is a picture by Frances, shot on the island of Gran Canaria, using a Nikon F on a tripod and her favourite lens, the 35mm f/2.8 PC-Nikkor. It was shot on Ilford XP-2 in rapidly changing weather – we had to wait for sun bright enough to give shadows – and the exposure was approximately 1/60 at f/16. This is one of the few pictures that we have ever taken which we have on our walls. (FES)

We could, if we had to, survive with just these two lenses each.

The difference between our choices, though, illustrates the impossibility of suggesting what *you* will need next. If you shoot a lot of sports and action you will need lenses which we hardly ever use, such as long, fast lenses. If you habitually shoot out of doors in good light, you certainly will not need a 35mm f/1.4. We can, however, make a few generalisations which are valuable.

DON'T BE AFRAID OF EXOTIC LENSES

Most photographers, almost by definition, buy 'middle of the road' lenses: middling focal length, middling apertures, and no special-application lenses such as ultra-speed lenses, ultra-wides, ultra-longs or macro. If nothing else, the price of such

Sigma 300mm f/2.8 Apo
The 300mm f/2.8 Sigma is certainly not an everyday lens – the price alone rules it out for many people – but once you have a lens like this you may be astonished at what it can do. If you want to shoot sports and action, there is no easy alternative. Although its very high speed means that it can be hand held, we normally find that it is more useful on either the Slik pistol-grip tripod head shown here, or on a more compact head on a monopod; it is a heavy lens to hold if you are using it for several hours at a time.

Door, St Augustine, Florida

These two pictures, of the door to the chapel in the Fort at St Augustine, Florida, represent the extremes of focal length that would be available with a typical two-zoom outfit. Both were taken from roughly the same viewpoint, one with a 35mm lens and the other with a 200mm lens. The carved coat of arms is the same one that is seen at the top of the door in the wide-angle shot. What is more, if most of your photography is done out of doors, you would not even need fast lenses. Modest variable-aperture zooms would deliver surprisingly good results at f/8 or f/11 using reasonably fast film. (FES)

lenses is a major deterrent. That's fine – if middle of the road lenses are what you need. On the other hand, if you really, really feel the need for out of the ordinary lenses, then save your pennies and buy them. It is all very well to buy what everyone else buys, but *all four* of our favourite lenses are out of the ordinary. Ask yourself if you have special needs which could better be met by special lenses, too.

BUY THE BEST YOU CAN AFFORD

Buying the best you can afford does not mean that you should only buy the best

or the most expensive. For instance, we would rather have a 13mm f/5.6 Nikkor than our 14mm f/3.5 Sigma. On the other hand, the Nikkor is over $9000 (say £6000) more expensive than the Sigma (we generally buy our lenses in the USA, where they are cheaper), so we bought what we could afford.

At the very bottom of the range, if the choice is between a cheap 'n cheerful second hand lens or no lens at all, go for the cheap 'n cheerful lens if you can afford it. It may not deliver professional quality, but, unless you are trying to sell your pictures (or to win competitions with large prints), does

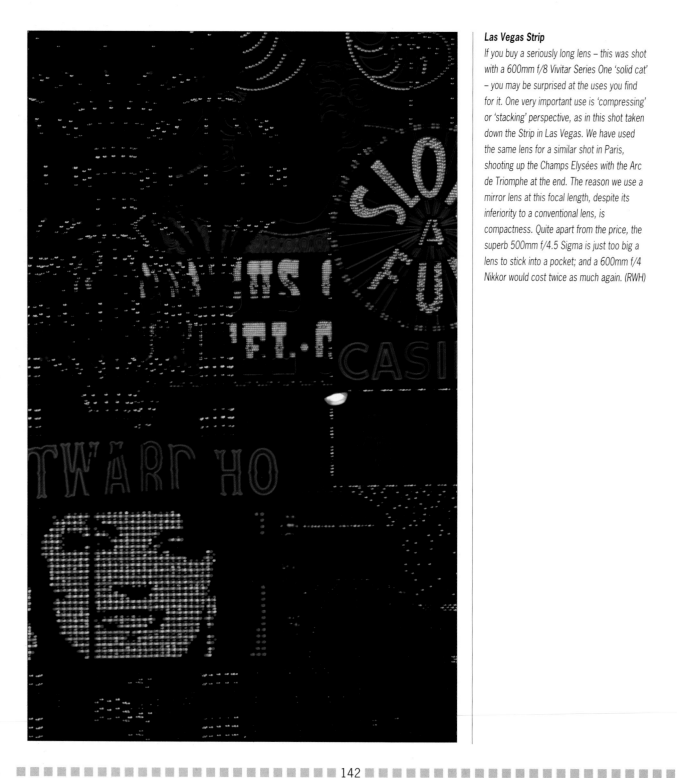

Las Vegas Strip

If you buy a seriously long lens – this was shot with a 600mm f/8 Vivitar Series One 'solid cat' – you may be surprised at the uses you find for it. One very important use is 'compressing' or 'stacking' perspective, as in this shot taken down the Strip in Las Vegas. We have used the same lens for a similar shot in Paris, shooting up the Champs Elysées with the Arc de Triomphe at the end. The reason we use a mirror lens at this focal length, despite its inferiority to a conventional lens, is compactness. Quite apart from the price, the superb 500mm f/4.5 Sigma is just too big a lens to stick into a pocket; and a 600mm f/4 Nikkor would cost twice as much again. (RWH)

**Confluence of Great Ranjit
and Tista rivers**

*Remarkably, this is not a telephoto shot; the
foliage in the top left-hand corner and in the
foreground gives it away. In fact, it was shot
with a 35mm lens, and shows the confluence
of two rivers in the Himalayas between
Darjeeling and Kalimpong. The milky Tista
absorbs the deep green Great Ranjit. The
earliest European travellers, well over a
century ago, remarked on the colours of the
two rivers. Normally, a rather longer lens
would be recommended for mountain
photography, but as a second choice, 35mm
must be the winner. (RWH)*

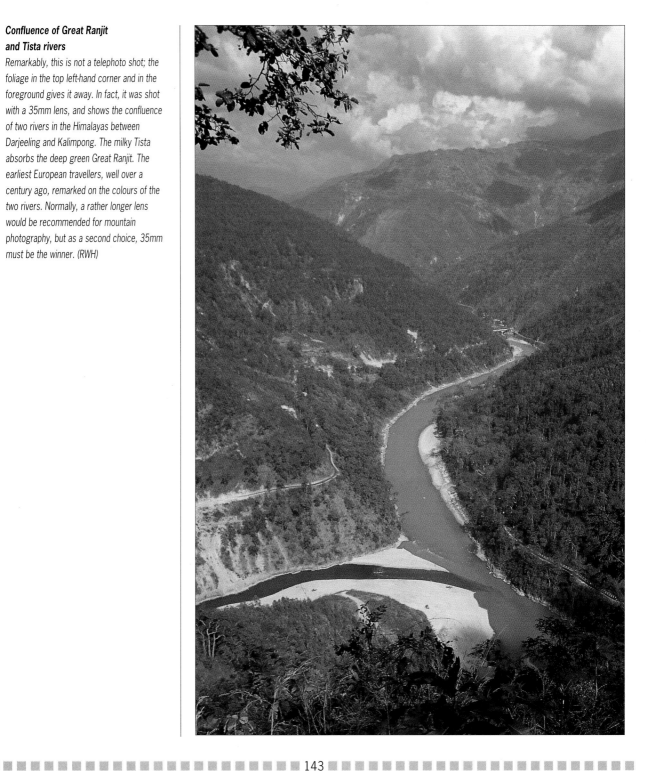

Neon sign, Las Vegas

The lenses you choose are always dependent on your personal vision. Not many people, for instance, would think of using black and white to photograph the neon lights of downtown Las Vegas! Even though we were using a tripod, the exposure time still had to be reasonably brief to catch the right sequence of illuminations; this was probably about 1/15 at f/4 on Ilford XP-2, and even at that there is a double image of the girl's leg, which 'kicks'. This is one of those places where you need to watch the subject during the exposure, either with the naked eye or through a separate viewfinder. The lens was the 35–85mm f/2.8 Vivitar Series One, probably at about 65–75mm. (FES)

Cleaning lenses

The correct way to use lens tissues: roll two or three together, and tear the roll in half. Use one half to brush loose dust off the dry lens. Then breathe on the lens, and use the other half to clean the lens finally. Unless the lens is downright filthy, this is all you need to do – and you should not need to do it very often. The camera, incidentally, cost us $14 (under £10) at a photo fair, and gives images as sharp as an SLR. (RWH)

this matter? Maybe when your finances improve you can buy something better.

Of course, it will normally be cheaper in the long run to buy a good lens in the first place, because you will be spared the expense of trade-ins and the losses attendant thereon, but the real argument for buying the best you can afford is that it throws you back upon yourself. If you have inferior equipment, you can always blame that: how many photographers do we all know who are constantly whining that they could take better pictures if only they had better equipment? With good equipment, by contrast, you know that the camera and the lens can deliver the results; if there are faults, they are yours. This is quite a spur to effort: you have to live up to your equipment, instead of blaming it (often unjustly) for your own shortcomings.

DON'T BUY MORE LENS THAN YOU NEED

At the time of writing, we were just considering the purchase of a 180mm f/5.6 Sigma macro. There is also a 180mm f/2.8 Sigma macro, but it costs about twice as much, and besides, it is a lot bigger and heavier. For macro photography, you usually have to stop well down for depth of field, so wide apertures are not much use anyway.

This does not mean that there is no place for the 180mm f/2.8. If we wanted a general-purpose 180mm

Four-wheel-drive racing

There are action pictures of four-wheel-drive racing on pages 100–1, but 'cutaways' in quieter moments are also well worth taking. This was almost certainly shot with the same 300mm f/4 lens that was used for the action shots, though arguably an extended-range zoom like the 50–300mm f/4.5 Nikkor would be ideal for covering this sort of event. The only problem lies in developing the muscles you would need to carry it! We would prefer to work with two or even three camera bodies simultaneously: one with a 200mm, say, one with a 300mm, and maybe one with a standard zoom. This is why it is so important to ask yourself what you really want to photograph before you start buying lenses. (RWH)

lens, we would not hesitate to buy that instead – but we don't. We already have an old 200mm f/3 Vivitar Series One, only 1/6 stop slower than f/2.8, so we don't need the speed. Because we work together, it is useful to have two lenses of this focal length, and the smaller size and lower price of the f/5.6 Sigma make sense to us.

Also, we used to own both 800mm and 1200 lenses. They were just too long and too slow for anything we ever did – and the 800mm was too close to the 600mm to be convenient. They were simply 'more lens than we needed', so we sold them.

Admittedly, as professionals, we never know what we are going to have to shoot next, so we tend to overbuy in case we need high-specification lenses; but many people buy faster lenses than they ever use, or lenses whose

sharpness will be completely wasted on the modestly sized prints that they normally shoot.

DON'T BUY LESS LENS THAN YOU NEED

The mirror image of our previous exhortation is that if a lens won't do what you want, it's no use.
For example, when we wrote this we were also contemplating the purchase of a 300mm f/2.8 – Sigma, again. These are expensive lenses, but we know from previous experience that we really need that speed in order to be able to hand hold the lens (occasionally!), and for action stopping. The 280mm f/4.8 which we used to own was simply too slow (f/4.8 is half a stop slower than f/4, one and a half stops slower than f/2.8).

San Bartolomé

Many years ago, Leitz used to sell a 105mm f/6.3 'Mountain Elmar' as the ideal lens for mountain photography. The focal length, they reasoned, was just right, and the light in the mountains is pretty good, so they could sacrifice speed in the interests of compactness and light weight (in the 1930s, remember, people walked far more and drove far less than they do today). Many photographers would still agree that something in the 80mm to 150mm range is as useful now as ever it was. This was shot with a 135mm f/2.3 Vivitar Series One. In the rocky, volcanic interior of Gran Canaria, we found that the 35–85 zoom was the most useful lens we owned, though the 90mm f/2.5 had the edge for ultimate sharpness. (RWH)

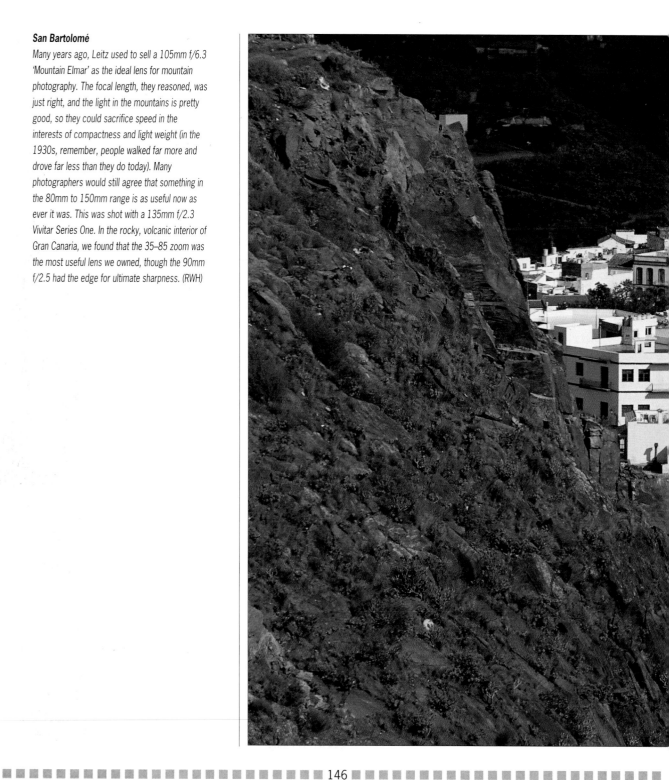

BEWARE OF 'BARGAINS' THAT YOU DON'T REALLY NEED

Economists talk about the 'price/demand curve': when the price falls low enough, the demand will be there. Thus, while we might not buy a 135mm lens at (say) £100, at £25 we would find it hard to resist. The danger here is of buying things which you do not really want or need, just because they are cheap. Then, you cannot afford to buy the lens that you do want or need, either because you already have something that is almost as good, or because you don't have the money, having spent it on the 'bargain' earlier.

We have to plead guilty; we own two or three lenses which we bought cheaply, though they usually came with something else as a package deal. We don't do it very often, though!

HOW BIG AN OUTFIT DO YOU NEED?

The growth in the size of lens outfits is well illustrated by the history of photojournalism, beginning in the days of the rangefinder Leica. Traditionally, Leica users bought three lenses: 35mm, 50mm and 90mm. Regarded as the 'photojournalist's trinity', there were many photographers in the 1950s who earned a living with just these three.

Then the Nikon F came along, and in Vietnam (for example) you would see a photojournalist with two Leicas (and

Thirsty, miserable, always wanting more
Using a wide-angle held intentionally at an angle creates a feeling of alienation – a feeling which is accentuated by harsh contrast, deliberately poor technical quality, and the inclusion of graffiti. The chopped-off car wheel and the wide-angle distortion make the picture still more unsettling. This is a very different New Orleans from the tourist haven which many people (including us!) have photographed. It is sometimes a good idea to make a deliberate attempt to adopt a different vision. (FES)

the same three lenses) and a Nikon. There would be a 200mm f/4 on the Nikon, because Leica rangefinder cameras cannot reliably be coupled to lenses longer than 135mm. Once again, many photojournalists earned a living throughout the 1960s with just four lenses.

Today, with an incredible range of lenses available, and with more outlets for photography than ever before, many photojournalists own at least half a dozen lenses: maybe 20mm, 35mm, 85mm or 90mm, an 80–200mm zoom, a fast 180mm or 200mm, and maybe a 300mm f/2.8. On top of that they will hire specialist lenses for certain assignments: 17mm or wider for shooting inside an aircraft cockpit, a fast 400mm for sports.

Large Outfits: Pros and Cons

If you can afford it, there is no doubt that it is wonderful to own as many lenses as you want. We own lenses from 14mm to 600mm, and we can select from our outfit whichever lenses we need for a particular job. For technical illustrations in the studio, the 90–180mm Vivitar is extremely useful; for interiors, the 14mm Sigma is ideal. For architectural photography, the PC-Nikkor is wonderful. For low-light reportage, it's the 35mm f/1.4 – and so forth.

The problem, though, is that it is simply impossible to carry all these lenses. We find that even with the two of us working together it is a hassle to carry more than eight or ten lenses. If you do carry that many lenses, you are forever changing them; and that is quite apart from the price, or the question of security (lenses are very easy to steal).

Small Outfits: Pros and Cons

To be brutal, many photographers could survive (even professionally) with just three lenses: a 'standard zoom' of 35–85mm f/2.8; a 'tele zoom' of about 80–200mm or 70–210mm, again preferably f/2.8; and a single ultra-wide – 24mm, 20mm or 17mm. The zooms would need to be the best available, but modern zooms are astonishingly good.

On the other hand, such an outfit would not be fast enough for some types of photography: there would not be a lens that would focus close enough for a photographer who was into macro work, and you wouldn't have a shift lens for architectural photography.

Specialist Outfits

What we have, therefore, amounts effectively to several different outfits: one for reportage, one for interiors, one for landscapes and general outdoor photography, one for close-up and macro, and so forth – and this is the best way to look at your own outfit requirements.

Write down all the kinds of photography that interest you. If that is too difficult (and let's face it, most of us will try anything if we have the chance), write down the kinds of photography that you don't do. For example, we almost never shoot sports and we don't take many portraits, and, in any case, we don't use 35mm for portraits. This will help you to realise the subjects that are important to you. Categories could include landscapes, towns, candid people shots, travel, close-up, action, weddings, portraits, advertising, book and technical illustration, etc. You can devise more of your own.

Pick the two or three categories which interest you most, and for *each*

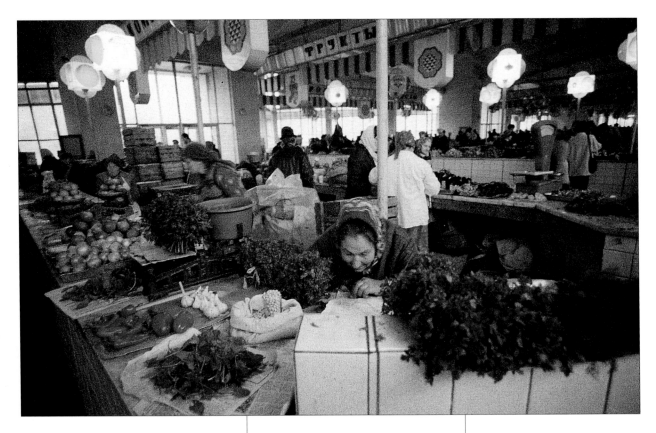

category write down your 'dream outfit'. For reportage, for example, you might choose 20mm f/2.8; 35mm f/1.4; and 85mm f/1.4. For close-ups, you might choose just one lens, a 105mm macro, say.

Now see how much overlap there is between your two or three dream outfits, and compare them with the equipment you already own. How far from the 'dream' are you? Maybe you have a 90mm f/2 instead of an 85mm f/1.4. Well, you can probably live with that. But if you really, really want to shoot more macro, and you don't own a single macro lens, maybe that is where you should start to look at what is available, and to start saving your money up.

LENS CASES AND OUTFIT BAGS

How should you carry and protect your lenses? And, for that matter, how can you make sure that filters do not degrade image quality unacceptably? Unless you give some thought to these questions, you are not building a lens outfit; you are just building a collection. .

Caps

You should of course always protect your lenses with front caps when they are not in use, and with back caps when they are off the cameras. The risks if you do not are myriad: scratched or chipped glass; bent mechanical linkages; dirty electrical contacts; and

Dorogomilovskaya market

The 'Free Market' on Bol. Dorogomilovskaya Ulitsa in Moscow is a fascinating place, but the light is very poor: even with ISO 1000 film and 50mm f/1.2 and 35mm f/1.4 lenses, we were shooting at 1/30 to 1/60. There are some people who are still afraid of cameras, either for religious reasons or because they recall the old days of Uncle Joe – or perhaps out of simple vanity. This old woman actually hid behind the newspaper after we took this shot, and at Zagorsk another old woman told us that God would punish us for taking pictures of the monastery. (RWH)

Winter storm

When you are photographing a winter storm, a wide-angle helps you to get into the middle of things, while a short tele helps you to capture the drama of individual breaking waves. In other words, a standard zoom is ideal. You need good weather protection both for yourself and for your camera. Roger used a Ewa-Marine 'rain cape' on his Pentax PZ-1/Z-1, which was fitted with the 28–80mm variable-aperture Pentax zoom, and he needed a bath to warm up and to wash off the salt water when he got home. Exposure determination was by programmed automation, shooting on Scotch ISO 1000 film. (RWH)

(at the very least) dust which can get on to your pictures as well as into delicate mechanisms.

The 'Optical Lens Cap'

Opinions are divided about the wisdom of using a skylight or UV filter as an 'optical lens cap' to protect the front element of a lens: the gentlemen on the Leitz stand at Photokina one year frowned at the filter on Roger's 35mm f/1.4 Summilux and said, 'Why do you suppose we make lens caps?' On the other hand, a filter can afford considerable protection.

Strictly, any filter will cause some degradation; but on the other hand, the degradation if you use a high quality filter is negligible. What we do is to leave filters on those lenses which we commonly carry ready for action, and leave their lens caps off, but we use all other lenses without filters, uncovering them only for use. In really difficult conditions (for example, shooting straight into the light), we remove the filters even from the ready-for-action lenses, if we have time.

Cleaning

Incompetent cleaning does more harm than insufficient cleaning. What you do not want to do is to grind dust and grit into the front element of the lens; and this is how you avoid doing it.

First, use a brush or a blower brush to remove the worst dust, grit and so forth. Alternatively, roll two or three

lens tissues together; tear the roll in half, and use one half as a brush to remove the dust and grit.

Second, breathe on the lens and wipe it with a *clean* lens tissue (not the one you have just used as a brush) or chamois leather or lens cloth (not the silicone-impregnated kind sold for spectacles). Chamois leathers clean lenses the most effectively, but make sure yours is superclean. Ours lives in a resealable plastic bag, and only comes out for cleaning lenses. It is never even put down anywhere, just back in the bag. An old, soft, well-washed rag (handkerchief or T shirt) may be OK, but it is risky: there may be grit trapped in the fibres unless you are very careful.

If the lens is really dirty, with finger-marks or other grease marks, you may need to use a little lens-cleaning fluid on a lens tissue, or a pre-moistened ProPhot 'baby wipe' type cleaner. Do not tip lens-cleaning fluid on to the lens; ninety-nine times out of a hundred it won't matter, but the hundredth time it may seep into a lens cell and even between lens elements.

Of course, prevention is better than cure, and caps will help keep the lens clean to start with. So will lens shades, for that matter: not only do they cut out stray light, but they also help protect the front of the lens from dust, rain, spraying champagne and sticky fingers, and in the event of a 'ding' they spread the load and avoid a damaged filter ring.

Lens Cases and 'Wraps'

The traditional lens case of black or brown leather, with a red plush lining, affords excellent mechanical protection but is something of a dust trap and is very bulky. We use these only if we are carrying lenses in the pockets of a 'photographer's vest' or in the 'poacher's pockets' of our superb Billingham jackets – a piece of clothing every photographer ought to own.

Drawstring cases are handy and compact, and arguably slightly less dust-prone than boxes, but offer only limited protection. Thick chamois-leather bags are almost certainly best, followed by Billingham's canvas bags. Soft padded drawstring cases are excellent too, and some of our lenses live in small purses which were originally designed for other things: for interchangeable backs from medium-format cameras, for example, or for compact cameras. You can often find padded cases for compact cameras in dealers' 'junk bins' at very modest prices.

'Wraps' are a comparatively recent invention: the lens is placed in the middle of a triangle or square of fabric which is then folded around it, and secured with Velcro or similar hook-and-loop fastening. The great advantage of a wrap is that it can accommodate a wide variety of lenses, but it is a little slow to use. Wraps are ideal for packing lenses inside a hard-shell case.

Outfit Cases

Selecting an outfit case or bag is always a trade-off between good protection, compact size, ease of use, flexibility and price.

Several small hard-shell cases score very highly on the first three, but fall down on flexibility: they can be configured for a limited number of specific lenses, and if you want anything else, bad luck. Camera manufacturers' own cases are often of this type. Our

favourite bag in this category is made by The Bottomline in British Columbia.

Hard-shell cases with cut-out foam offer superb protection (provided the foam does not crumble and decay, as some types do), and are pretty good on size and ease of use. Price varies widely, with the extremely expensive Zero Halliburton cases usefully light and very solid, and the rather cheaper Doskocil or similar cases a little heavier and bulkier. Where cut-out foam really falls down is on flexibility; the only way to accommodate different lenses is to have several blocks of foam, each cut differently.

Hard-shell cases with movable dividers are a little bulkier and do not offer quite such good protection, but are extremely versatile and very quick and easy to use. The most versatile are the ones where the dividers are held by Velcro, rather than being slotted into cut-outs; we use a case of this type all the time, though it is actually semi-stiff rather than a true hard-shell.

Soft bags are generally the most convenient, and offer far more protection than you might expect, but they still do not offer quite as much protection as hard shells and they can be surprisingly bulky for the amount of equipment they hold. We own both Billingham and Sundog soft bags. The Sundog has a waist strap as well as the shoulder strap, and is much easier on the back if you have to walk any distance.

For carrying large quantities of equipment, backpacks are ideal. We use a big Sundog, one of the Art Wolf designs. If you have to walk far, backpacks are much easier on the back than any other kind of case.

Prices of all types of bag vary widely, and most of the time you get what you pay for. Sure, you can buy bags which *look* like Billingham or Sundog or Zero Halliburton at prices which are half those of such illustrious names; but when it rains, or when it comes to a knock, you soon see why the good bags cost more.

One last thing. Our bags are chosen to look as little like camera bags as possible. The more like a camera bag something looks, the more attractive it will be to thieves. A cheap, shiny light-alloy case with a great big NIKON or PENTAX or OLYMPUS sticker practically screams, 'I am an amateur – please steal my camera case'.

FILTERS

Traditionally, there is a distinction between 'filters' and 'effects screens', but it is not always very useful; the polariser, for example, is classified as a 'screen'. In most of what follows, 'screens' and 'filters' are lumped together, though there is a section on

Filter holders and adapter rings
Three ways of using gelatine filters, and three adapter rings. The Hoya filter holder (left) fits 52mm filter threads. The Hasselblad lens shade, in the centre, has been fitted with a 52mm adapter to replace the original bayonet filter fitting; filters fit into a metal slide (here seen partly withdrawn) and slip in the back. The clamp-on Kodak shade on the right accepts filters in plastic holders, the porte-filtres. All three use 75mm square (roughly 3x3in) filters. In the middle, at the front, a 49–52 stepping ring allows the use of 52mm filters on 49mm Schneider filter mounts, while a 67–72mm ring allows the use of 72mm filters on a lens with a 67mm filter mount.

It was impossible to get this picture of an elegantly framed house in Gran Canaria sharp from front to back, even by stopping the 90mm macro lens down to f/22 – and at that point, the shutter speed required for Fuji 50 was down to 1/30 and 1/15 second, which would have risked subject movement as the wind stirred the leaves. What we did, therefore, was to shoot at f/16, which allowed fair depth of field and a reasonable (1/30 and 1/60) shutter speed. Even at that, although the shapes are beautiful, it is not a picture which you want to enlarge too much. (FES/RWH)

effects screens such as starbursts, soft focus, multi-image and the like.

As already mentioned *any* filter causes some degradation of image quality unless it is designed to be a part of the optical system of the lens. This is actually done in some mirror lenses, and in a few wide-angles and fish-eyes equipped with filter turrets. In these cases, using the lens without a filter may well cause image degradation: an ultra-violet filter is left in the optical path when no other filtration is required.

With filters mounted in front of the lens, vignetting (darkening of the

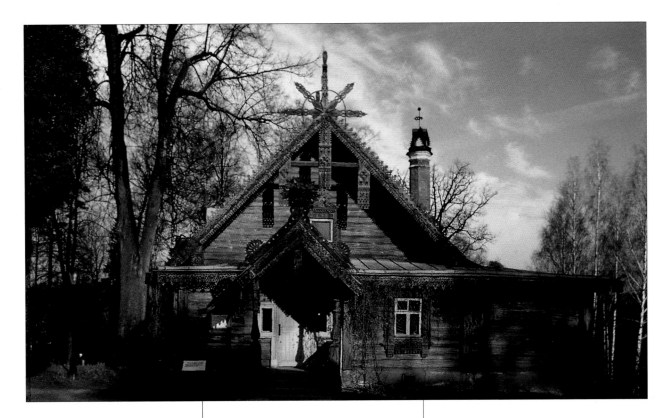

Dacha

Frances's faithful 35mm f/2.8 shift lens captured this lovely old wooden dacha near Zagorsk, but because of poor light she was shooting only at f/5.6 on Fuji 50; the result is that depth of field is barely adequate. In order to use a shift lens properly, you normally need to stop down at least to f/8, and we prefer to go to f/11 or f/16 if at all possible. The long throw of the focusing mount and the rather dark screen (even with the Beatty Intenscreen fitted) mean that it is quite difficult to determine focus precisely, and still harder to determine depth of field. (FES)

corners because of the filter blocking the light) may be a problem, especially with wide-angles. Slim filter mounts are obviously safer than thick ones. To check, mount the filter on the lens, focus at infinity, and look through the viewfinder while stopping down to the minimum aperture. Vignetting is one reason why you should never stack filters one on top of the other if you can avoid it: always remove a UV filter, for example, before adding a polariser. The other reason for not stacking filters is because the extra glass-air surfaces increase the risk of flare and reflections (see page 33).

Round Glass Filters

These, the most usual of filters, either screw or (more rarely) bayonet on to

the lens. Quality varies widely, and the better the quality, the less the image degradation. In particular, look out for plane-parallel surfaces; looking through the filter at an angle will disclose any ripples or irregularities. Also, look for mounts in which the glass is retained by a screw-in retaining ring, rather than being spun into the mount – spun-in mounts may introduce strains into the glass, with resultant degradation of image quality. Finally, look for multi-coating. Some filters are still only single coated, and you can still find uncoated filters all too easily. Camera manufacturers' own filters are normally of the highest quality, but so are the best filters from independent manufacturers. We now use mainly B+W and Tiffen, as well as Hoya HMC

and some old Vivitar VMC filters, all with perfect confidence. There are others which are as good.

Today, almost all filters are 'dyed in the mass' (coloured glass), though you may occasionally find laminated filters, where gelatine filters (see below) are cemented between glass. While there is nothing wrong with laminated filters – B+W makes an excellent line – they can delaminate if they are dropped, if they get wet, or if they are carelessly cleaned with lens-cleaning fluid. Delamination wreaks havoc with image quality, but fortunately it is very easy to spot when it happens.

Gelatine Filters

Gelatine filters give the least image degradation of all, and offer the widest range of colours. On the down side, they are surprisingly expensive. They are written off if they are finger-marked or if water is splashed on them, because they cannot be cleaned; and they have to be used in special filter holders. They are widely used in the studio by professionals, but they are rather less useful on location. If you look after them, they last just about forever.

Plastic 'System' Filters

Ever since the ingenious M Coquin invented his 'Cokin' system, there have been more and more 'system' filters. Unfortunately, all but the best of them introduce significant image degradation: they are typically far from plane parallel, and some of the plastics that are used are very dubious indeed. This does not matter too much with medium-format and large-format pictures, but the quality loss with 35mm may be unacceptable for critical use with sharp lenses and slow films. Only a very few makers, such as Lee and Tiffen, use glass instead of 'optical resin' or plastic.

Effects Screens

These all degrade the image, and (once again) the plastic filters typically give the worst degradation. Some cheap filters function very effectively as soft-focus screens.

For soft focus, the very best screens are the terrifyingly expensive Zeiss-patented Softars, with little lenticules moulded into the surface of the filter, and the next best bet is probably the Pro-4 Interactive filter set, which uses holes drilled in clear plastic. The Pro-4 set is also very much cheaper.

For other effects, the least image degradation in our experience comes from B+W screens, which are typically two to five times the price of cheaper screens!

And so, at the end of it all, you get what you pay for. But is that all there is to it? Not quite.

Cornfield, Châlons sur Marne

A colour version of this picture appears on page 2. Quite often we will shoot a subject in both colour and black and white, so we need to carry (at least) two camera bodies. Usually, either the colour picture or the black and white turns out to be clearly superior, but on this occasion we still cannot decide which we prefer: the rich colours of the one, or the pearly gradation of the other. You don't want to carry a heavy outfit on a country walk, so we had one Nikon F each, and two lenses: the 35mm f/2.8 PC-Nikkor and the 90mm f/2.5 Vivitar Series One. We also had a lightweight (4³/₄lb, 2.1kg) tripod. Exposure was about 1/30 at f/16.

ENVOI

Whatever lenses you buy, whatever lenses you want to buy but can't afford, whatever filters you decide to use, remember this: ultimately, photography is about taking pictures. It is not about having the most equipment, or the latest cameras and lenses, or the most exotic equipment. It is about using the equipment that you have.

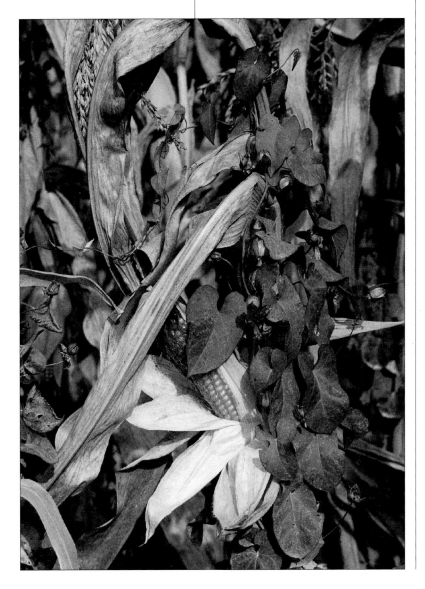

It is true that better equipment will give you better pictures, but only if you are a good photographer to begin with. A bad photographer can spend thousands, and still take bad pictures. A good photographer may find himself or herself limited by inferior equipment, but there will still be that spark, that determination, that *something* which lifts a picture out of the ordinary.

There will be times when you wonder whether you can possibly justify all that money you have spent on cameras and lenses and film, and times when you can't think of anything to photograph. When that happens, try this simple remedy.

Go through this book – or any other photography book, for that matter – and look at the pictures. Pick out the ones where you think, 'I could have done better than that'. Read the caption, to see if we were deliberately trying to show up some point which illustrated a defect or fault of some kind; and if we weren't, then just think about it. What pictures have you already shot that were better? What pictures have you in mind to shoot which will be better? How would you go about shooting them? What lenses would you need? How would you meter them?

When you have been thinking like this for a few minutes, you will realise that some of the magic has flowed back into photography for you; that you are looking forward to the next time you can go out with your camera. And do you know what? In that frame of mind, you probably can do 'better than that'. If you can, we shall have succeeded in what we set out to do.

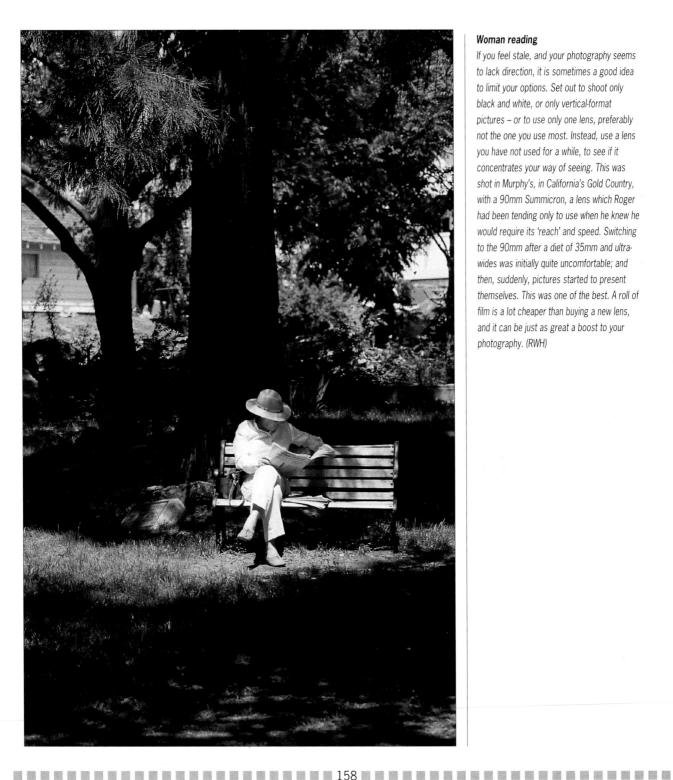

Woman reading

If you feel stale, and your photography seems to lack direction, it is sometimes a good idea to limit your options. Set out to shoot only black and white, or only vertical-format pictures – or to use only one lens, preferably not the one you use most. Instead, use a lens you have not used for a while, to see if it concentrates your way of seeing. This was shot in Murphy's, in California's Gold Country, with a 90mm Summicron, a lens which Roger had been tending only to use when he knew he would require its 'reach' and speed. Switching to the 90mm after a diet of 35mm and ultra-wides was initially quite uncomfortable; and then, suddenly, pictures started to present themselves. This was one of the best. A roll of film is a lot cheaper than buying a new lens, and it can be just as great a boost to your photography. (RWH)

INDEX